A DECADE OF PUBLIC ART COMMISSIONS AGENCY, 1987-1997

PUBLIC:A

RT:SPACE

INTRODUCTORY ESSAY BY MEL GOODING

MERRELL HOLBERTON
PUBLISHERS LONDON

For James Hurford CBE, 1945–1997 Architect and a Founder-Trustee of Public Art Commissions Agency

CONTENTS

FOREWORD
Vivien Lovell, PACA

Public:Art:Space presents a selection of projects realised, unrealised, yet to be realised, from the decade 1987–1997. The desire for these commissions sprang from differing imperatives: many reflected the motives of the commissioner and were funded through whichever source was currently appropriate; others originated as initiatives by Public Art Commissions Agency (PACA) with artists and architects. Common to them all is the imaginative power of the artist to engage with the energies, the problems, the diverse and often contradictory levels of meaning and function of sites known as 'public space'.

It will be useful first to set the context for the commissions by charting briefly the shifting ground of what has come to be known as 'public art' over the recent past, and the particular role of PACA, and secondly to make some observations on current attitudes of artists to public space.

If the past decade has seen a steady increase in the volume of work commissioned, it has also been riven with contention. Public art has been at first marginalized and then to some extent appropriated by the avantgarde. It has been derided by the media, and there has been scant critical debate on the subject until relatively recently; now, along with new architecture, it is the subject of close scrutiny. As a term, 'public art' has been deemed an oxymoron, epitomizing a dilemma inherent since the advent of modernism and its focus on the autonomous, self-referential art object. A potential dichotomy exists between, on the one hand, the desire for utopian forms and places that enhance the viewer's experience of the art work, the environment and the world, and, on the other, modernism's role potentially to subvert, to question values and preconceptions. It has been the challenge for artists working on public commissions to transcend these polarities, and create works that genuinely engage people's imaginations yet sustain the capacity for infinite interpretation by successive publics. Public art eludes definition, and, like the breakthrough in information technology which transcends national borders and politics, public art and artists frequently slip between curatorial control systems.

Site specificity, a term fashionable in 1987, has been superseded by the dialectics of space and site, social geography, and the gendering of place. Since the community arts movement in the late 1960s, the public have been variously consulted, ignored or involved in the commissioning of art. Now 'new genre' public art prioritizes process over product by engaging the public in the genesis and creation of the work. In fact this important strand of activity can be traced back through decades, as an area where social change and public engagement are placed as high, or higher, on the agenda than the art work's physical manifestation. Mierle Laderman Ukeles's collaborations over a fifteen-year period with nine thousand workers in New York City's sanitation department provides an important example where respect for humanitarian and ecological values inform the tangible beauty of her artworks and performances.

Collaboration between creative professional practitioners has steadily gained ground; formal and informal 'alliances' have engendered new territories for artistic activity, ever since the ground-breaking Institute of Contemporary Arts (ICA) conference 'Art and Architecture' in 1982. Patterns of patronage have shifted, too, along with changing fashions in funding sources, and, with the advent of the National Lottery in Britain, public authorities and cultural organizations have briefly been in a stronger position to exercise their powers as enlightened clients.

Current theory regarding eligible space for public art includes public galleries and museums; accordingly, public art is no longer defined simplistically as 'art beyond the gallery'. These spaces and places are indeed more truly public than corporate space with only quasi-public access; however, they are still not as 'public' as the street, which conversely is the site of private transactions of all kinds. Established sectors and sites of public art (art in transport, art in the health sector, social housing *etc*) have broadened to include innovative commissioning in public and private collections, historic houses and landscapes, the media, the Internet. Curators have followed artists into these spheres. The art of display – and the display of art – is currently a fashionable area of research in art history and can be traced from the Great Exhibitions and the Venice Biennale, and the development of sculpture parks (the museum without walls) and city art collections, through to recent and current manifestations such as the garden festivals, 'Documenta' and the Münster Sculpture projects.

The curating of public art requires, according to Theo Dorgan of 'Poetry Ireland', a 'brutal finesse' in liaising between artistic creativity and the various vested interests that shape public environments. PACA's role has been to negotiate space between the artist's territory – the site of the imagination – and the jurisdictions of key design practitioners, users and funders of the social space in question. It is one of enabler, seeking to reveal potential and open opportunities during the process of delicate transaction between artists and clients. As a facilitator, PACA encourages interdisciplinary collaboration,

consultation and creative debate, whilst protecting the artist's professional integrity and helping define his/her sphere of operation.

There was a clear need in the 1980s for PACA – and a small number of similar organizations – to meet the demand for independent professional management of public art, engendered largely as a result of the Arts Council of Great Britain's 1976 Art in Public Spaces scheme, an initiative subsequently devolved to the Regional Arts Associations. The feasibility study for PACA was part of my research brief whilst Public Art Co-ordinator at West Midlands Arts. Support was provided then and subsequently to PACA by the Calouste Gulbenkian Foundation. West Midlands Arts has allocated revenue funding for PACA's regional advocacy and educational role since its inception; the Arts Council of England's support, too, has been invaluable, first through an Incentive Funding Award in 1989 enabling PACA to buy premises, and later through a three-year Enhancement Funding Award from 1991 to 1994, which consolidated the organization's financial base to a greater extent. From a firm regional base, PACA has developed a national and international profile, reflected both in its portfolio of projects and in the range of artists commissioned.

Current practice in public art engages with issues of spatial, social and environmental concern: artists, with others, are leading in these fields, precisely because they operate independently, free of hierarchies. They are the first to recognize potential and to act in the transformation of space. Artists characteristically lead the way in urban regeneration. At the same time they open new sites of debate – in ecology, music, choreography, geography or science.

The implications of social space, of 'public' space, are the subject of much debate. No public space is value-free and, as Henri Lefebvre notes, "The section of space assigned to the architect [or, one might add, the artist] – perhaps by developers, perhaps by government agencies – has nothing innocent about it: it answers to particular tactics and strategies; it is, quite simply, the space of the dominant mode of production."

The issue for artists such as Tess Jaray in Centenary Square, Birmingham, or Andrea Blum in her unrealised design for New World Square in Bristol has been how to introduce the possibility of a personal reflective experience within a site of grand scale and international aspiration. But whereas Jaray's scheme was eventually realised to a broader brief than orginally planned, without loss of human scale, Blum's horizontal layering for New World Square,

incorporating non-hierarchical materials, personal spaces, art/information and food kiosks, linked by underground lit waterscapes and electronic message channels, was rejected. There was simply too much at stake for those already involved in controlling the space, as was also the case with Marta Pan's unrealised design for Victoria Square in Birmingham.

Elegant transition from cerebral space, via pictorial space, to the space of popular usage is embodied in the proposal by Antoni Malinowski and Future Systems for a linear site in the Royal Docks. The public there would have completed the work by connecting a series of images on railings through their walk along the dock edge. Similarly, in Mark Pimlott's proposed boardwalk, parallel to but set back from the dock edge, the elevated journey along the site offers a new viewpoint and a new place. Susanna Heron's environmental works in Hackney and Dublin create a *genius loci* that quietly yet forcefully draws upon the individual's imagination and sense of engagement with the location. Light, space and place form interdependent elements in thw work of Martin Richman. Tyseley's Energy from Waste Facility, clad, coloured and lit from inside and out by Richman with architect Ray Perry, illuminates our perception of the transformative powers of energy and light.

Choreographed space, deriving from human scale, gesture and movement, is informed by function and usage (the transaction/the desire line). dECOi Architects' interdisciplinary collaborations with William Forsythe, choreographer, explored the fluid space of dance movement through cyberspace into a built sculptural form. Conversely, taking this book as the site, Mark Goulthorpe of dECOi and artist Max Mosscrop have interrogated the infinite spatial configurations between the book, their work and the reader with their precisely indeterminate quasi-anamorphic metaphorical 'eye-spines'. The resistance of these collaborative pages to be interpreted through a single viewpoint sets up a conundrum that can be further explored three-dimensionally on PACA's website documenting their collaboration (http://www.paca.org). Thus their projects will reach beyond the self-selected readership of this book to a broader participatory pubic on the site of the World Wide Web.
February 1998

PUBLIC:ART:SPACE
Mel Gooding

LIGHT

It is a cold December evening. The surfaces of pavement and roadway in central Wolverhampton gleam dully after a slight mid-afternoon drizzle. It is going dark. Then the Christmas lights go on, and in the streets through the centre by the high ground of the town church, St Peter's, and the late nineteenth-century Art Gallery below it, the air is filled with children's voices singing carols. These are broadcast from speakers discreetly placed above eye level on lamp-posts around the columns of which there is a subtle kinetic display of lights in permutations of green, blue, red, orange and yellow. This is *Children's Voices*, a work commissioned from Ron Haselden as part of Wolverhampton Borough Council's *Out of Darkness* project. Walking the streets of their town over the Christmas season the children will know that these are their lights, this is their music. The recordings, made by Haselden in schools all over the borough, rotate from speaker to speaker, and the artist has ingeniously ensured that however often a child may pass through the illuminated area, he or she is never likely to encounter the same song with the same pattern of ever-changing lights. The children will know, however, that somewhere someone will be hearing their voices singing as the lights move and change in magical correspondence to the sound. Children and parents claim celebratory possession of their town streets at Christmas.

As part of *Out of Darkness*, Martin Richman and Tony Cooper have illuminated St Peter's Church with a white light that creates a halo around the outline of its grand combination of Gothic and Victorian structures, bringing into night-time visibility the grace and subtlety of the porch and tower crenellation and crockets, and the tracery of the pierced parapet. From within, bright light irradiates the stained-glass windows, reversing out the 'walls of light' that were the great invention of the Gothic church builders. The church is thus revealed not only as a thrilling ensemble of stone forms but as a great enclosed space, within which the spiritual metaphor of 'interior light' is nightly re-enacted. Situated close below the church mound is the Art Gallery, a fine manifestation of late Victorian cultural beneficence and civic pride. For this, Martin Richman devised a dappled white light to play over the Neoclassical stonework: reflected from open tanks of water concealed in a narrow external basement area, it registers the unceasing kinesis of its source. Oppositions, of light to darkness, stone to water, constancy to variegation, animate a contrast of architectures: subtle interventions at a high-energy site, precise and simple of effect, highlight two central aspects of a civic culture.

Public art serves many purposes, but none can have more point and dignity than that of investing a public space with a renewed vitality, extending its availability as a place to be, in which a sense of identity, and of the possibilities of the civil life, are enhanced. The Wolverhampton project was initiated with that purpose: the light that creates spectacular moments in the night-time townscape brings the greater accessibility that comes with feelings of safety and a sense of well-being. It presents, then, a striking instance of what art can achieve – bringing the aesthetic into play with the behavioural – when a professional agency dedicated to the fostering of a responsive public art enters into active collaboration with a local authority. The first permanent project in which artists have been commissioned to integrate light into the urban fabric, *Out of Darkness* has taken nearly ten years from its conception to the realisation of its first stage; subject to the complicated constraints of the local democratic process, it has also required negotiation of both European Regional Development and Arts Council Lottery funding.

In all of this Public Art Commissions Agency (PACA) has played a crucial role. Philosophically focussed, sensible of the political complexities, sharply aware of the problems of public understanding and of the factors that impinge upon its public reception (education, aspects of presentation, local and national media *etc*), it brings critical, organizational and mediational skills into the promotion and development of a public art. Together with a number of other similarly committed agencies, such as Art in Partnership and Public Art Development Trust, PACA has brought a new kind of energy into this expanded field, collaborating with, and guiding, commissioning bodies to foster an art in public places that is neither hermetic in its concerns nor populist and condescending. The projects promoted by PACA over the first ten years of its activity have been extraordinarily diverse, ranging from the transformation of a vast public square at the centre of Birmingham to a modestly scaled commemorative sculpture in Shrewsbury, from Antony Gormley's problematic cast-iron figure in Birmingham's Victoria Square to Susanna Heron's contemplative *Sunken Courtyard* on the campus of Hackney Community College in London's East End, as well as many temporary interventions into

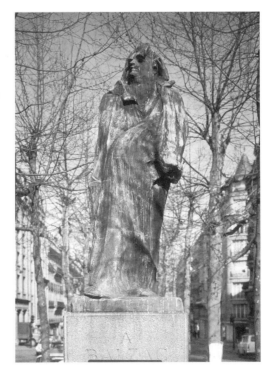

**Auguste Rodin,
Balzac, bronze, 1898,
Place Brea-Vavin, Paris**

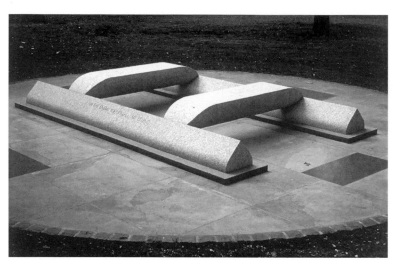

Paul de Monchaux,
Symmetry, Wilfred Owen
Memorial, 1993–94,
Shrewsbury

the public domain. This diversity of effort raises many questions. How are we to define the differing purposes of these different works in different places? In what ways have agencies like PACA effected change towards the commissioning of public art works that actively respond to the circumstances of a modern democracy? What kind of art is that? Why do we need it?

NEW KINDS OF NARRATIVE
We can begin with something widely acknowledged: the need to make permanent memorials to artists and writers that goes back to classical times. Conventional tributes in appropriate places (the birth-place town square, for example) are expressions of a communal pride in having produced a person of artistic distinction, but they rarely enter into creative engagement with the spirit of the artist's work. The most celebrated exception, Rodin's heroic figure of Balzac, which sought to represent physically the volcanic potency of the novelist's extraordinary imagination, was of course rejected by its original commissioners. (Forty years later, in 1939, it was erected in Montparnasse, where it dominates its busy crossroads setting.)[1] In the little park on the site of the old cemetery ground at Shrewsbury Abbey, within a few hundred

yards of where Wilfred Owen lived from the age of eleven, Paul de Monchaux's memorial to the poet attempts no such manneristic vertical grandeur, but engages effectively and subtly with the anti-heroic themes of recognition and reconciliation that are central to Owen's poetry of "War, and the pity of War". Two parallel recumbent granite forms reach to each other by bridging arms, to form a stone buckle. One carries the climactic paradox of 'Strange Meeting': "I am the the enemy you killed, my friend"; the other the poet's name and dates. This simple symmetrical structure, resembling a First World War trench duckboard or pontoon raft, is set on a circular apron of sandstone flags into which are laid plates inscribed with simple narratives, reminders, to those who use the monument as a quiet seat, of the poet's exemplary life and tragic death. Children often play within the sculpture's intriguing horizontal structure, emblematically innocent of its commemorative purpose. De Monchaux's sculpture combines abstract symbolic structure, visual motif and language to communicate a necessary knowledge.

At the lower end of Birmingham's Centenary Square there is a monument to the dead of Owen's war, a Neoclassical domed temple of white Portland stone. Between this 'Hall of Memory' and a handsome civic building which occupies the site of Baskerville's house are installed the six standing stones of David Patten's *Monument to John Baskerville – Industry and Genius*, at first sight like a row of waist-high fluted cenotaphs. This reminder of a great printer's life-work, and of his creation of the classic-modern typeface that bears his name, is in fact a gigantic imitation of a Baskerville setting of the poet Virgil's name, the letters reversed as for printing. An embossed bronze plaque in the pavement nearby informs you of Baskerville's first use of the face in the 1757 printing of Virgil's *Aeneid*, and of the poem *Industry and Genius*, dedicated to him, in *The Birmingham Gazette* that year. What makes Patten's sculpture so unusual and effective a public work is its address to the significance of Baskerville as typographer, its identification of the typeface as the focus for public celebration. For what has been more important to the development of social, cultural and political awareness in the modern age than the clarity of good printing and the vernacular translation of great texts? That is the democratic significance of Baskerville's work, and to recognize that is the quite proper work of this sculpture, in which the scaling up of the type-punches paradoxically reminds us just how small are the "twenty-six soldiers of lead" with which a radical printer once promised "to conquer the world". Like De Monchaux, Patten has moved beyond the purist abstraction of modernist sculpture, combining word and motif to bring history and narrative back into the space of the city: a story is told; a history is implied.

Other commissioned works in Birmingham use alternative means to respond to the city's history, its present and its future, in ways that actively engage thought and feeling about the actuality of belonging to 'the city' considered as a great collective enterprise occupying a complexly defined site. In a restless age

without the confident public certainties of the past not every intervention can be sure of passive acceptance. Indeed, one function of public art in the modern city is to reflect the multivalent realities of the democratic present; to surprise people into creative interaction with the work, into constructing its meanings in relation to their own lives in their own time and place. Antony Gormley's proposal for his sculpture *Iron:Man* in Victoria Square recognized this: "It will be an unnamed work (by preference) until time and usage give it a name. It will become not what the artist or dominant iconography make it, but what the people of Birmingham perceive it to be It will, I hope, act as a focus for public feeling." Its fabrication by a local foundry, Firth Rixson Castings, was consistent with Gormley's determination that a work for the city should be "an image of human potential and transformation [made] from the material and skills at hand". The founders' commitment to the project exemplified the kind of vital participation that Gormley and PACA conceived as crucial to the success of the commission: *Iron:Man* did not arrive from outer space; it was 'made in Birmingham'. The figure is now known in the city as the 'Iron Man', Gormley's non-committal first noun having become an adjective: it has been 'given a name' and impressed itself on the imaginations of those who use the city centre.

The Iron Man raises critical questions: what does it mean to those who encounter it? What is it for? Gormley's awkwardly leaning figure (three-times life-size) has a monumental presence distinct from that of the pedestalled traditional statuary that signifies to its public a vertical validation of those it commemorates, and confirms their mythic 'historical' status. On the contrary, his anonymous figure is obdurately enigmatic; it enters the mind not as the representative figure of a public virtue, but fraught with abstract ambiguity. It is at once a reminder of the past, of the age of iron and the immense energies of industrialism, a symbol of humankind as yet earth-bound and unfree, and an image of human potentiality, a chrysalis-like form rising from the ground, instinct with the energy that will break its bindings and the confinement of its iron casing and allow the spirit to fly free. Its form contains these contradictions, and embodies (literally) those historical dialectics. These dynamics are compressed with such tension in Gormley's totemic landmark that it is impossible not to conclude that they are responsible for the vitality of the discussion that continues around its presence. That the 'public feeling' for which it has become a 'focus' might contain diversities of response – unconscious and conscious, antagonistic and friendly – is essential to its purposes: its ambiguities free the imagination and challenge the preconceptions of those who, going about their quotidian business, encounter it. It is neither authorative nor comfortably affirmative; it is catalytic.[2]

It must be added that the Iron Man's problematic presence, its intractability to fixed interpretation, would have made it a powerful foil to Marta Pan's beautiful but unrealised scheme for Victoria Square, commissioned by PACA for Birmingham City Council. To the classical decorum, horizontal ordering and idealizing clarity of

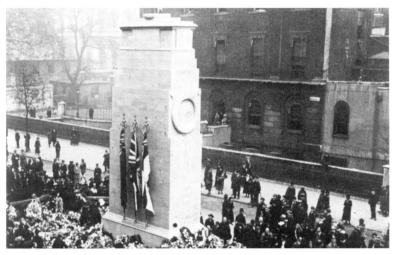

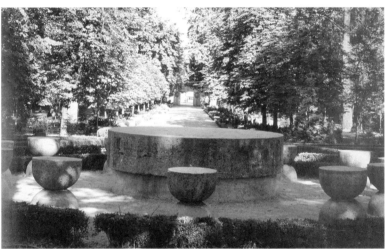

top: Edwin Lutyens,
Cenotaph, 1920, Whitehall,
London
above: Constantin Brancusi,
The Table of Silence, 1937,
Turgiu Jiu, Romania

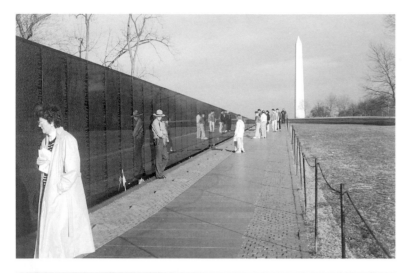

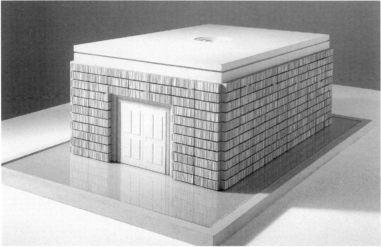

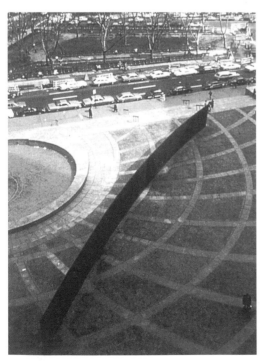

top: Maya Yin Ling, Vietnam Veterans' Memorial, 1982, Washington DC
above: Rachel Whiteread, Maquette for the Holocaust Memorial, 1995, Vienna
left: Richard Serra, *Tilted Arc*, 1981, Federal Plaza, New York

Pan's civic architectonics it would have opposed a stark icon, a recalcitrant image of the ineluctable material realities of personal and historical process. The idea that a public art might exploit such tensions, introducing thematic relations between civic architecture and signifying objects within its spaces, is classical in origin, and finds its greatest manifestation in the complex ensemble of the Piazza della Signoria in Florence. To persuade modern city governments of the need for a reconstitution, allusive and critical, of what Walter Grasskamp has called "the city as a narrative space" – an "urban cultural narrative to which architecture [is] amenable"[3] – is the hardest of the tasks confronting those agencies that seek to influence and facilitate public commissioning, and mediate its reception. This new kind of narrative will admit an openness to diverse readings rather than the closures determined by banal symbolism or figurative literalism.

NECESSARY MONUMENTS

The equivocal success of Gormley's figure only serves to emphasize how difficult it is to conceive an effectively democratic figurative public sculpture. It seems inevitable now that Lutyens's Whitehall Cenotaph, one of the truly great monumental sculptures of the century, should be an abstract monolith, and that Brancusi's stupendous memorial ensemble to the war dead at Tirgiu Jiu, Romania, should resort to archaic and totemic forms. In both cases the work assimilates modernity to the ancient architectural functions of commemoration and ceremony: it is an environmental focus of a kind of ritual. The Cenotaph ('empty tomb') was designed as the centrepiece of a ceremonial national remembrance, the resonance of which reverberates through the year, investing the monument and its site with an emotive charge that can be felt on any day. At Tirgiu Jiu the ritual determined by the forms and their disposition, being rigorously personal, acts in opposition to the idea of collective ceremony. Entailing a kilometre walk between *The Table of Silence*, *The Gate of the Kiss* and *The Endless Column*, the symbolism of the separate components and their relation to each other enjoin contemplation of the central realities, physical, emotional and spiritual, of the individual life. Brancusi's great work, no part of which refers directly to the War or its dead, demonstrates that the monumental can signify a personal politics as an aspect of a public good.

Two powerfully affective sculptural projects in recent times have responded to the modern demand for appropriate permanent memorials to the collective dead of war or holocaust: both have resorted to a monumental abstraction without recourse to heroic rhetoric. Maya Ying Lin's 1982 Vietnam Veterans' Memorial in Washington DC (described by the critic Helen Vendler as "that mirror-black granite Plutonian cleft in the earth") adopted the minimalist formality of a reflective mirror wall inscribed with an inclusive roll call, without distinction, of all the dead: this performs an ancient cermonony – 'the naming of names' – without militaristic bombast. It provides the focus for a never-ending progression of private ceremonies. Rachel Whiteread's proposed

Holocaust Memorial for Vienna consists of a negative cast of a library reading room with an external wall lined with concrete, book-lined shelves – a moving reference to the historic culture of the People of the Book, and also a kind of visual numbering. Like her temporary and unforgettable *House* in East London, the white block-like form assumes a monumental but paradoxically ghost-like abstract presence: vacancy made solid; memory actualized in concrete. Both works propose critical reflection upon the past rather than thoughtless acceptance of historical inevitability.

THE FAILURE OF MODERNISM: THE CRISIS IN PUBLIC ART
However, the modernist abstraction to simplified motifs that has been so successful in its application to twentieth-century monuments has failed, by and large, in public sculpture that has no memorializing intent. Sited in public places with misguided intentions, a great deal of modernist sculpture has been met with public indifference: it has seemed to serve no proper purpose. To understand why, we must return to the issue central to the crisis of public art in our time: what are its 'proper purposes'? It is a question that must be faced by any commissioning agency, and by any artist who is prepared to place work in public space, or make work in public visibility. It applies, of course, not only to permanent monuments or object art, but to projects that may be temporary, and on a modest scale. By confronting this question and by encouraging attempts to answer it, professional agencies like PACA have transformed the practice of art in the public domain, and brought about a new level of understanding in many local authorities and in public bodies at national and local levels. This has not been easily achieved. Complex conditions always affect the reception of art in a public place, whether in the form of a temporary event or a permanent monument. The conditions of democracy are bound to make life difficult for those who propose and promote such interventions; they must be negotiated in the language of priorities and within a cultural discourse the terms of which are slippery and contentious. Consultations with the public or its representatives are often fraught with misunderstanding, differences of opinion, conflicts of value and the clash of material interests. Democracy does not favour the arbitrary, but neither does it encourage consensus.

For many years the very term 'public art' has been seen as problematic, even prejudicial, and there have been good reasons why this should be so. It has been commonly assumed that public art is object art, and commissioners and artists alike have (unconsciously) regarded public places as an extension of museum space, seeking sympathetic settings for work addressed primarily to those within the hermetic discourses of modernism and postmodernism. (No post-war artist had more commissions, world-wide, than Henry Moore: "... the setting makes a difference to the mood with which one approaches a sculpture," he said in 1955, "and a good setting is one in which the right conditions are present for a thorough appreciation of its forms.")[4] But the space of the museum or gallery is essentially contemplative, it is a place

apart, accessible on its own (negotiated but conditional) terms to a public which chooses to go there. Within its dedicated spaces, notions of the 'good setting' and the right conditions for the appreciation of art and 'its forms' may have an appropriate validity. Sheltered space and a tolerant specialist public have encouraged, moreover, an art discourse and a curatorial culture within the museum or gallery of increasingly rarified conceptual sophistication.

Things, however, are different outside, where new art may be received with incomprehension, indifference or hostility. "The habit artists have got into over more than a hundred years," writes Daniel Buren, "of working, consciously or not, for a specific and sometimes enlightened public, that of the museum, has caused it to become drastically cut off from a public that could be just as enlightened but is not specialist, and which, above all, has never received any artistic education." Grasping this reality, PACA has made a virtue out of a crisis. In defining its principles and practice in relation to the triad of artist, public and place, it has been primarily concerned to integrate into diverse public places an art that genuinely engages with different and heterogeneous audiences. "In the street," writes Buren, an artist who has worked there longer and more effectively than most, "the artist suddenly finds himself confronted with this reality. This reality changes everything."[5] The removal in 1989 of Richard Serra's *Tilted Arc* from the Federal Plaza in New York, and its subsequent destruction, provides for Buren "a striking demonstration of the penalty that comes with thinking that the artist in the museum and the artist in the street can and should behave in the same way." It is especially significant that Serra's work, which some found spectacular and beautiful, was actually conceived for its site by the artist, and commissioned by a federal government agency dedicated to placing art in public places. Buren is as critical of those who commissioned the work Serra proposed without regard to the likely impact of its obstructive actuality upon the regular users of the square, as he is of the artist's assertion of his own freedom of expression.[6]

NEW MODELS: TEMPORARY INTERVENTIONS AND USEFUL PROVOCATIONS
Yet a genuine public art, in the open, is possible: diverse in its forms and manifestations, distinctive of place and definitive of democratic social identity, it creates in people the enhanced sense of their own reality that is the purpose of all art. A democratic public art will create space for the civilized behaviour of the experiencing subject in a shared field. Art is a means to the liberating experience of subjective creative imagining (architecture, scholarship and politics are among others), to the excitements of mind and spirit that come with the state of being fully human. In conditions of freedom meanings are not given, they are constructed and shared; their depth and complexity are functions of the receiver's sensibility, intelligence and temperament. An unprecedented diversity of forms and media characterizes the art of our age, in which the development of

investigative and critical functions have paralleled those of modern science and philosophy towards open uncertainties and the interrogation of conventions and orthodoxies. A properly modern public art can no longer be solely an art of permanent monuments, of objects for contemplation, but will comprehend within its ambit the short-term intervention, the temporary installation that provokes thought or wonder. The conditions for the realisation of such temporary art projects may differ from those that constrain the siting of object sculpture or the permanent modification of public space, but they demand no less careful and subtle identifications of what is appropriate and who is best for the specific assignment. The professional agencies have addressed these implications.

PACA has made a number of pioneering initiatives in this respect, commissioning temporary interventions in which the matching of artist to placement has been the key to a successful project. Pierre Vivant's *Moonlight (By Permission)* at Warwick University, for example, lasted only for a month (the period of a full moon cycle) early in 1990. As the natural moon passed through its eternal phases, lunar images were projected by lights aligned with the University campus surveillance cameras, visible in their entirety only by the cameras themselves, and seen by viewers at ground level only as fragments of light. These images were re-composed into a representation of the moon's cycle on six telemonitors mounted in the University Sculpture Court, a space the artist had found prison-like and oppressive, and had noticed to be under constant surveillance by its own camera. The arc of monitors countered this impression by providing 'eyes' to see beyond to what Vivant called the "cosmos of the campus": an apt and beautiful metaphor for the processes of research and projection by means of which fragmentary knowledge may be transformed by imagination (image-making) into "completeness and meaning". But it reminds us, too, that watching the moon, regarded as the object of poetic or of scientific enquiry, we are watched in turn, that in the sublunary world there are boundaries to freedom, and permissions to be granted or withheld. *Moonlight (By Permission)* was an outcome, among others, of Vivant's residency at the University: his work had particular resonances for a particular public. David Ward's spectacular *Well, One Thousand Lights* at Leamington Spa Pump Rooms, commissioned by PACA as part of a programme of site-specific works in public places, also used light as metaphor. For just two weekends in late 1997 Ward filled the abandoned swimming pool with a thousand light-bulbs to create a brilliant simulation of the healing waters that had filled the pool during its lifetime of use. His installation was, in effect, at once a vivid, fleeting, public memory, and, as its title implies, an image of the inexhaustible energies that constantly renew the human project as its impermanent housings fall into desuetude. To remember and remind is a perennial purpose of art, and not least of public art.

PACA has recognized from the beginning that a public art, permanent or temporary, must engage with architecture. *Host*,

a remarkable project in Venice in 1996, explored this relation. Conceived by two artists and an architect, the work was seen by them as a means to the definition of the problematic relations between a historically resonant architecture and an art of temporary installation. It linked to this (as is evident in its title) an element of public provocation that extended the implications of the work as a whole. Taking place on the fringe of the Architectural Biennale, *Host* structured three topographically separated components into a conceptually unified work that encompassed themes of transience and transubstantiation, relating aspects of architectural survival and decay to social change, regeneration, and the claims of the eternal as represented by orthodoxies of religion. It comprised an exhibition of objects modelled on the emblematic 'aedicule' (the 'little building' like a simple hut that is the generative image of architecture), a number of publicly sited, unidentified slot machines which dispensed packets of unblessed communion wafers embossed with the aedicule motif, and an aedicule structure on stilts in a deconsecrated oratory, coated with mud seeded with germinating grass. Its discrete elements each directly related to specific locations in the city, inviting a subjective journey between them that might reveal complexities of relation between past and present, the 'stones of Venice' and its 'dying generations', between the claims of history and religion and the desires and demands of contemporary social culture. *Host* provided a model of imaginative collaboration between architects and artists, in which the disciplines of each were creatively merged in a manner necessary to the development of a complex yet responsively integrated public art.

PACA has contributed significantly to this new thinking on the relation of art to architecture, not least in its thoughtful matching of artists to permanent projects, as we shall see in what follows. But PACA has been committed also to the promotion of debate around the developments in public art, notably through its programme of speculative proposals. This invites artists and collaborative teams to propose work for contentious sites, or for nodal points within the built environment where any intervention is likely to create controversy. We may take Jochen Gerz's projection for the famously empty plinth in Trafalgar Square as an example. Gerz proposes to place on the plinth a square of turf cut from the home football pitch of the current English league champions. This would be carefully maintained, and replaced, of course, each time the title changed hands. The contradictions contained in Gerz's perfectly judged provocation are of a kind that make popular objections and media antagonisms to his idea at once inevitable and problematic for all concerned. It would be received as a work of 'conceptual art' (sited in the hermetic discourse that attends to such art) and yet it is undeniably actual, democratically charged, moreover, with significances within the immediate grasp of the huge public following of the national game. It is an anti-heroic gesture, elevating a humble clump of earth to the temporary status of monument whilst it denies the pedestal to

any human candidate. It opposes the living grass (and the team it represents) to the mineral permanence of stone or bronze; the annual to the perennial (an opposition we have noted in the grass-clad aedicule of *Host*). It is both wittily absurd and sentimental: ironic in its relation to other statues in a square, and to heroic public sculpture in general, it is nonetheless un-ironic in its celebration of the sport itself. It confuses the categories of art and nature. Gerz's proposal goes to the heart of the debate around public art, demonstrating with economy of wit that the wider public need not be excluded from participation in it. It presents the idea of a public work of which the meanings are amplified by the cultural significance of the site proposed for it.

ART AND ARCHITECTURE: ART IN SPACE; SPACE AS ART
The successful permanent public art work, whatever its scale, promotes a heightened awareness of both topographical and social space as the open theatre of conscious being, and of both civic and personal relations. Public possession of a public place and its objects is thus both political and imaginative: political, in that democracy claims the streets, squares, parks and commons of our towns and cities as the shared property of the people, who are entitled to its enhancement and maintenance as the complex site of public interaction; imaginative, in that buildings and objects, and their dispositions in public space, create the conditions for the civilized consciousness of people living private lives and making their own histories. As Mary Miss, the American artist who has contributed with great effect to the debate on public art in the USA, has said: "... there are archetypal needs that are met regularly in different cultures ... for protected spaces, places for reflection, places for distraction"[7] To which we may add: open places in which the subjective 'text' of the individual life finds the historical and cultural 'context' that signifies a social identity. In a polity which seeks to bring a civic unity to a culturally heterogeneous society, such signifying sites are crucial to the creation of a civilized life.

The ideal of the civilized life, and the ways in which the artist and the architect may help effect its realisation, has long been at the centre of Tess Jaray's concerns. Working as a painter on architectural themes she has studied the recurrence of systematic decorative forms through time and across cultures. She brings deep knowledge of these to bear upon her commissioned work in the public sphere. In Birmingham's Centenary Square, working closely with the sculptor Tom Lomax and with the City architects, she played a central role in the creation of a great civic space, an open topography for the play of the many private imaginings that are the essential components of the mental map of the collective imagination. Dominating the top of the square is the new International Convention Centre and Symphony Hall for which a number of artists were also commissioned to make works. These include Ron Haselden's kinetic neon sculpture, *Aviary*, which wittily signals the cage-like off-centre entrance to the Centre's lobby, and Deanna Petherbridge's spectacular *trompe l'oeil* mural

Architectural Fantasy, the ziggurat format of which follows the outer skin of the external drum of the concert hall down four floors, with gentle variations of colour to left and right that relate to entrances to the auditorium. Outside, at the square's centre, Jaray has created a low podium for Raymond Mason's *Forward*, subtly raising the sculpture from the floor of the square itself but respecting its anti-grandiose sentiment. Another pediment, trefoil in design, extends into the grassy area at the lower end of the square, supporting a central fountain by Tom Lomax. In each case the art work is a focal point within the total architectural experience, a means to orientation, an identifiable location within the larger ensemble of buildings and spaces, inside and outside.

"Our aims for the square can be simply described," Tess Jaray wrote of the Centenary Square project: "to create a place that people will want to be in, not just rush through, simple in shape, rich in surface and satisfying in its detail. It is to give people pleasure, and a sense of being in a special place." The modesty of this formulation belies the visionary ambition that animated the process of its successful achievement. To be in Centenary Square is to be drawn inevitably into consideration of the meaning of the city. Walk the square across the insistent visual rhythms and repetitions of Jaray's brickwork pavement; sit by the fountain; take a picnic lunch to the lawn, its simple greenness and complicated asymmetry a calculated foil to the complex variegation and perfect symmetry of the pavement. To do these everyday things in such a space at the heart of a great city is to claim a right. This great square is an arena for thoughts and actions of a kind impossible elsewhere: its configurations of buildings, spaces and objects are designed for the ceremonies, public and private, of the civilized life. Those who come here, however often and for whatever purposes, looking across the stylized abstraction of Jaray's great brick carpet, will experience that "sense of being in a special place": a square in a city; a signifying site on the surface of the earth.

In the integration of art into the architectural fabric of the city and its institutions, the spatial element becomes the central desideratum. For behaviour is conditioned by space, and if the creation of space and of facilities for behaviour is the primary function of architecture, the artist's intervention consists in imaginative modifications that will amplify the users' sense of the possible meanings of a given place. Public space is that which is ultimately within the ownership and care of the people as defined in democratic politics. Not all public space can be open at all times: colleges and schools, hospitals, government buildings and embassies, for example, need to be sequestered, protected from the distractions, disruptions and the possible dangers occasioned by unrestricted access. In these situations artists must work within architectures appropriate to particular functions; but as in the open city this is more than a matter of embellishment. Art should enter these dedicated places not as a decorative afterthought but as a means to the activation in their users of a reflective civilized consciousness; of their being in a place shaped both to specific

uses – learning, healing, debate, diplomacy *etc* – and to those general purposes, beyond immediate utility, of the human project, which include the contemplation of matters of value, the pursuit of happiness, and a sense of well-being.

Works by Susanna Heron at the European Union Council Building in Brussels, at the new British Embassy in Dublin, and at Hackney Community College in London, exemplify the successful achievement of these diverse purposes. Each of these interventions has been marvellously integrated into architectural space conceived in terms of its human uses and meanings. Heron has said "I am a maker of spaces, not objects." There is no space without objects to define it, and in each of these projects Heron has used natural materials and built structures in dispositions that constrain the user's movement in space and time, and create circumstance for reflection. The twenty-one-metre-long *Slate Frieze* for Brussels, with its aleatory linear incisions and carved bas-relief, brings into hectic lives embroiled in the day-to-day business of negotiation, debate and legislation a reminder not only of other time-scales (implicit in the slate itself, and in the lapidary markings that are a record of their own making) but of other modes of being and doing (not only implicit in the wall as a work of art, but imaged in the endlessly meandering loop and arabesque of the line). In Allies & Morrison's Dublin Embassy the work is activated in the walk from gatehouse to entrance. This first passes a rough boulder, sunk in the grass and roughly incised like a neolithic marker stone, before it arrives at a simple bridge over a moat, from the surface of which the pure rectangular plane of the eponymous 'island' of smooth slate rises, and submerged beneath which can be discerned a cloud-like oval form, also of slate. Grass and stone, water and slate, solid rock and reflected cloud, the straight and the curved: Taoist oppositions to be pondered in a place where troubled histories are necessarily remembered. In the centre of the crowded enclosed campus of Hackney College, a huge community development in one of the poorest boroughs in the country, alive with hyper-energetic youth caught up in the hurly-burly of learning and life, Heron has created *The Sunken Courtyard*, a beautiful water garden in which fast-flowing and apparently still water are contrasted. At one side of the courtyard the windows of the subterranean library, a place set apart for thought and study, look out across pool and stream to a vast expanse of pure ultramarine. Above this inverted sky can be glimpsed the branches of a great London plane tree. From the parapet of the astonishing blue wall, or from the viewing platform at its side, it is possible to contemplate the ensemble of slate, water, white birch tree and blue expanse – in the artist's words, "a mirror to the weather and the changing seasons". In these places dedicated to social utility, a commissioned work of public art effectively enlarges the imagination, and celebrates things essential to the civilized life.
Barnes, London, January 1998

1. For an account of the commissioning and subsequent history of Rodin's *Balzac* and of the artist's other public monuments, see Catherine Lampert, *Rodin: Sculpture and Drawings*, London (Arts Council of Great Britain) 1987.
2. Questions relating to the 'public's' interpretation of Antony Gormley's other major public sculpture *Angel of the North*, are raised by Paul Usherwood in 'Is it a Bird? Is it a Plane?', *Art Monthly*, no. 213, February 1998.
3. Walter Grasskamp's discussion of "the city as a narrative space" can be found in 'Art and the City', his introductory essay to the catalogue of *Contemporary Sculpture. Projects in Münster 1997*, edited by Klaus Bußman, Kaspar König and Florian Matzner, Münster (Verlag Gerd Hatje) 1997. This was the third decennial exhibition in the city to explore "the possibilities of art in public space". Over sixty projects by international artists were realised in this event, and nearly thirty existing works were renovated, making the 1997 *Sculpture. Projects* by far the most significant contribution to the debate on public art in recent years. Grasskamp writes of the nineteenth century as the age when the bourgeoisie "aspired to a prominent share in the narrative filling out of city space Thus did the city inflate itself once more as a narrative space. War memorials, political monuments, triumphal arches, obelisks taken as trophies, scenes of city history and cultural heroes raised upon pedestals permeated the picture of the reorganized and expanding cities." Radical modernist architecture, however, "dispensed with narrative decoration at a stroke". "Façade narrative was lost with the end of both *architecture parlante* and the order of the urban terrain as a visually meaningful, associative entity"
4. Henry Moore spoke about 'Sculpture in the Open Air' in a talk recorded for the British Council in 1955. It is quoted by Richard Calvocoressi in his essay 'Public Sculpture in the 1950s' in *British Sculpture in the Twentieth Century*, edited by Sandy Nairne and Nicolas Serota, London (Whitechapel Art Gallery) 1981. See also in this volume 'War Memorials' by Richard Francis, and 'Overhead Sculpture for the Underground Railway' by Richard Cork.
5. Daniel Buren's 'Can art get down from its pedestal and rise to street level?' is to be found in *Sculpture. Projects in Münster 1997*.
6. For an account of the controversy over Serra's *Tilted Arc* and discussion of other issues relating to 'the works of art in public places' debate in the United States in recent years, see 'Architectural Sculpture', chapter 5 of Irving Sandler's Art of the Postmodern Era, New York (HarperCollins) 1996.
7. Mary Miss is quoted from Sandler's account.

PROJECTS

THE EMPTY PLINTH
Jochen Gerz, *Trafalgar Square, London*

A speculative proposal

JOCHEN GERZ
b. Berlin 1940. Lives and works
in Paris

"The front line does not necessarily lie between the new educated cultural well-wishers and the crowd who, whipped up by the media, chases innocent new art. It can run riot through the public mind – splitting, disrupting, fragmenting its pretended oneness. Only in this way does art, as a historical project since the beginning of modernity, confront the public – and itself – as a truly public agent. Public space seems to be the last contemporary art gallery where the cultural consensus does not obscure and undo the artwork itself. Trafalgar Square is all an artist could wish for to fight the tautologies of visibility within the terms of vision." *Jochen Gerz*

Under its programme of speculative proposals, PACA invites artists' initiatives for contentious sites and points of intersection and transit. This work occurs mainly between official systems and schemes, and is part of the agency's commitment to advocacy and debate in the realm of public art. A dialogue with Jochen Gerz, renowned for his iconoclastic approach to the concept of 'monument', led to an invitation to propose a work of art for the empty plinth in Trafalgar Square. A media campaign, led by the Royal Society of Arts, was already under way: alongside PACA's invitation to Gerz, an official 'plinth committee' was being convened to formalize a procedure for commissioning or placing artists' work.

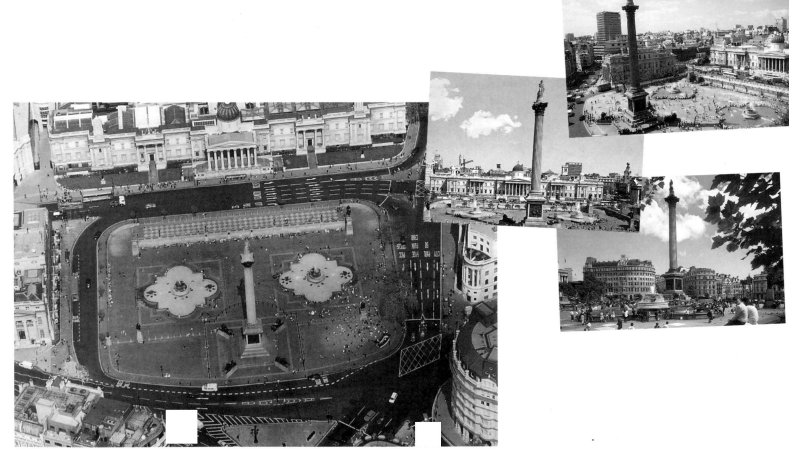

JOCHEN GERZ

Jochen Gerz's proposal for the empty plinth sinks its teeth deep into the questions surrounding the place of art in contemporary society and the perception of it.

Only the smallest increase in the depth of the plinth would be needed, the artist proposes, to transform it simultaneously into a truly contemporary national monument and the object of tellingly heated controversy. For the extra millimetres atop the plinth would accommodate a glorious square of turf from the home ground of the current English league champions: Manchester United, Newcastle, or maybe one year Coventry City? The chosen sample would be as lovingly maintained as it was on the pitch, until replaced as the league title changed hands. A label similar to those on the other plinths in the square would explain the origin of the barely visible grass to unsuspecting passers-by and proud fans alike: a thin green line, where national sporting pride meets unsporting aesthetic prejudice.

"The work's first function will be to display 'art' as an image of the public mind: to frame the unquestionable 'art' on the other three plinths as petrifications of the public mind. It will show how art becomes 'art', it will show public success, the lack of public discourse, reification. In this way, the work on the fourth plinth will address the discreet 'keepers of the past' witnessed by the media (which is the public) at which the withdrawal of contemporaneity – in art or elsewhere – takes aim. The existing non-proposition of the empty plinth links the power of all power – absence – to its (empty) promise: hope. On the other side of the bargain is the child's discovery: the emperor is naked. To make the fourth plinth empty is the second function of the work, and in order to accomplish this, it has to become present, that is, quite visible, even if this means that it will be offensive, provocative. A third function within the strategy of the project will be to prevent the work from being a speechless victim in the midst of the media-organized turbulence of the public mind." *Jochen Gerz*

The piece wilfully courts media scandal yet presents tantalizing dilemmas for its would-be media critics with their resistance to change: the perceived emptiness of the plinth, suddenly in focus after more than a century, is the product of an error of the past rather than the conceptual indulgence of contemporary art; and it is not the achievements of an individual or the ego of an artist, but football, the national pastime, which is to be valorized in this international site at the heart of the capital.

CENTENARY SQUARE, BIRMINGHAM
Tess Jaray; David Patten

CLIENT
City of Birmingham
ARCHITECTS
Birmingham City Architects

TESS JARAY
b. Vienna 1937. Lives and works
in London
DAVID PATTEN
b. Birmingham 1954. Lives and
works in Baxterley, Warwickshire

PACA is no stranger to city-centre squares. One of its earliest and most prominent projects was the public art programme for the International Convention Centre, Birmingham, completed in 1991, and the adjacent Centenary Square, named in celebration of the city's formal inauguration in 1890. As the first major civic scheme to which 'percent for art' was applied, its programme provided a precedent for the adoption of the 'percentage for art' principle by other local authorities and development corporations.

DAVID PATTEN
MONUMENT TO JOHN BASKERVILLE –
INDUSTRY AND GENIUS, 1990

This most discreet of works originated in an invitation from PACA to the artist to propose a work for the square. John Baskerville, the inventor of Baskerville type, lived in a house on the site of the International Convention Centre: the 1991 opening of the Convention Centre coincided with the bicentenary of the destruction of his house during the Birmingham riots of 1791.

"The standing stones represent the letter punches which he cut to make his type, and the word VIRGIL reminds us that Baskerville's first book, published in 1757, was a reprint of the Roman author's poems. *Industry and Genius* refers to a poem of the same title which first appeared in Aris's *Birmingham Gazette* on 21 January 1751 with a dedication to John Baskerville.

"Public art can have many roles in the urban environment not least its ability to peel back the 'haphazard layers' and reclaim specific meanings for specific sites." *David Patten*

TESS JARAY WITH BIRMINGHAM CITY ARCHITECTS
CENTENARY SQUARE, 1988–91

Centenary Square is an area exclusively for pedestrians, created as a grand-scale public space in order to open up the centre of the city for its people. The painter Tess Jaray collaborated with the City Architects Department to design the entire 10,000-square-metre area, including the spectacular paving scheme comprising sheer sweeps of interlocking pattern from just four colours of standard pavior brick; the stonework and street furniture for the square, the seats, railings, litter bins, bollards, tree grilles, and light standards. Jaray collaborated throughout the scheme with Tom Lomax, working with the City Architects Design Team. Paradise Bridge, also designed by Jaray, formed a new pedestrian link to the city centre over the lowered inner ring road.

Centenary Square is also the setting for two large-scale sculptures: *Forward*, 1988–91, by Raymond Mason, and *Spirit of Enterprise*, 1989–91, by Tom Lomax.

above: Paradise Bridge
opposite: Centenary Square

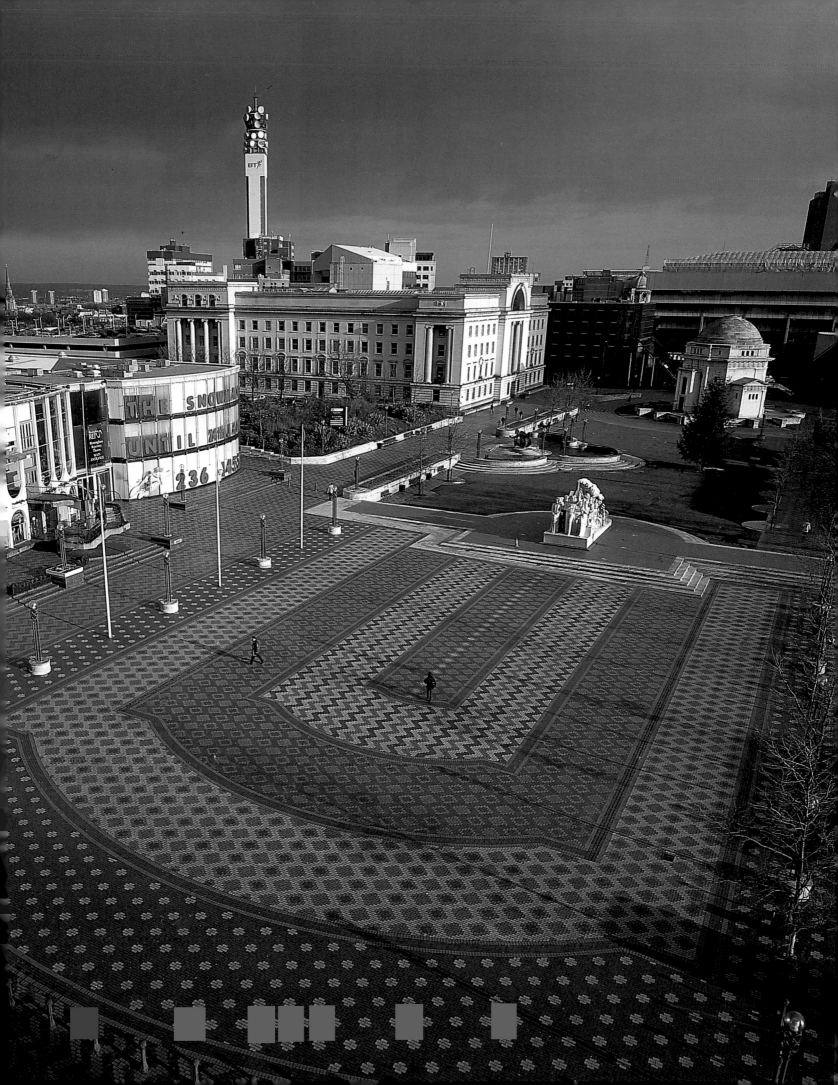

CLIENT
City of Birmingham
ARCHITECTS
Percy Thomas Partnership and
Renton Howard Wood Levine

RON HASELDEN
b. Gravesend, Kent 1944. Lives and
works in London and Plouer-sur-
Rance, France
DEANNA PETHERBRIDGE
b. Pretoria, South Africa 1939. Lives
and works in London
VINCENT WOROPAY
b. London 1951. Lives and works
in London

INTERNATIONAL CONVENTION CENTRE, BIRMINGHAM

Ron Haselden; Deanna Petherbridge; Vincent Woropay

Centenary Square was part of an overall scheme for the International Convention Centre, which was completed in 1991. The works commissioned for the Centre are distinctive, but are well integrated by virtue of their strong references to architectural structures.

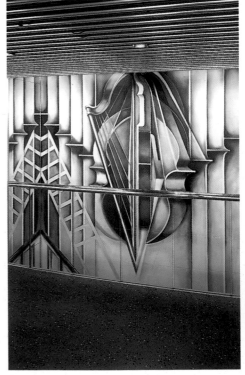

DEANNA PETHERBRIDGE
ARCHITECTURAL FANTASY, 1990–91
Inside the Convention Centre, on the exterior drum wall of the Symphony Hall, Deanna Petherbridge's oil-on-plaster wall drawing runs through all four storeys of the building, taking the form of a ziggurat. The multiple perspective of the drawing reflects the design of the Convention Centre, its external bridge to the Hyatt Hotel, the Mall's raised walkways and the different seating levels within. It shifts from monochrome on one side to colour on the other, aiding orientation.

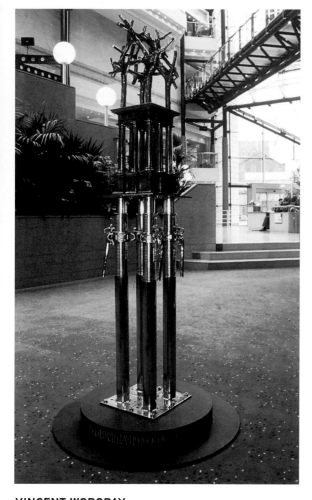

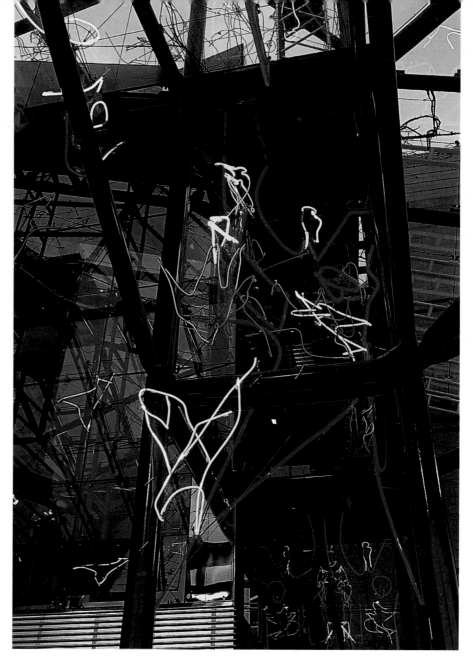

VINCENT WOROPAY
CONSTRUCTION: AN ALLEGORY, 1991
The work, in bronze, chromium and slate, embraces three contrasting ages of construction: contemporary building props support classical Doric columns, surmounted in turn by a hut built of trees and branches. It is sited within the Convention Centre, adjacent to the box office.

At the western end of the Convention Centre Mall is located a large-scale glass artwork by Alexander Beleschenko; on the south wall a wooden relief, *Convention*, 1992, by Richard Perry, sponsored by Pinsent & Co; and outside, adjacent to the canal, is *The Battle of the Gods and the Giants*, 1990–91, a bronze sculpture by Roderick Tye, sponsored by Ingersoll Publications and *The Birmingham Post and Mail*.

RON HASELDEN
AVIARY, 1988–91
Sited at the main entrance of the Centre, Ron Haselden's computerized neon work takes flickering flight across the blue-steel structure. An abstract tree grows through an 'aviary' containing different species of birds. A computer governs the sequence of the neon, simulating bird movement and flight.

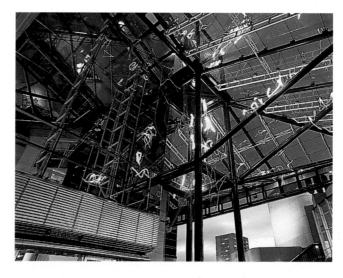

above, left and overleaf:
Ron Haselden, *Aviary*

27

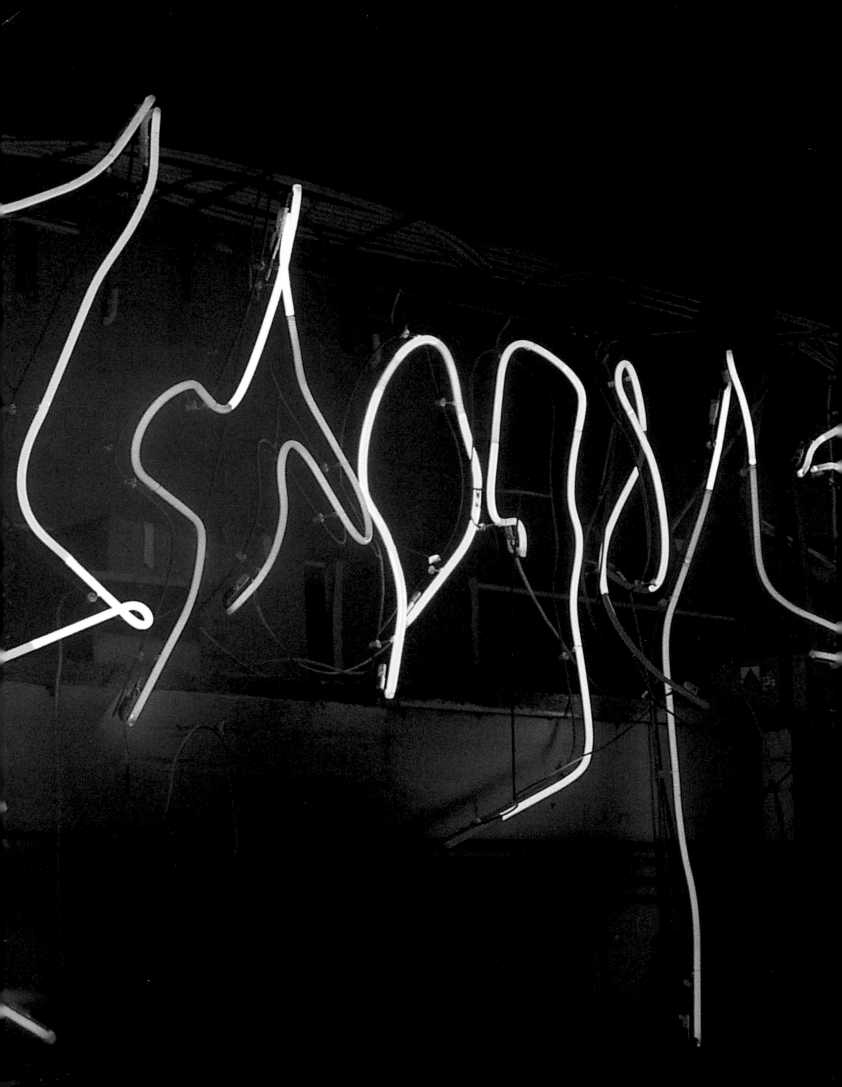

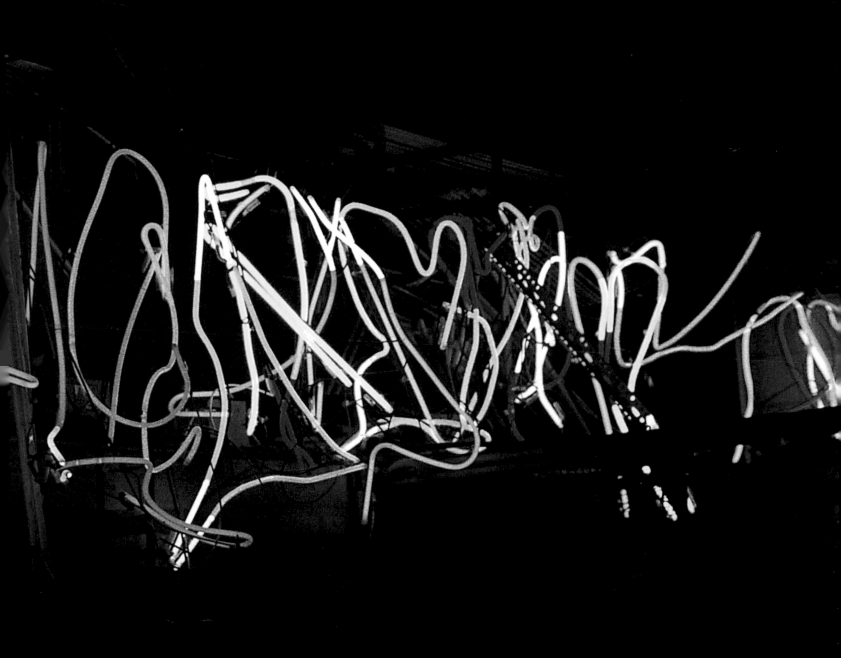

ANTONI MIRALDA
b. Terrassa, Barcelona 1942. Lives
and works in Miami and Barcelona

THE HONEYMOON PROJECT: THE ETERNITY RING

Miralda, *Birmingham*

The Spanish artist Miralda, creator of large-scale participatory events, orchestrated the symbolic marriage of the Statue of Liberty and the Barcelona Column of Christopher Columbus in a series of ceremonies, exhibitions and events worldwide, developed over the period between the centennial of the Statue of Liberty in 1986 and the fifth centenary in 1992 of Columbus's arrival in America. The project explored the nature of the complex union of cultures and the exchange of goods and ideas which began when Columbus opened up the Americas to European exploration and exploitation.

"Honeymoon … continues and in a certain sense concludes his work on the persistence of ritual and ceremony in contemporary society. This theme is seen in a humorous light and is intended as a feast that brings people together in peace and happiness. It is, above all, a form of art that reasserts and claims people's right to imagination." *Maria Lluïsa Borràs*, General Catalogue Venice Biennale 1990

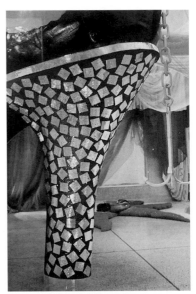

above and right: Installation at the Venice Biennale, 1990
bottom right: Engagement clothes for the Statue of Liberty. Ceremony in Jacob Jarvis Convention Center, New York, 1986

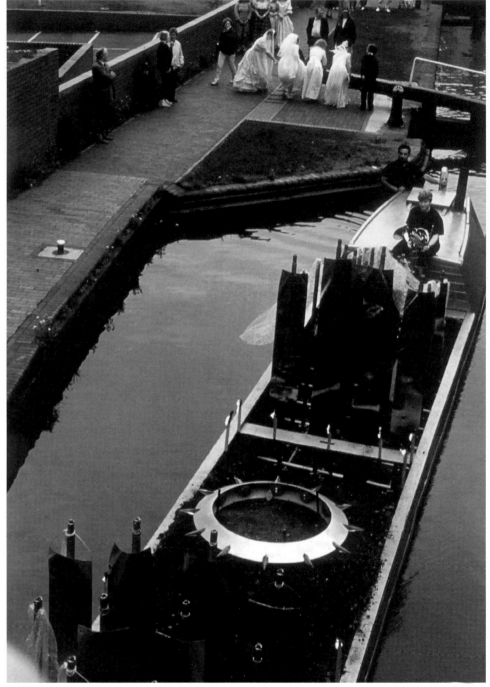

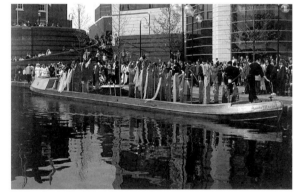

'The Golden Barge', an event organized by Jane Kelly and Hattie Coppard. The Eternity Ring travels on its barge journey to the city centre through the canals of Birmingham. The horn player sounded each time the barge rose up into sight from the locks.

The project began with the blessing of the couple's engagement by the Mayor of New York in 1986; Liberty's Trousseau was made in Terrassa, Spain, 1987; her Petticoat was shown in Miami and her Bouquet and Bridal Veil in Barcelona, 1987; the Columbus Costume contest took place in Tokyo, the Wedding Cake was made in Paris, the Wedding Rings in Valencia and the Nuptial Bedspread in New York, 1989; the Nuptial Cape was made in Philadelphia, the Bridal Gown in Paris, the Gondola Shoe in Venice, 1990. The project culminated in 1992 with the Wedding Ceremony in Las Vegas.

The British contribution to the project, commissioned by Birmingham City Council with the Ikon Gallery and PACA, involved the creation of an Eternity Ring inspired by the city's historic Jewellery Quarter. PACA had invited Miralda to deliver the inaugural presentation at its international symposium 'Context and Collaboration' in 1990, and to propose a 'Honeymoon project' for Birmingham, timed to lead up to the official opening of the International Convention Centre in 1991. The ring was sent to New York for the Nuptial Procession in 1992.

The Eternity Ring was made to the scale of Liberty's finger and incorporated twelve diamonds symbolizing the nation of the European Community. It was hollow, and was filled with thousands of finger rings donated by local community groups and businesses in Birmingham's Jewellery Quarter. On completion the Ring was paraded along the canals and through the city on its way to the Convention Centre, where the Grand Ring-Filling Ceremony took place, the culmination of a series of events and artworks created by artists Jane Kelly, Hattie Coppard and Anurhada Patel, and guest designers Pam Hogg (London) and Chus Burés (Madrid). Finally a procession of local groups, artists and 'wedding guests', in culturally diverse traditional dress, placed their rings inside the Eternity Ring, which was then taken for exhibition at the Ikon Gallery prior to its journey to America.

1991–93

CLIENT
Trustee Savings Bank

ANTONY GORMLEY, OBE
b. London 1950. Lives and works
in London

IRON:MAN
Antony Gormley, *Victoria Square, Birmingham*

"I propose to construct a three-times life-size cast-iron body-case from four sections of $^{3}/_{4}$-inch-thick cast iron weighing 7 tons.

"The piece will be placed centrally on the apron in front of the TSB building. It will be buried up to its calves and will lean seven degrees backwards and five degrees to the left. It will face the end of New Street.

"This work naturally has resonance with the industrial history of Birmingham, the transformation of that history and the beginning of something else. It is purposefully enigmatic, suggesting both a rise and a fall.

"I should stress that while this work may seem ironic in the context of the Victorian pomp that surrounds it, it uses monumentality of scale in a radically different way from, say, the Victoria monument that is its neighbour.

"It will be an unnamed work (by preference) until time and usage give it a name. It will become not what the artist or a dominant iconography make it, but what the people of Birmingham perceive it to be. It will be attached to the earth, not raised above it, and most importantly, it will, I hope, act as a focus for collective feeling."
Antony Gormley

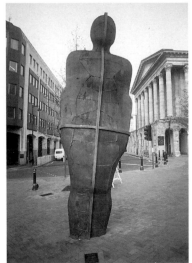

The sculpture by Antony Gormley was commissioned through PACA by the TSB as a gift to the city on the occasion of their move to new headquarters in Victoria Square. From an open international competition, five artists were shortlisted: Miles Davies, Paul de Monchaux, Antony Gormley, Phillip King and Athena Tacha. Their maquettes were exhibited in several city-centre venues and public opinion sought prior to the selection panel making its decision. TSB's sponsorship attracted an Association for Business Sponsorship of the Arts award of £25,000 under the Government's Business Sponsorship Incentive Scheme, allowing a local artists-in-schools programme to take place in five Birmingham comprehensive schools during the course of Gormley's commission.

Despite public support from many directions, *Iron:Man* attracted considerable initial hostility from the media, spearheaded by *The Birmingham Post and Mail*. Press coverage even went so far as to suggest that, at the formal opening of Victoria Square, screening had been placed by the Council to hide the work from the eyes of Princess Diana. But although it remains controversial, *Iron:Man* has now made its mark on popular imagination and is firmly established on the perceptual map of the city.

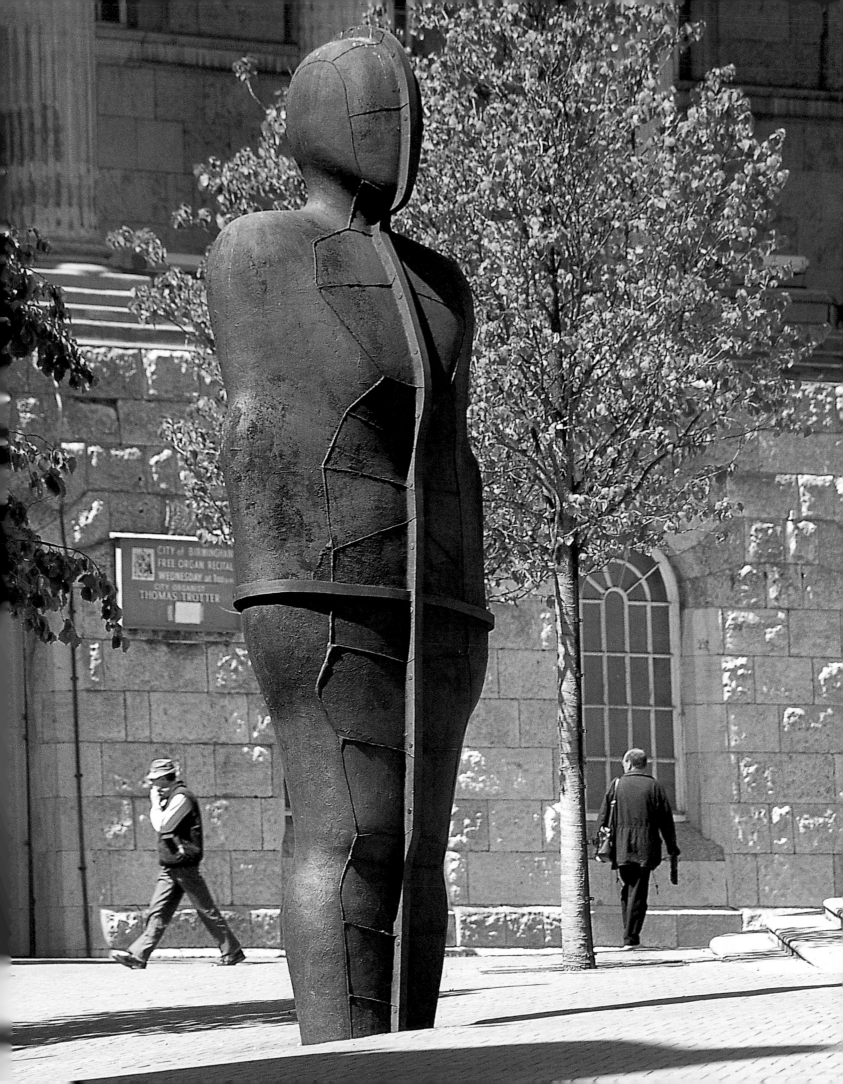

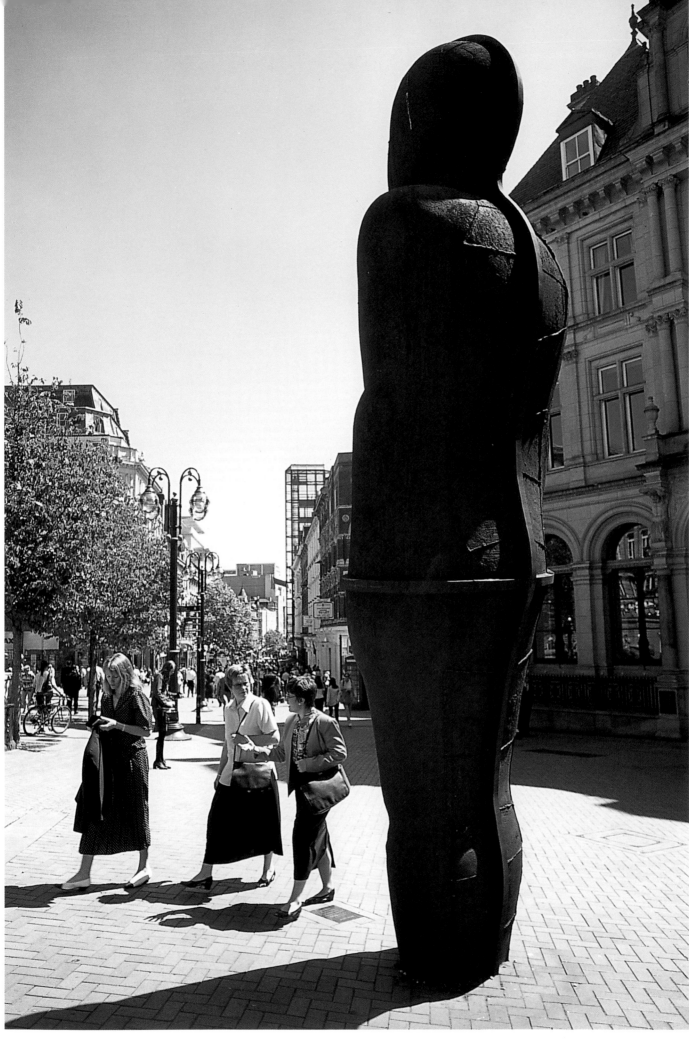

VICTORIA SQUARE, BIRMINGHAM
Marta Pan, *Water Feature (unrealised)*

CLIENT
Birmingham City Council

MARTA PAN
b. Budapest, Hungary 1923.
Lives and works in Saint
Rémy-les-Chevreuse, France

As part of the development of Birmingham's Victoria Square, PACA led an international competition for Birmingham City Council with the aim of commissioning an artist to design an environmental water sculpture. Marta Pan's proposal was intended to be carried out in collaboration with the landscape architects of the City Council. Her designs had been agreed in principle in advance of the TSB competition won by Antony Gormley.

The work was unrealised; following design development, Birmingham City Council decided against Pan's scheme in favour of a more decorative, less collaborative, artistic approach. The Arts Council of Great Britain was invited to advise and the sculptor Dhruva Mistry was subsequently appointed.

left: Antony Gormley,
Iron:Man, Victoria Square

"The incline between the Council House level and New Street offers the possibility of creating a composition of steps and water steps, alternating with horizontal terraces and ponds.

"The water course consists of a four-metre-wide river, 40 metres long, with falling and running water. It is shallow, presenting no danger to children. Water arrives on the steps from below a cylindrical sculpture and runs all the way down through steps and ponds, disappearing under a similar sculpture. Seventeen more sculptures of various heights and diameters emerge from the river, like symbols of the past, or of the future. They are of any age, and thus accord with the old and recent parts of the city.

"All sculptures are in white Carrara marble. The steps give the orientation of the Square. They are large and low, comfortable for walking and also for sitting. Two-by-two-metre squares, planted and unplanted, of different heights, create a garden between the Square and New Street. A rock garden joins the upper and lower levels on the Christchurch Passage side.

"The three elements of the composition – stone, vegetation and water – create a simple and attractive focal point." *Marta Pan*

HACKNEY COMMUNITY COLLEGE
Bettina Furnée; Dimitra Grivellis; Susanna Heron; Pat Kaufman
Artworks for a new campus in Shoreditch

CLIENT
Hackney Community College
ARCHITECTS
Hampshire County Architects;
Perkins Ogden Architects

BETTINA FURNÉE
b. The Hague 1963. Lives and
works in Cambridge
DIMITRA GRIVELLIS
b. Cyprus 1950. Lives and works
in London
SUSANNA HERON
b. Welwyn Garden City 1949.
Grew up in Cornwall. Lives
and works in London
PAT KAUFMAN
b. Chicago, Illinois 1950. Lives
and works in London

The £30-million Shoreditch campus is the largest further education development in Britain and was completed in May 1997. For this scheme, PACA provided artistic direction by researching and shortlisting artists and designer–makers. The projects were managed by Hackney Community College's own team. The scheme includes gates and screens by blacksmith Matthew Fedden, glass panels by Alexander Beleschenko and a light beacon by Martin Richman as well as the projects highlighted here. All artworks were supported financially by an award from the Arts Council Lottery.

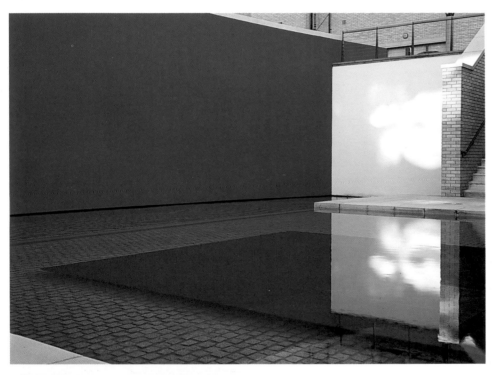

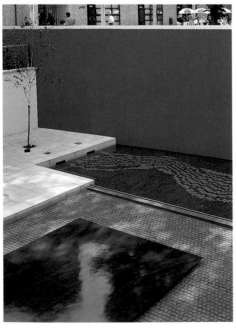

SUSANNA HERON
THE SUNKEN COURTYARD

"From the windows of the underground library a huge and slightly curved ultramarine-blue wall reflects in water. An underwater mosaic in black and white granite setts is viewed from the public courtyard above, its design coinciding with the fast-flowing current of water in the lower pool. A white tree *(Betula jacquemontii)* has been planted to grow on the lower level and reflect in the pools; in the upper pool the submerged slate floating platform acts as a black mirror in the surrounding white granite setts. A slate boulder rests on the viewing platform at ground level.

"*The Sunken Courtyard* reflects the weather and the changing seasons, creating a sense of place and bringing an awareness of the natural world into the urban environment." *Susanna Heron, 1995*

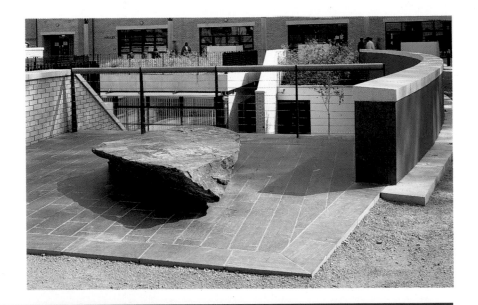

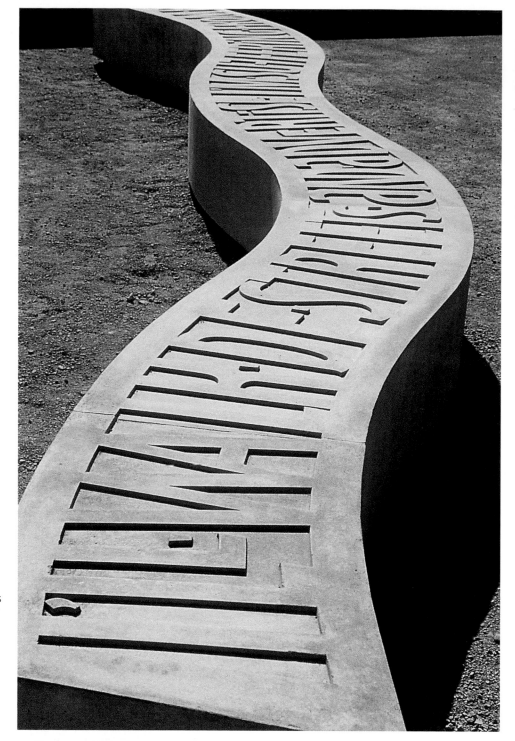

BETTINA FURNÉE
STATE OF ROCK

"The northern courtyard is the principal open space of the campus, and houses both a public library and the college library. The college library is situated below ground level in the centre of the square, with an amphitheatre leading down towards it. The amphitheatre has stone steps, and will be used for open-air performances and as a general seating area. The four large and wavy seats along the top edge of the amphitheatre have been designed to accentuate the perimeter line, and to provide a physical barrier from the drop to the steps below.

"I selected the lines from the first verse of *A State of Rock* by Benjamin Zephaniah, who lives locally, to appear on the top edge of the seats, they read:

I am tangled up and I just can't sleep,
I am drinking water strong and neat,
Music got me lost in de beat,
I am in a state of rock.
Well I'll keep rocking till sunrise
I'll see de day through riddimwise,
I'll walk de streets and advertise,
I'm suffering from rock.

"The letters are set closely together and span across the entire width of the seat, designed to create a relief pattern with its own rhythm and intricacy. The seats themselves vary in length, and their waviness loosely relates to the curves of the amphitheatre. A view from the windows above gives the impression of the top row of seats from the amphitheatre 'breaking free' or expanding from their formal setting, which could surely be seen as a visual metaphor for the educational aims of the college." *Bettina Furnée*

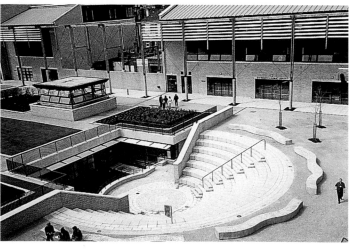

PAT KAUFMAN
QUARRY

"The work was sited in a small courtyard positioned between two buildings – a sort of cul-de-sac divided from the main campus by a walkway, planned as an area of privacy for the resident caretakers and a retreat for students and staff. My intention was to make a work which would encourage participation without betraying the location's essential privacy: in the circumstances, it seemed appropriate to think in terms of functional sculpture inspired by classical culture whose traditions underlie both garden architecture and contemporary education. In keeping with the garden theme, I decided to use stone, a material which endures and can improve with time.

"The final work consists of two benches, or couches, in Portland stone facing each other on a circle of granite setts, their proportions based on classical building elements in the Agora of Athens. However, the height of the two blocks making up each seat has been slightly exaggerated in order to encourage a sense of isolation and unreality, since all but the very tallest people sit with their feet dangling slightly off the ground, evoking the freedom of childhood. The sense of apartness is reinforced by the refusal of the sculptures to give any information about themselves until they are approached up close: seen from the street or from the interior pathway, there is no hint that this seemingly two-dimensional façade is actually three-dimensional, nor that the frontal view hides a companion piece, and that a hollow interior is formed by the opposition of two massive stone blocks." *Pat Kaufman*

below: Dimitra Grivellis
Crêche Mural (detail)

DIMITRA GRIVELLIS
CRÊCHE MURAL

"The brief was to depict wildlife from land and sea ... Each porcelain panel is a flying carpet with end patterns derived from different cultures to represent the cultural diversity of the audience. These patterns relate to the areas the animals come from – Africa, the Middle East, Asia and North America.

"The mural works as a teaching aid in a number of ways. The animals are clearly recognizable. They are in proportion to each other. The children can see that a mouse is small, an elephant is big, but a whale is huge. The possibilities for counting activities are endless. There are 206 creatures – 20 zebra, 12 elephants, 25 penguins and so on. Each panel is filled with material for illustrating lessons and creating stories." *Dimitra Grivellis*

A PLEASURE GARDEN OF UTILITIES
Muf, *Hanley City Centre, Stoke-on-Trent*

CLIENT
Stoke-on-Trent City Council

MUF
established London 1993
Juliet Bidgood, b. Bedford 1962.
Katherine Clarke, b. Jersey, CI
1960.
Liza Fior, b. London 1962.
Cathy Hawley, b. Bristol 1970.

PACA is currently coordinating a programme of commissions to provide coherence and focus for the pedestrianized areas of Hanley City Centre. Seven sites are identified, of which five are spaces leading into the city centre, concentrated in and around Piccadilly, Lamb Street and Market Square. Prior to this programme, artists were commissioned to make temporary interventions on these sites, prompting debate and engaging the public in advance of the more permanent work. The proposals for the sites were widely exhibited to canvass public opinion, and in an extension of this consultation process local artists were employed as mediators of the proposals.

The selection process, which also shortlisted proposals by John Aiken, Anna Heinrich with Leon Palmer, Pierre Vivant and Simon Watkinson, resulted in the appointment of the Muf design team to realise their proposal for Piccadilly. Funding is being sought to develop the proposals for other sites.

above: Drawing of night-time occupation of the site: the proposal allows for 24-hour occupation, and will be lit as both destination and route, providing a social space in the street.
right: Axonometric drawing of 'A Pleasure Garden of Utilities'
below: View of model

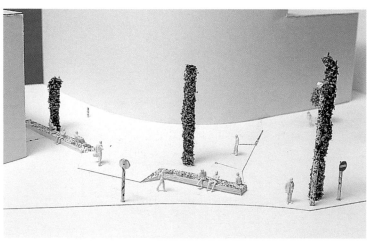

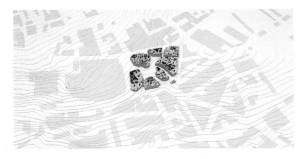

"Our intention is to shift the priority from the car to the pedestrian by a constellation of pieces which remodel the existing landscape as a 'Pleasure Garden of Utilities', a space where the work of the city meets the social life of the city dwellers. The proposal is to make a space of repose with materials and processes which give presence to the culture of the work of Stoke. The scheme comprises two long, ceramic-clad contoured and patterned benches, strategic scented planting, patterning and lighting and a video installation.

"The shape and the culture of a place is formed through time by the activity and industry of the people who live there: political and technological decisions of the past decades have reshaped the landscape. The once visible culture has been drained from the skyline: in some places it still exists, but no longer in that familiar form of chimneys, kilns and pit heads; in others it no longer exists.

"The constituent parts of the proposal, the materials and the making, aim to give visibility to the culture of work. To make imaginable this place as the place where the person who passes you in the street is the person whose hands dug the coal that fired the kiln that made the pottery that was passed from hand to hand to make the plate from which you ate your dinner. The ceramics and the patterning will be made in Stoke in collaboration with local factories and using local skills.

"The closed door of the lavatory building adjoining the site will be framed by planting and become a

miniature nightly cinema where the changing culture of work will be revealed by a back-projected video, *What Men Do*.

"The social life of the town is active and vibrant: the 'Cultural Quarter Project' will expand the social life of Hanley to include, alongside the current bars and clubs, theatres and restaurants. We propose that ceramic patterned tiles are used to mark out the prospective licensed areas of pavement forming a shared public ground between the public pavement and the café forecourt where this expanding economy spills onto the street.

"Similarly the ceramic, contoured surface of the bench allows for two people returning from the theatre and fifteen girls in mini-skirts visiting the cash-point; the lighting marks route and destination and the site is peopled by the projection of the video." *Muf*

right: Model of Hanley town centre, showing the project site highlighted and the overwhelming scale of The Potteries shopping complex, left, within the landscape of Hanley.
below: Perspective of ceramic benches.

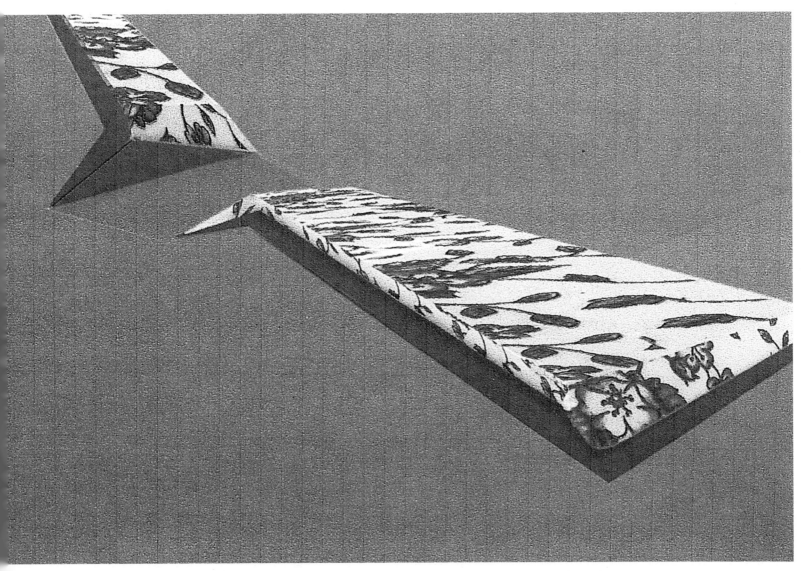

CLIENT
Cardiff Bay Development Corporation

EILÍS O'CONNELL
b. Derry, Northern Ireland 1953.
Lives and works in London
PIERRE VIVANT
b. Paris 1952. Lives and works
in Oxford and Saint-Quentin en
Yvelines, Paris
PLACE
Jonathan Adamson
b. Leeds 1950. Lives and works in
Huddersfield and London
Andrew Darke
b. Preston, Lancashire 1948. Lives
and works in the Forest of Dean,
Gloucestershire
Anneké Pettican
b. Brentwood, Essex 1967. Lives
and works in Manchester

A STRATEGY FOR PUBLIC ART IN CARDIFF BAY

Initial programme: Eilís O'Connell; Pierre Vivant
PLACE – Jonathan Adamson, Andrew Darke and Anneké Pettican

PACA led the Public Art Consultancy Team which devised the Public Art Strategy for Cardiff Bay Development Corporation. This led to the adoption of a 'percentage for art' scheme and the establishment of a dedicated public art office, the Cardiff Bay Art Trust. PACA was retained to organize an open international competition, and from a shortlist with proposals by landscape architect Kathryn Gustafson with Jane Kelly, and architect Ian Ritchie with Francis Gomila, two projects were selected to create landmarks for the development area: Eilís O'Connell's *Secret Station* provides a marker for the approach to Cardiff Bay from the M4/A48(M), whilst the work by Pierre Vivant is situated on a roundabout in Ocean Park, at the entrance to a large residential area and an adjacent industrial site.

Eilís O'Connell
Secret Station

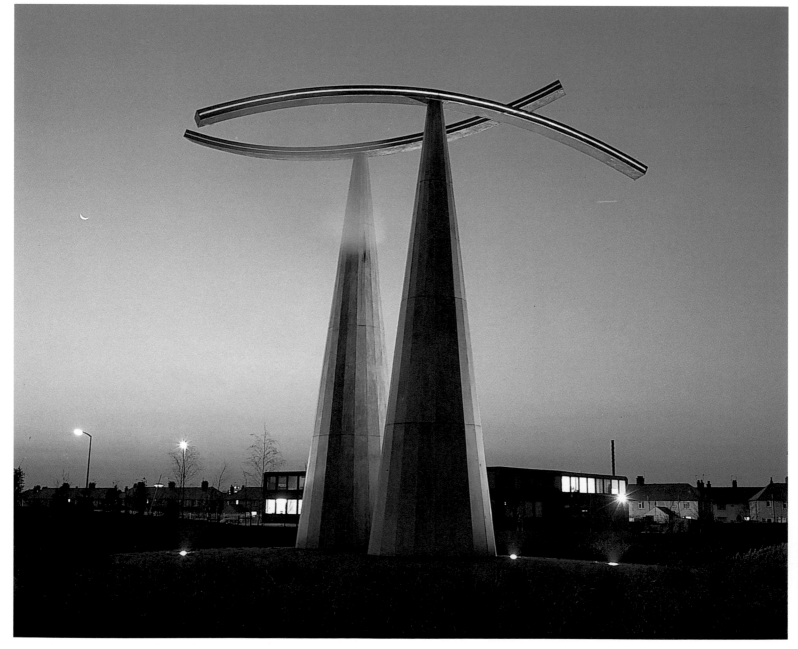

EILÍS O'CONNELL
SECRET STATION, 1990–92

"I had always been interested in how and why landscapes change, how a territory's history can change its geography. Industry and new technology can cause the demise of a place or radically regenerate it. This tension is evident all around us. Cardiff was a perfect city in which to explore these issues. During my research there I found an old painting of Cardiff Bay, as a port alive with steam ships swarming in and out of the bay. This made me realise the importance of coal and steam in Cardiff's history and I decided to use steam as a component of my sculpture. Nowadays steam is not considered efficient, so I balanced it with the most up-to-date energy-efficient lighting system.

"It was important that this sculpture was not static but functional. Both cones puff steam in alternating rhythms and at night the arcs are illuminated by fibre-optic light which gradually changes colour: deep blue to turquoise, viridian and lime green. Both cones operate like little factories and serve to house the fibre-optic projectors, water tanks, steam generators, pressure systems and timing devices. By using both old and new technologies, I wanted the sculpture to emphasize Cardiff's history in relation to its future.

"During the two years I spent working on this project I just couldn't find words to title it. In the end I found them by accident in Seamus Heaney's poem *The Diviner*. The two words were great together: 'secret', a very intimate and private word, with 'station', which suggests the public and the impersonal."
Eilís O'Connell

above and overleaf: Pierre Vivant *Untitled*

PIERRE VIVANT
UNTITLED, KNOWN LOCALLY AS 'THE
MAGIC ROUNDABOUT', 1992

The piece uses the indigenous materials of its site: roadsigns and conventional landscaping materials. From the centre of the roundabout there spirals a group of six geometric shapes, constructed with aluminium frames covered with standard road-traffic signs. Their shapes denote in three dimensions the Highway Code sign categories of Prescription, Information and Warning. These are encircled by corresponding geometric topiary shapes. The intention was that the topiary should be allowed to grow to a size similar to the volumes enclosed by the signs, as a secondary and more organic presence overriding the original dominance of system and order.

The commissioner, Cardiff Bay Development Corporation, is in the business of developing an infrastructure for cities. This modular approach, emanating from a central point but enclosed by a defined territorial perimeter, signals the structured nature of urban regeneration development, against more unstructured urban growth.
Notes from an interview with Pierre Vivant, November 1997

PLACE: JONATHAN ADAMSON, ANDREW DARKE
AND ANNEKÉ PETTICAN
ATLAS, 1996 and ongoing
THE GRAVING DOCKS AND BARRAGE

The enclosure of Cardiff Bay and its estuary is a highly-charged ecological issue. With its proposal for a pipe under the new lake and barrage in order to preserve the tidal flow, and thus the slowly changing mud formations in the Graving Docks, PLACE has focussed on some of the consequences of bay and estuary barraging which have been otherwise little discussed. The proposal has received much support in principle from the educational sector and arts bodies, including Public Art Forum and PACA.

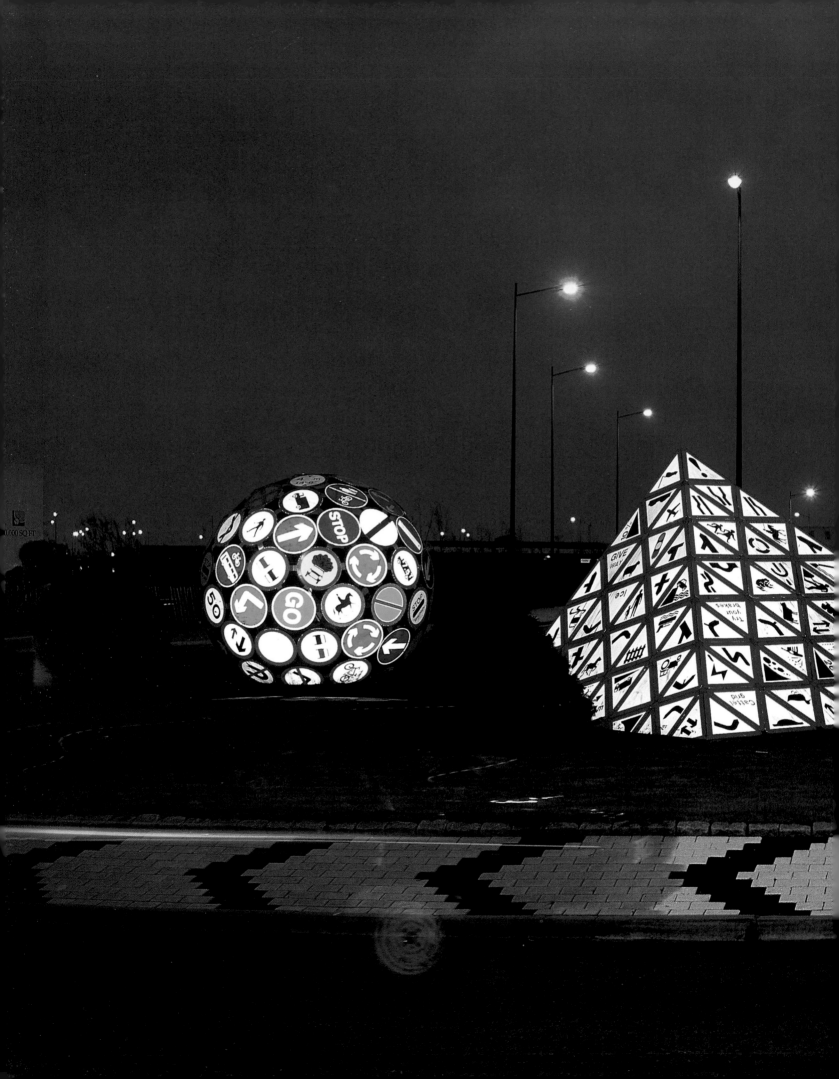

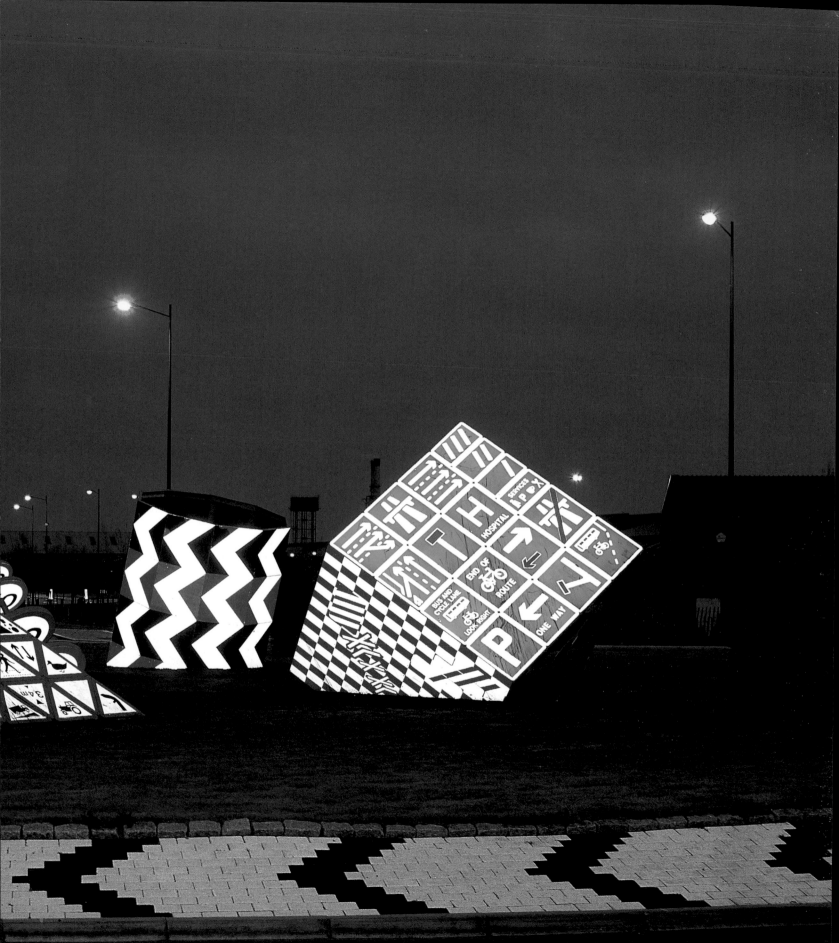

LONDON DOCKLANDS

Bosch Haslett; Sir Anthony Caro; Bill Culbert; Siobhan Davies; Antoni Malinowski with Future Systems; Eilís O'Connell; Jorge Orta with Lucy Orta; Mark Pimlott; Pierre Vivant; Richard Wentworth

CLIENT
London Docklands Development
Corporation

BOSCH HASLETT
established Amsterdam 1989
John Bosch, b. Netherlands 1960.
Gordon Haslett, b. United Kingdom
1962.
SIR ANTHONY CARO
b. New Malden, Surrey 1924.
Lives and works in London
BILL CULBERT
b. Port Chalmers, New Zealand
1935. Lives and works in London
SIOBHAN DAVIES
b. Durban, South Africa 1966.
Lives and works in London
FUTURE SYSTEMS
established London 1979.
ANTONI MALINOWSKI
b. Warsaw, Poland 1955. Lives
and works in London
EILÍS O'CONNELL
b. Derry, Northern Ireland 1953.
Lives and works in London
JORGE ORTA
b. Rosario, Argentina 1953.
Lives and works in Paris
LUCY ORTA
b. Sutton Coldfield, Warwickshire
1966. Lives and works in Paris
MARK PIMLOTT
b. Montreal, Canada 1958. Lives
and works in London
PIERRE VIVANT
b. Paris 1952. Lives and works
in Oxford and Saint-Quentin en
Yvelines, Paris
RICHARD WENTWORTH
b. Samoa 1947. Lives and works
in London

London Docklands Development Corporation (LDDC) commissioned and supported a number of permanent and temporary works of art of which several were organized by PACA.

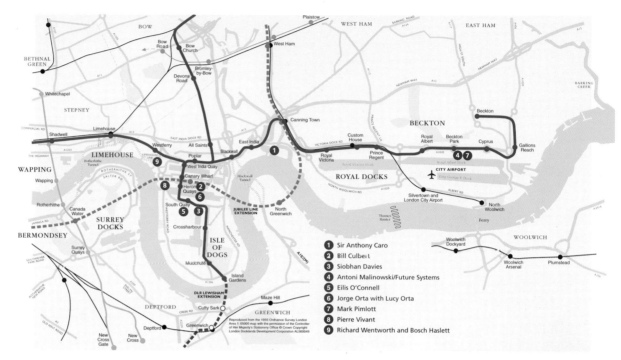

1 Sir Anthony Caro
2 Bill Culbert
3 Siobhan Davies
4 Antoni Malinowski/Future Systems
5 Eilis O'Connell
6 Jorge Orta with Lucy Orta
7 Mark Pimlott
8 Pierre Vivant
9 Richard Wentworth and Bosch Haslett

Reproduced from the 1993 Ordnance Survey London
Area 1: 65000 map with the permission of the Controller
of Her Majesty's Stationery Office © Crown Copyright
London Docklands Development Corporation AL560049

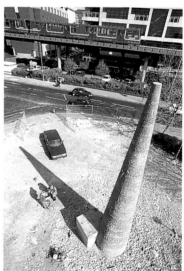

EILÍS O'CONNELL
VOWEL OF EARTH DREAMING ITS ROOT, 1994–98
CIRCULAR PLAZA

"It is a strange, fragmented space, situated at the junction of two roads and overlooked by the Docklands Light Railway, which runs parallel to Marsh Wall, then swings dramatically across the road. It is clearly visible from the trains, and this is its most exciting feature. For this reason, the proposal includes ground drawings in stone which, when seen in contrast to the gravel, will be visually exciting when viewed from the train.

"This space is governed by the mechanics of movement and from the very beginning I wanted to create a place that would act as an antidote to the sense of speed that pervades it. The existence of well established London plane trees on the site reinforced my concept of the site as a refuge from its surroundings.

"My decision to use a carboniferous limestone reflects my preoccupation with the site as it was first recorded on a map: a marsh, which is neither land nor water, but a little of both. Time and human intervention have transformed it into solid ground, into a hard urban landscape, with little remaining of its origins.

"The transitional nature of the site can metaphorically be seen in the development of the limestone over 370 million years. The stone's surface is marked by bivalve shells and colonies of crinoids which were trapped and suspended in water, forming reef-like structures which are still visible today.

"The sculpture consists of a cone 9.6 metres high and a cube of 1.5 cubic metres. The cone will be turned on a specially built lathe, using stones from fossil beds, and formed from sixteen blocks which will be dowel-jointed with stainless-steel pins and epoxy.

"The ground drawings will be laser-cut using fossil bedstone. It will be hammer-dressed to prevent slipping. The ground drawings are a series of arcs surrounding the sculpture, creating an energy within the volume of the space.

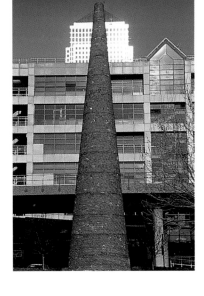

"The title *Vowel of Earth Dreaming its Root* comes from a verse in *Kinship* by Seamus Heaney:

This centre holds
and spreads,
sump and seedbed,
a bag of waters

and a melting grave.
The mothers of autumn
sour and sink,
ferments of husk and leaf

deepen their ochres.
Mosses come to a head,
heather unseeds,
brackens deposit

their bronze.
This is the vowel of earth
dreaming its root
in flowers and snow,

mutation of weathers
and seasons,
a windfall composing
the floor it rots into.

I grew out of all this
like a weeping willow
inclines to
the appetites of gravity."

Eilís O'Connell

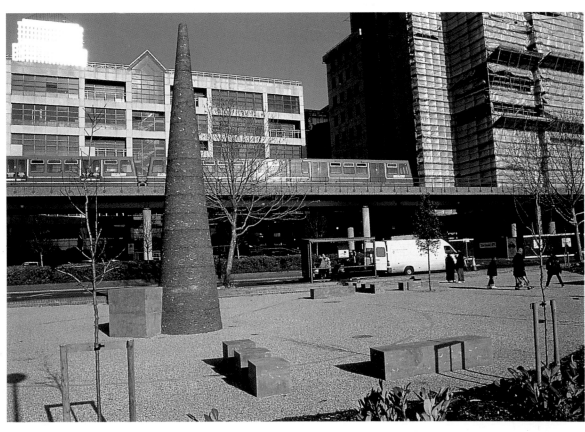

PIERRE VIVANT
TRAFFIC LIGHT TREE, 1995–98
HERON QUAYS ROUNDABOUT

This project, which observes the importance of trees in the urban landscape, comprises three trees on a traffic roundabout. Two are London planes; the third is made of traffic lights and replaces a plane tree which was removed because it was dying. The proposal calls for a preservation order on the surviving planes. The new tree deploys 65 'three-aspect' units – the familiar red, amber and green – given green casings and arranged in clusters of three on eighteen branches, with thirteen 'statutories' – red and green men and filter arrows – mixed on the remaining six branches. The random sequence of light changes will imitate not the seasonal rhythm of the other trees, but the sleepless, 24-hour day of nearby Canary Wharf.

left: Richard Wentworth,
Globe, **at manufacturers prior to installation**

RICHARD WENTWORTH
GLOBE, 1995–98
CANNON WORKSHOPS WALL

Richard Wentworth's proposal for the Cannon Workshops Wall was selected from a shortlist of four, with those by Michael Craig-Martin, Ron Haselden and Katayoun Dowlatshahi.

"Canary Wharf's proximity to the Meridian is the basis for *Globe*, which I see as a heraldic solution to the demands of the brief.

"Geographical good fortune is the source of London's success, and in their previous form the West India Docks were central to it. Two hundred years later it is international time zones which dictate the ebb and flow of life and business at Canary Wharf. *Globe* uses the sheer length of the largest wall to reveal a sample of these times and places simultaneously, re-employing the generous nineteenth-century tradition of displaying time publicly.

"The row of sixteen internally illuminated clocks will be controlled by a specific programme to keep pace with artificial time differences and, in keeping with the brief, all the technical requirements will be hidden from sight behind the wall, with an absolute minimum of interference to the existing structure."
Richard Wentworth

**SIR ANTHONY CARO
THE SALOME GATES, 1996
EAST INDIA DOCK BASIN**

"The new Nature Reserve at East India Dock uses the old dock basin as the starting point for an entirely new way of making the water available to public use. What was once the repair dock for vessels from all over the world is now a place for recreation, somewhere quiet where people can relax, picnic or watch the birds nesting.

"When I first saw the dock my inclination was to try to recall something of the old atmosphere of the docks by using specifically dockland equipment and materials. However, it soon became apparent that just as the nature reserve in docklands was an entirely new concept, so it was important that rather than reflect past history the gates also be new in approach.

"I have therefore tried to make the gates into a single sculpture. So far as I know gates previously have always been made starting from the premise that they are first and foremost barriers to be opened and closed at will. My endeavour is to start from the other end, to make a large, flat sculpture which is also a gate, not a gate which by means of its decorative style has a sculptural look to it. This is why I found it necessary to abandon the new central pier in brick and replace it with a pier in steel. This means that the entire gap will be filled with a single sculpture.

"After abortive visits to dockyards at Gravesend and Chatham we finally went to Portsmouth where there is an enormous scrapyard. Whole ships, submarines and light vessels are dismantled and cut up. A distorted ladder with its high curved ending was the starting point for the project. Its strict form culminating in the loose curves seemed to set the tone of the free feeling of sculpture, together with the strict control needed for gates.

"I incorporated the steel veils, seven of them (hence the name), and these close off the East India Dock, giving no more than a glimpse of the area behind. When the gates are open the new exciting space of water and sky will be revealed.

"I have used dockyard units for details like the gate fastenings and locks. These call to mind ships while the gates themselves, temporarily closing off the nature reserve, are like lock gates holding back the water till the level gets changed." *Sir Anthony Caro*

Dock Lighting

From an international open competition devised by London Docklands Development Corporation and PACA, six artists were shortlisted to develop ideas for their own choice of location in the areas around West India Dock and South Quays. In addition to those mentioned, David Ward, and Anna Valentina Murch with Douglas Hollis, created designs in response to the brief. The proposals by Bill Culbert and Siobhan Davies were initially accepted by LDDC, then cancelled in the face of financial cuts in the last few months of the development corporation's existence.

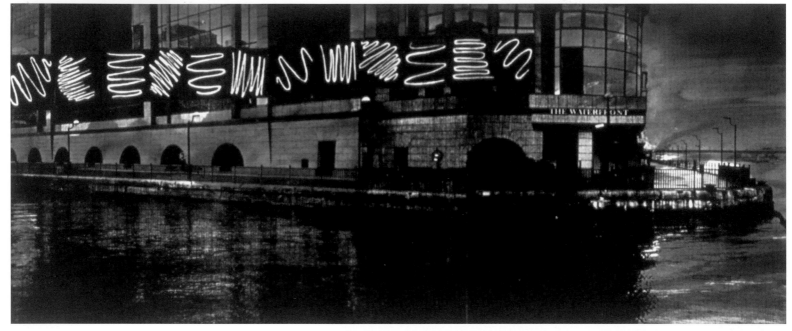

BILL CULBERT
WATERMARKS, 1996 (unrealised)
VARIOUS SITES, INCLUDING MILLWALL
INNER DOCK

"*Watermarks* are a series of twelve panels two by two metres square. Each panel contains a neon mark of fluid energy – the marks are from calligraphic sources developed by myself specifically for these Docklands works. They are fluid in that they are to do with movement, particularly of liquid. The works are to be used in situations where reflection in the Docks water will continue and constantly change their curves and the complexities inherent in them.

"I have used six colours, three primary and three secondary. These will create a harmony and colour ambience. The twelve marks are all different, representing in their own ways differing energies and sensibilities, calm, vigorous, gentle, rhythmic, all made as hand movements." *Bill Culbert*

Originally intended for siting on façades of buildings and on trucks in spaces adjacent to the dock edge, the *Watermarks* proposal was revised for installation on rafts in the dock.

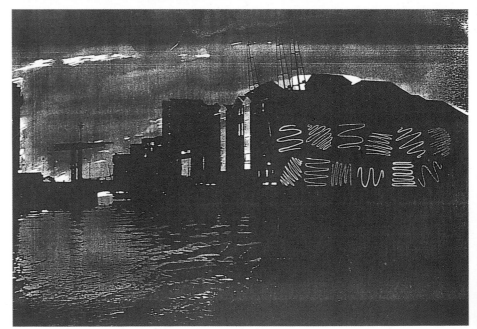

top: Basketball court, its markings to be replaced by strips of fibre-optic and reflective plastic, the chain-link fence to be coated white, the nets to be flood-lit from above.
above: Distribution of *Light Objects* in the Isle of Dogs (night view), a skateboard lagoon, exercise track, basketball courts, cricket nets and squash courts.
right: Cricket nets illuminated by bands of coloured light.

BOSCH HASLETT
LIGHT OBJECTS FOR LONDON, 1996 (unrealised)
"Over the past fifteen years the Isle of Dogs has been rejuvenated. The combination of urban intensity, suburban comfort, efficient transportation, open spaces and historic landscape has formed a new type of city. The problems of noise, congestion and pollution, so typical of London, have been solved. A mix of public and private investment has built new infrastructure, offices, factories, houses, parks, tourist attractions and schools. It is sharply divided into zones according to different programs such as working, living and recreation. They exist in isolation, operating quite independently of each other; the parts do not add up to give a greater whole. This makes an efficient but sterile city.

"*Light Objects* infects the sterile city with a series of active-light objects combining art and urban design. Each object is designed specifically for one type of activity. Light, colour and form are used to make the objects as attractive as possible. The design is pro-active: taking pleasure in the city is not only allowed but encouraged. It blurs the edges between different zones. Rigid boundaries are loosened up. Office workers go to the suburbs to play basketball, residents run through tourist attractions to keep fit, school kids rollerblade through office plazas. *Light Objects* adds a new layer of urban activity with minimal physical intervention. The objects intensify the visual effect of each activity creating a new range of urban spectator sports." *Bosch Haslett*

below: Luminographic
painting on the façade
of Salute Church, Venice
Biennale, 1995
right: Drawbridge
below left: Neon signs
on dockside cranes
below right: Port-hole
lights in the walkways
along the quay

JORGE ORTA WITH LUCY ORTA
SIGNS – LIGHT, 1996 (unrealised)

"Docklands is rich in signs. Ropes, chains, mooring rings, locks, bridges, cranes, boats; elements which become part of the alphabet and are transformed and re-engraved: port-holes and neon signs embedded into the quayside and under the bridges; light signs engraved on to the side of the boat cranes; a luminographic boat navigating the canal, projecting signs on the dockside buildings. The passer-by rediscovers this new dock environment, its memory and codes reinterpreted by the lights.

"Like windows on our memory, the port-holes are a poetic reminder of our inheritance. Embedded in the quayside between the West India and Millwall Inner Docks, they assume a human aspect through their contact with the passer-by.

"The neon signs are installed underneath the drawbridge. As the bridge rises, the signs in its belly structure appear. The bridge is transformed into a sculpture. It produces sound which interacts with the pedestrians, a musical creation of sound signs from computer analysis of the image mixed with sounds specific to the docks.

"The luminographic boat, carrying high-powered image projectors and electric generators, navigates the Thames from Tower Bridge to the Isle of Dogs, an ephemeral event which creates a magical play with the scale of light and its reflections in the water and on the architectural structures of the port."

Jorge Orta with Lucy Orta

SIOBHAN DAVIES
LIGHTING PROPOSAL, 1996 (unrealised)
MARSH WALL VIADUCT

"I propose to project the moving image of light reflecting off water on to the underside of the viaduct at Marsh Wall, on the sections of the structure over The Cut and either side of it.

"The piece is starry and romantic. The dancing lights of the reflections transcend the oppressive quality of the low concrete ceiling, making it feel light and fluid, the opposite of its materiality.

"The implied image of water is a reflection of Docklands as a place built around water, and its incidence on the underside of the viaduct connects with ideas of transportation and travel central to the history of the area.

"The piece will augment the low level of lighting present in this area, while not overwhelming the lights visible from boats and buildings across the water. The nature of the image will pull together the diversity of scales visible at this site, in that although large scale, it is delicate, moving and intricate."

Siobhan Davies

Royal Docks Business Park

LDDC's final engagement with public art was an invitation, coordinated by PACA, to seven artists, including Darrell Viner and David Ward, to create proposals for a mile-long linear site adjacent to the designated Business Park in the Royals, opposite City Airport. The two proposals detailed here were agreed in principle but cancelled in November 1997 when the LDDC withdrew its plans to develop the Business Park. It is, however, conceivable that the projects can be reconsidered if the London Borough of Newham goes ahead with the scheme.

right and overleaf:
Drawings show parallel bands of use adjacent to the Royal Docks. "At the Royal Dock site, everything has been planned – historically and currently – to be continuously adjacent, parallel. Everything can make contact with that which is next to it at any point, or remain separate. The way the place has been planned allows for either possibility." *Mark Pimlott*

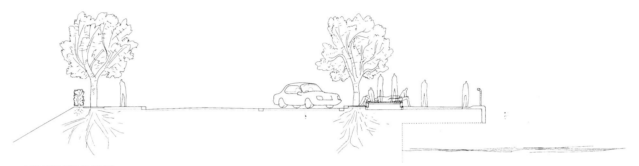

MARK PIMLOTT
A HIGHER PLACE, 1997 (unrealised)
ROYAL DOCKS BUSINESS PARK

"Cities and their places are products of the culture's imagination. The city's places are made up; inventions. Each aspect of the city's physical character is legitimate and worthy of attention not simply as facts or realities but as representations. This includes those elements which are unconsciously produced as meaningful: those things and places that are proposed as merely functional, useful; as transparent. It seems that even function is fictional.

"The reason for acknowledging the city as made in this way is part of my attempt to understand the motivation for its making, and to make the moment of its making visible and palpable to those who make it and live in it. That motivation may be tied to fear of the Other or death or the World's indifference; or a tentative desire to begin, unified with nature.

"My proposal is simply this: to make another place in the city particular to and specific to this part of the city – the way it has been made, the way it may continue to make itself, the way it may begin again. I propose to make a piece of ground from which the moment of this making may be visible.

"In the case of the Royal Docks, a series of parallel bands of different kinds of space and different kinds of use run alongside the existing dock. The dock was designed as a piece of infrastructure, orchestrating and rationalizing the activities which took place alongside it. Today, the activities that take place around the dock are different from those that used to take place when the dock was a working place. There are many new activities and uses which are particular to our time, and many which are common to other times and other places, other cities.

"The proposal defines a 2440-mm-wide band of space that is related to other parallel bands of space, so that the ordering of the site becomes visible, both as it is today and as a residue of what it was. This involves marking out a piece of ground by raising it, so that a new, higher place is made, which is sensed to be a plinth, a path, and a register of the dimensions of the greater place. The raised ground is integrated with adjacent infrastructures and equipment planned by the LDDC for the site. The organization of the rest of the enormous site can be seen from the higher place; it serves as a frame for viewing the World.

"In Britain, the seaside boardwalk is a place for people to parade, to look at each other and the city and the enormity of the sea. The way it has been made, its material, is specific to the experience it holds. It is partly civilized, partly natural, partly confident, partly tentative.

"The boardwalk is exciting because it offers the experience of both the civilization of the city and the weakening of its conventions by a fascinating, unrecriminating and potentially endless beyond. It is not only where the city and the World meet, but where the city, relaxed and vulnerable, meets itself.

"The proposal is for a boardwalk at a place which has been and still can be considered to be at one of the edges of the city, London. This is a place that was a resort for Londoners before it was a working dock. Here, there is the possibility of experiencing the vastness of the (largely man-made) landscape and the parallel activities and fictions of the city at work and at play." *Mark Pimlott*

BAND OF TRANSPORTATION

BAND OF BUILDING.

BAND OF NATURE

BAND OF ROAD

BAND OF NATURE

NEW BAND OF PEOPLE

BAND OF PEOPLE

BAND OF WATER

BAND OF RUNWAY

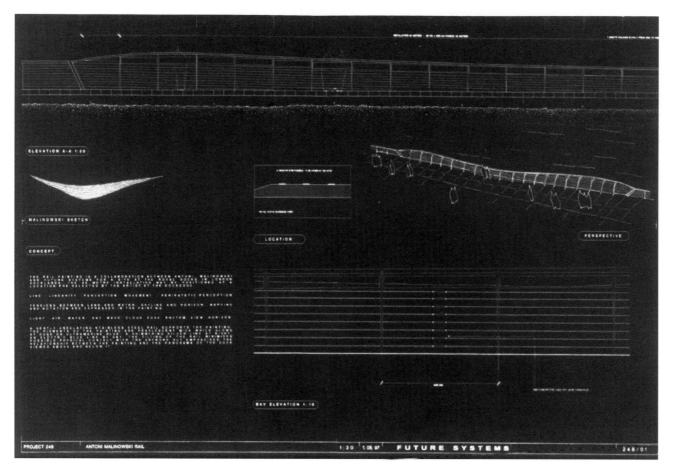

ANTONI MALINOWSKI WITH
FUTURE SYSTEMS
ROYAL DOCKS BUSINESS PARK, MAY 1997
(unrealised)

The rail painting is a collaboration between Antoni Malinowski and Future Systems for a site at the Royal Docks in London Docklands. The 40-metre installation may be positioned at a location pre-selected by the artist at the dock edge.

"A gently undulating stainless-steel rail supports the painting. The pigments of the painting are pearlescent mica which glows at dusk on ultramarine blue. A shimmering, silver line at night, an electric-blue line by day. The tilting of the rail minimizes possible physical contact with the artwork but emphasizes the relationship between the painting and the panorama of the dock viewed above and below it."
Antoni Malinowski with Future Systems

LINE – LINEARITY – PERCEPTION – MOVEMENT – PERIPATETIC PERCEPTION

TENSIONS BETWEEN LAND AND WATER, SKYLINE AND HORIZON, MAPPING AND NOTATION ARE EXPRESSED IN THE PAINTING.

LIGHT – AIR – WATER – SKY – WAVE – CLOUD – EDGE – RHYTHM – VIEW – HORIZON

Detail of Rail Painting

GATEWAYS FOR THE MILLENNIUM

International Collaborative Workshop
Alliance for Art, Architecture and Design: a Public Art Forum/RIBA initiative

CLIENT
National Alliance for Art,
Architecture and Design

'Gateways for the Millennium' was the ironic title of an international collaborative workshop which took place at the Royal Institute of British Architects (RIBA) in 1994. More than one hundred architects, artists, landscape architects and representatives from other creative disciplines, from philosophy to choreography, spent a weekend working in teams on real or notional projects which addressed the given theme. The purpose was to provide a stimulus for new collaborative practice, reflecting the essence of its organizing body, the Alliance for Art, Architecture and Design.

The Alliance encourages and promotes collaboration between artists, architects, craftspeople and other creative professionals, for a lasting effect on the planning and design of public spaces. It aims to encourage a wider awareness of the benefits of interdisciplinary collaboration through exhibitions, conferences and seminars, press campaigns and the lobbying of government. PACA's Founder-Director, Vivien Lovell, then Chair of Public Art Forum, initiated the Alliance in 1991 with the support of Richard MacCormac, then President of RIBA. It was launched at a seminar at RIBA in April 1992. Other key members were Richard Burton, Andrew Wheatley, Andrew Knight, Vanessa Swann, David Wright, Robert Breen, Graham Roberts, Alan Haydon, Martin Richman and Susanna Heron. The International Collaborative Workshop produced some extraordinary proposals: video monuments of two thousand one-second contributions to an electronic store of information; a 'mass global phone party' hosted by the telecommunications companies; rethinking the East Thames Corridor Strategy to incorporate millennial beacons; the Millennium Exchange, an opportunity to swap significant objects from life with fellow citizens; the building of 1:1 scale sections of a larger Millennium project; a glass bridge across the Thames from Waterloo to Downing Street.

"A range of approaches was in evidence at the Alliance. Some of the groups simply accepted the chaos of the whole affair, throwing their imaginative energy into entertaining presentations. Some spent the time in quiet consideration of the meaning of what they were doing. Still others got down to serious urban development and planning for the future. Some groups allowed for a more sardonic, less idealistic account of human nature and offered wry comment on the eagerness to celebrate the Millennium in the first place. 'Whose Millennium?' they asked.

"Groups looked at how the Millennium might be used to focus on issues of civil rights, racism, homelessness and equality of dignity and opportunity for all, and how to keep these in the public eye. There was also preoccupation with what was being lost and acknowledging the appalling events of our century, recognizing that 'the future is a condition of the present'."
Faye Carey in Art and Architecture, *Autumn 1994*

"Richard Burton's was one of the groups that voiced a sense of unease with the idea of the monument as such, and proposed a celebration of the Millennium as an opportunity to start a healing process in Western industrial society, which he described as being 'on a countdown'. The group suggested choosing a simple concept for a world net of 'special places' which would represent a complete contrast with normal life, and proliferate throughout the whole of the next century as the legacy of the Millennium. A similar idea was put forward by another architecturally minded group, which interpreted the idea of a 'gateway' as an opening into a new state of mind, located in, again, a series of special places throughout the country ... providing rest and 'solace away from visual promiscuity'.

"Humorous, philosophical, sober, cynical, abstract, prosaic, the workshop uncovered a wide range of attitudes to the Millennium and how it should be marked, which was productive less in terms of coming up with a viable strategy for action than in opening up some sort of discussion as to the real significance of the event to us all at the end of the twentieth century."
Clare Melhuish in Building Design, *8 July 1994*

A PACA initiative

DAVID WARD
b. 1951 Wolverhampton. Lives and
works in London

WELL, ONE THOUSAND LIGHTS
David Ward
The Royal Pump Rooms and Baths, Leamington Spa

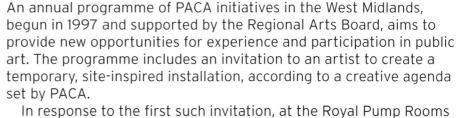

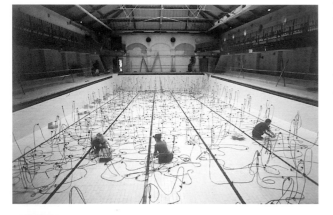

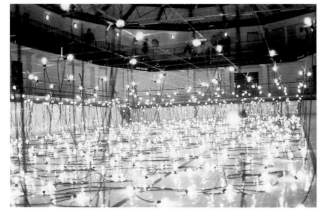

An annual programme of PACA initiatives in the West Midlands, begun in 1997 and supported by the Regional Arts Board, aims to provide new opportunities for experience and participation in public art. The programme includes an invitation to an artist to create a temporary, site-inspired installation, according to a creative agenda set by PACA.

In response to the first such invitation, at the Royal Pump Rooms and Baths in Leamington Spa the sculptor David Ward created a work in the swimming pool, which had been abandoned and drained ten years earlier. On two consecutive weekends in the autumn of 1997 the Victorian pool was full once again, this time with light. Through wiring one thousand electric bulbs at and below the surface level of the absent water, the project re-created the glitter of light on the old pool. The distinctive and locally emotive architecture of the building was brought to life again, by the echoes of the gentle talk of spectators, their faces lit from below, and the shine of reflections on the municipal tiles.

The artist deliberately sought the multiple associations of his chosen title: the sense of a continuous source, a spring of creativity, water or knowledge, the upward movement of fluid, the architectural space which admits light to the rest of a building, the state of good health, effective action.

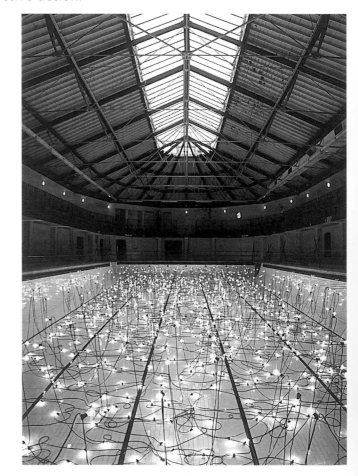

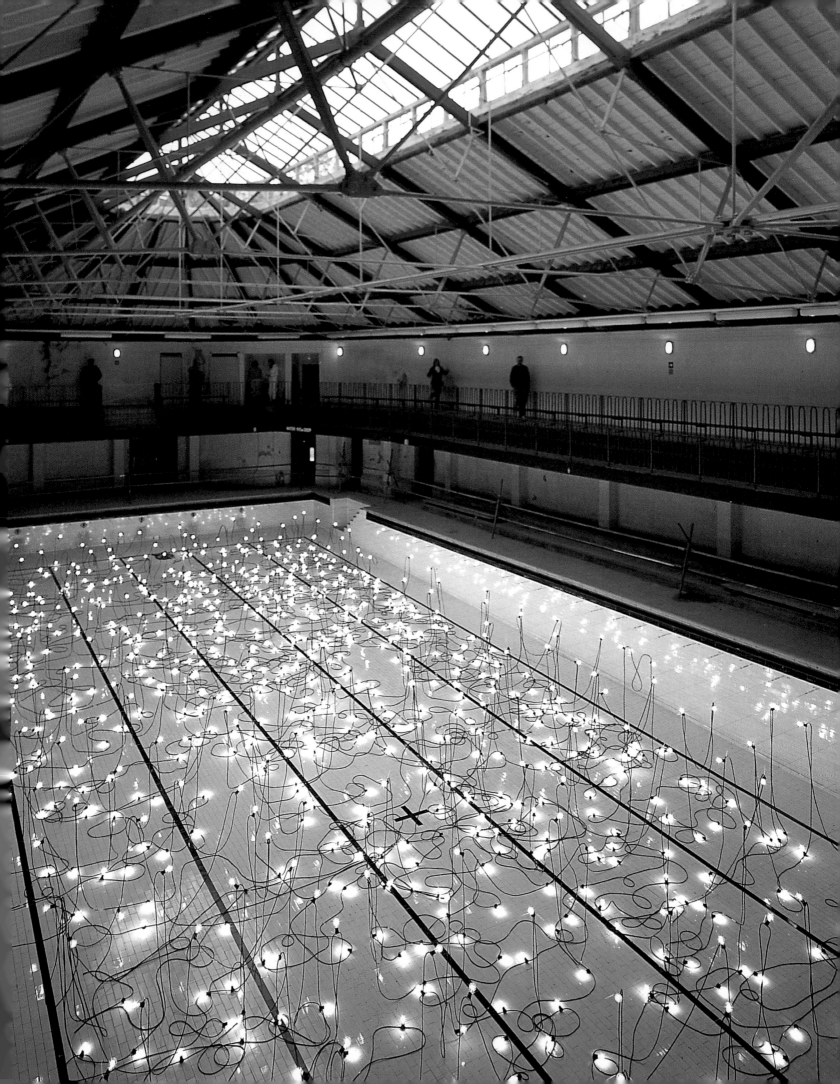

OUT OF DARKNESS

Tony Cooper; Siobhan Davies; Richard Ellis;
Ron Haselden; Janet Hodgson; Martin Richman
Wolverhampton Town Centre

CLIENT
Wolverhampton Borough Council

TONY COOPER
b. Leek, Staffordshire 1962.
Lives and works in Glasgow
SIOBHAN DAVIES
b. Durban, South Africa 1966.
Lives and works in London
RICHARD ELLIS
b. Derby 1964. Lives and works
in Birmingham
RON HASELDEN
b. Gravesend, Kent 1944. Lives
and works in London and Plouer-
sur-Rance, France
JANET HODGSON
b. Bolton, Lancashire 1960. Lives
and works in Liverpool
MARTIN RICHMAN
b. Southsea, Hampshire 1949.
Lives and works in London

In 1989 PACA prepared a public art strategy for Wolverhampton. The study, undertaken with artist Jane Kelly, suggested amongst other ideas that the town might be reconfigured by light. 'Out of Darkness Cometh Light' is the town motto of Wolverhampton. *Out of Darkness* was the result, funded by the Arts Council Lottery, the European Regional Development Fund and the local authority, and led to the creative involvement of a number of artists in the interpretation or reinvention of various buildings and sites in the city, through the medium of light. The project was the first permanent project to involve artists' lighting schemes throughout an entire town. Guest selectors were Jonathan Glancey and Deanna Petherbridge.

The brief for *Out of Darkness*, advertised internationally, called for artists to contribute to a broad vision for Wolverhampton town centre. The proposed light-based artworks were to illuminate and highlight buildings throughout the town, bring the town to life, focus new attention on its striking buildings and the open spaces available to the local communities, add excitement to the town's night time appearance and enhance its cultural identity.

Twelve artists, from a list of 82, prepared proposals for both offered and self-selected sites. Permanent commissions are complemented by short and longer term temporary installations. The following proposals are a selection from the first phase of the scheme.

RICHARD ELLIS
CENTRAL LIBRARY
"Le Corbusier defined Architecture as '... the masterly, correct and magnificent play of masses brought together in light'.

"The entrance to the building was taken as the focus for this design. Particularly at night, the qualities of the building are hard to perceive, and the entrance itself appears distinctly unwelcoming.

"When seen from a distance, the columns and arches of the entrance are the points to which the viewer's attention is drawn, by a series of spotlights placed at the tops of the arches. The centre of the piece is contained within the vaults of the arcade. The roof consists of a series of interlocking barrel vaults with two different radii. The junctions of these set up a distinctive rhythm, where the introduction of directional light would not merely add brightness, but would open up the opportunity to play many games with the building's geometry. Two large spotlamps with a cut-out metal disc, or 'gobo', in the focal plane project shapes and images into this space. The images are cast on to the different shapes of the roof and are distorted accordingly. From some viewpoints, the images will appear to be almost complete, whilst from others they will be greatly fragmented." *Richard Ellis*

SIOBHAN DAVIES
LINES OF DESIRE (unrealised)
WEST PARK

"Many of the trees in West Park have graffiti carved on to them. Five trees will be selected and the text of their graffiti transcribed into neon signs and sited back into the branches of the trees from which they are taken. The piece dignifies individuals' rites of passage through adolescence as signified by the graffiti. Its universal language will be relevant to most people who now use the park.

The suggested graffiti to be used are:
'L 4 M' in a heart
'I LOVE YOU'
'BINGO + DEE'
'MAXWELLE WAS HERE 8/7/71'
'DAVE CARL PHIL MICK STEVE'

The work will be installed in late summer and will gradually become more visible as the season changes to autumn and winter and the branches are left bare. The neon will then gradually be covered as new leaves grow, until, at its least visible, it is removed the following summer." *Siobhan Davies*

The work was envisaged as a temporary, year-long installation. Siobhan Davies has been invited to make an alternative proposal for the stairway in the Civic Centre.

MARTIN RICHMAN AND TONY COOPER
ST PETER'S CHURCH

Martin Richman and Tony Cooper were asked to address a number of sites around central Wolverhampton. Their proposal for St Peter's Church, which has now been realised, was to illuminate the many fine stained-glass windows of the church from within, to make their richness visible externally. They also illuminated the various architectural layers of the outside of the building, using light to reveal the church as a record of its own history. In its sense of substance, the piece contrasts with another project by Martin Richman, at Wolverhampton Art Gallery, a substantial nineteenth-century civic building seemingly dematerialized by rippling lines of light and shade playing across its surface. Unusually, the Gallery has a dry moat; here, water in tanks placed at intervals is moved by agitators linked to a wind-speed detector. A floodlight shining on to the water in each tank is reflected on to the walls to create the evanescent effect.

TONY COOPER
SCHOOL STREET CAR PARK

"This project is for the exterior of the multi-storey car park and will be a permanent installation. All the external pillars will be illuminated with a faultless flood of intense fuschia pink. By priming the pillars with white the projectible colour would appear to radiate outwards away from the pillars, and each pillar would appear as a rectangle of sublime luminous colour weightlessly supporting a heavy concrete roof.

"By concentrating on the external pillars, large areas of colour could be constructed to articulate the building both horizontally and vertically, effectively creating columns of colour four storeys high."
Tony Cooper

JANET HODGSON
STAFFORD ROAD VIADUCT

"The viaduct is an impressive product of the industrial revolution. It stands alone as a monument to its time, massive and robust, functional in its design and elegant in its simplicity. It is significant that what is to be developed around the viaduct is a new park where industry will use the digital technology of the late twentieth century to develop and investigate science and technology for the next century.

"This lighting proposal is designed to make a visual link between art and science, crossing the divide between the two revolutions, industrial and digital, about to become evident on the site.

"It takes as its starting point the work of the late nineteenth-century artist Seurat, who was the inventor of chromo-luminarism or pointillism, a system of painting devised to split light and colour into their component parts. In Seurat's work there is an integration of science and art. He studied the science of light and the laws of optics and introduced into painting the experimental methods that Claude Bernard invented in science.

"The proposal utilises late twentieth-century technology to produce a synthetic version of Seurat's pointillism. The image of the viaduct is first turned into a negative, to roughly simulate night vision. It is then 'pointillized' using a programme which simulates Seurat's method of painting, turning it into pixels of its constituent colours. These dots will then be projected on to the surface of the viaduct so that it resembles a Seurat painting. From a distance the bridge will appear to be solid and whole but as one approaches the bridge it will disintegrate into a projection of large dots, setting up a series of oppositions between real and synthetic, image and object, positive and negative, daytime and night time, history and present day."
Janet Hodgson

top: Lighting test in advance of installation.
above: Computer-generated image of viaduct.
bottom right: *Children's Voices*, Wolverhampton town centre, Chrismas 1997

RON HASELDEN
CHILDREN'S VOICES, CHRISTMAS 1997

"The sounds of children singing songs from around the world will be the central theme for this proposed celebratory sound-and-light work for Christmas. The Christian 'Christmas Story' seems now to have been more widely adopted as a period for celebrating the family and reflecting upon the circumstances of others around the globe. I am acutely aware of the multi-cultural nature of Wolverhampton and the work must reflect this. The candid and optimistic pleasures expressed by children contribute enormously to the Christmas spirit as well as taking our thoughts beyond just ourselves in normal daily life.

"Local schools will be invited to participate in selecting songs for their children to sing with the intention of producing DAT recording compilations of fifteen songs or more. They will be accompanied by local musicians and recorded professionally to achieve a result of a high standard. The recordings could go on sale publicly as audio tapes or CDs to mark the event.

"The singing of the children will emanate from small speakers on street-lamp columns at a sound level which is easily audible but not unwelcome. Lights bedeck the columns and they will softly respond to the singing by rising and falling as bands of coloured light. Each column is basically one colour but as it receives signals from the sound levels this colour momentarily changes to a secondary colour which rises and falls, as a moving bar of light, up and down the column.

"The sounds from the streets such as bus engines, people shouting, car horns, ambulance and police car sirens will also interact and register as moving colour."
Ron Haselden

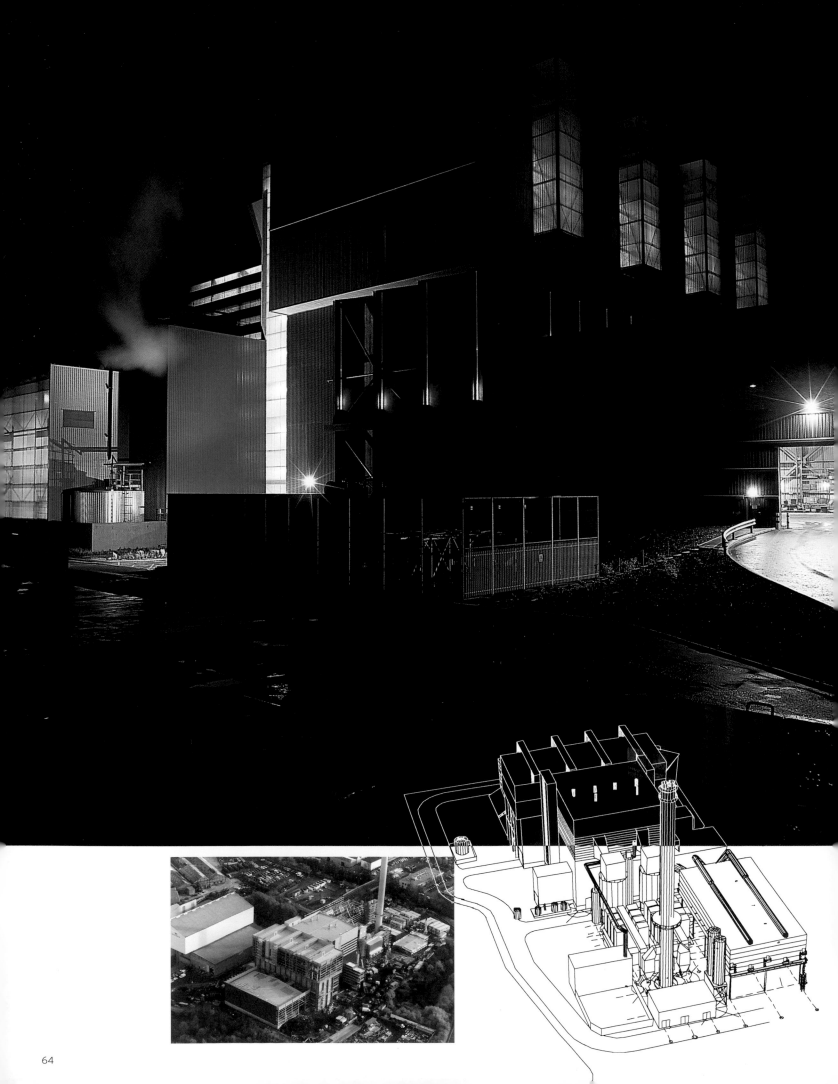

CLIENT
Tyseley Waste Disposal (TWD) Ltd
with Birwelco Ltd
ARCHITECTS
Faulks Perry Culley & Rech

MARTIN RICHMAN
b. Southsea, Hampshire 1949.
Lives and works in London

MADE LIGHT
Martin Richman
Tyseley Energy from Waste Facility, Birmingham

"Seen at dusk from the motorway the building is a slowly orchestrated veil of changing light. It seems to hover without weight in the middle distance, a haunted house out there beyond the street lamps and the drizzling trail of tail lights. Heavy engineering is transformed into a floating image of untouchable space brimming with light." *Niall McLaughlin*

This awesome night-time phenomenon, created by Martin Richman in collaboration with architects Faulks Perry Culley & Rech, is the outcome of a concerted effort between Tyseley Waste Disposal, Birwelco (constructors of energy from waste facilities) and PACA, responding to Birmingham City Council's commitment to 'percentage for art' through supplementary planning guidance to inward investors. Martin Richman was appointed through competitive interview.

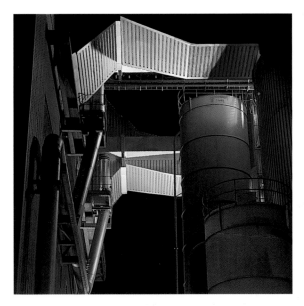

Tyseley Energy from Waste Facility can process in excess of 1,100 tonnes of waste a day, reducing its volume by up to 90%. It operates within strict environmental controls and provides enough electricity to power 25,000 homes.

"The phrase 'energy from waste' seems at once benign and eerie. What we discard is transformed into what we desire. An energy from waste facility is a place near town which we can visit and deposit a boot full of garbage into the national grid. It has a valuable function as an acceptable point of public contact with the whole troubled world of energy generation and consumption.

"At the entrance to the power station great steel grips sift and sort a melancholy waterfall of garbage. A huge shed, dominated by the intimate reek of dustbins, is constantly replenished by dumper trucks. In adjacent spaces the junk is incinerated in the furnace. The remainder of the power station deals with the output as either liberated electricity or captured pollutants. The fire is the pure inaccessible heart of the complex. It is a space of blinding light glimpsed through tiny armoured portholes.

"Martin Richman is an artist who makes space using light. In his work the bright space beyond reach has sensual and spiritual resonance. His project at Tyseley has been to clad the engineering plant. In doing so he uses light on the façade to represent this hidden inner fire." *Niall McLaughlin*, Made Light, *PACA, 1998*

"The structure itself is a series of large cubes and is heavily rectilinear. One's sense of the building is that it is a shell or membrane. Everything is on a huge scale and this vastness registers from some distance away, as the plant looms up above a dual carriageway. Richman, working closely with the architect, has envisaged the building as something that will most commonly be seen at a distance, and the lighting effects really only come into their own as the building bulks into view against the sky.

"From this distance one begins to experience it very much as a metaphor for the body, imagined as something diaphanous and pulsing with energy. Richman has set the lights to run in a sequence that alternates red, blue and white. In some sections the lights are placed in vertical tubes on the exterior, but the really transformative effects are created by internal lighting seen through transparent cladding. In the day this cladding looks opaque, and it is only as night falls that translucency is revealed by the presence of the lights.

"Richman talks of wishing to create a strong sense of counterpoint, of playing different shapes and colours off against each other. In fact, in daylight, the whole building seems to have been envisaged as a rather formal composition of different geometric shapes, in the modernist mode. As night falls, the colour sequencing works against this linear order and the structure takes on a far more indeterminate quality. The effect is not one of grandiosity but rather of intimacy." *Simon Morley*, Made Light, *PACA, 1998*

CLIENT
Mead Gallery, University of
Warwick

PIERRE VIVANT
b. Paris 1952. Lives and works
in Oxford and Saint-Quentin en
Yvelines, Paris

MOONLIGHT (BY PERMISSION);
MADE IN ENGLAND

Pierre Vivant
Artist's residency at the University of Warwick

At the invitation of the Mead Gallery, PACA commissioned Pierre Vivant to make a temporary installation for the Sculpture Court of the University of Warwick. The success of the commission led to the artist's appointment to a six-month residency at the University, entailing a gallery exhibition of documentation of previously executed works, and a series of temporary interventions on the University campus and beyond.

MOONLIGHT (BY PERMISSION)

"The duration of the piece is 28 days, from early January to early February 1990, corresponding to one full-moon cycle, at a time of year when the daylight span is short. Light projections and a closed-circuit telesurveillance system are the two means of creating the piece. The starting point of the piece are the six telesurveillance cameras, four exterior and two interior locations, which survey the campus. Each camera will be twinned with a fixed light (0.5 to 2kw) which will project, through gobos, a particular phase of the moon on to various aspects of the campus – buildings, walkways, trees, hall. For the viewers at ground level the projections will look like anamorphic segments of the moon, broken up by the volumes intersecting the path of the projections. In the Sculpture Court six telesurveillance monitors will be fixed to the wall on a 60° arc of a circle, each showing the shape of a particular moon phase reconstituted by the viewpoint/camera." *Pierre Vivant*

"Dependence on a fixed viewpoint is characteristic of Pierre Vivant's practice. Normally, human eyes must occupy the viewpoint to complete the circuit of the work. But in the *Moonlight* installation there are six such points and the circuit is already closed, by the cameras. But the array of monitors in the Sculpture Court in a sense re-opens it, discharging the mystery of surveillance, giving identity to the new smudges of light in the cosmos of the campus, and giving the previously enclosed Sculpture Court five outward views and a fresh vision of itself. For viewers standing in the harsh glare of the searchlight mysteriously attached to the camera above them, viewers whose looking turns to seeing, the searchlight becomes a cheery full moon, and the camera the means by which they have their own involvement in the installation.

"The light-hearted image of the moon introduces a reservoir of extra allusions: the celestial body projected on our very doorsteps, visible but unrecognized save from a particular viewpoint, is the beginning of an ironic inversion of the nature of the University. Self-contained and introspective as it may seem, and hampered by the bureaucracy which only reluctantly granted its permission for this installation, it is yet devoted to the extension of the outer limits of knowledge, of things which lie far beyond its own confines."
John Gillett, Moonlight (by permission),
University of Warwick, 1990

left: The Sculpture Court, with a constellation of telesurveillance monitors and a projection of the full moon. The images of the moon are distorted from every viewpoint other than that of the projector and corresponding closed-circuit telesurveillance camera.

top: **GREEN YELLOW**
(detail), oil-seed rape,
May 1990, Cuddesdon,
Oxfordshire
above: **RED**, poppies in
Set-Aside field, June 1990,
Kirtlington
below left: **ALONG**, grass,
Spring 1990, University
of Warwick campus
below right: **PAST**,
poppies in Set-Aside field,
June 1990, Kirtlington

MADE IN ENGLAND

The University of Warwick campus is in the heart of agricultural Warwickshire, its nearest neighbour the Royal Agricultural Society of England and the Royal Show ground. The works of the *Made In England* series, which occupied the rest of Pierre Vivant's residence at the University, soon breached the campus boundary to address the English agricultural scenery in all its apparent glory.

English contemporary landscapes are now processed industrially by a new generation of farmers and policed aesthetically by a new brand of consumer, less concerned by the effects of the new methods of production on the flavour of the product than by their effects on the idealized appearance of the land. The implicit understanding between the producers and the consumers, that this appearance will always conform to an unnamed but essentially 'pretty' model, refers to the concept of the English garden, seemingly natural but in fact tightly controlled, and extends it to the whole countryside. An archetype of quintessential Englishness turns into the most massive decor ever created, large enough to screen off the whole agricultural industry. In the projects of the *Made in England* series, it is this decorative surface which is repeatedly probed, tested and tasted.

The words projected and marked in the fields of England by Pierre Vivant act as sampling cores in the landscape: they sample its texture, test its materials, and record the effects of agricultural processes and the passage of the seasons. In a manner which is in the tradition of landscape painting, these markers also serve to frame a landscape which in every sense should bear the manufacturer's stamp *Made In England*.

The almost baffling ambiguity of the seemingly simplest of words is complemented by the deceptive nature of the simple physical appearance of these sculptures. Seen in the reality of the landscape, the words are elusive and feint. Yet they are simultaneously startling and monumental. A vague patch in the scenery suddenly coalesces into a confrontational and all-pervasive presence, offering a sense of a new meaning running right through the heart of things.

Each piece was made by night-time projection from a fixed viewpoint of a negative transparency of the required lettering, which was marked in the landscape by the cutting or picking of crops. The results became apparent only with the returning light of dawn. Thereafter, nature, or rather agriculture, reclaimed the site, the renewal of growth or the progress of the seasons altering and obliterating the work.
John Gillett, Made in England, *South Hill Park, 1993*

GREEN YELLOW (first state), oil-seed rape, May 1990, Cuddesdon, Oxfordshire

A PACA initiative with the
University of Warwick

ALESSANDRA ROSSI
b. Palmanova, Udine, Italy 1968.
Lives and works in Venice
CRAIG WOOD
b. Leith, Edinburgh 1960. Lives and
works in Wales

LIVELLI IN INPUT

Alessandra Rossi and Craig Wood
Palazzo Querini Stampalia, Venice/University of Warwick

above: Craig Wood,
Untitled, polythene, water,
1992, 'Modern Medicine',
Building One, London
top right: Installation of
collaborative work in the
Scarpa Garden, Venice
below: Alessandra Rossi,
Untitled, oil on canvas,
200 x 130 cm

Warwick University has had a thriving presence in Venice for nearly 25 years with students of History and History of Art studying for three months in the Veneto every autumn. Following acquisition by the University in 1993 of prestigious new headquarters in the Carlo Scarpa area of the Palazzo Querini Stampalia, two artists, one British, one from the Veneto, were appointed to create works inspired by the building, the parish of Santa Maria Formosa, Venice, or the Veneto itself, as the basis for an installation or exhibition in Venice and at the Mead Gallery on Warwick University's home campus. The residency gave one month for the visiting artist from Britain to undertake research and make work in Venice. The unforeseen outcome was a collaboration between the artists Craig Wood and Alessandra Rossi.

The collaborative artwork, after installation in the Scarpa Garden, toured to Brick Lane Gallery, London, prior to exhibition on the University of Warwick campus.

"*Livelli in Input* is a computer-manipulated montage printed on to PVC, measuring eight by four metres. The artists, mindful of their different practices, embarked upon a collaborative project with particular relevance to Venice. The work reflects the irony of the loss of culture to a newer, more vicarious form that claims to uphold it. Out of many tourist images, the Portico of St Mark's was chosen from a tourist book, an architectural motif as a relevant basis for composition and concept. They found a discarded cigarette card in a gutter, the photo on the card depicted a model named Jane. Her image, like that of the arches that frame her, suffers a loss of pictorial definition through the increase in scale. The erosion of the image refers to the erosion of culture by the homogenizing effect of tourism, an effect with parallels in the collaboration itself, with individual artistic practices sacrificed to the joint purpose." *Christian Anstice*

below: Installation in the
Scarpa Garden (detail)

A PACA initiative with Nuova
Icona, Venice

PIERRE D'AVOINE
b. Bombay, India 1951. Lives and
works in London
HEATHER ACKROYD
b. Huddersfield, Yorkshire 1959.
Lives and works in Dorking, Surrey
DAN HARVEY
b. Dorking, Surrey 1959. Lives and
works in Dorking, Surrey

HOST
Pierre d'Avoine with Heather Ackroyd and Daniel Harvey
Nuova Icona Gallery and Oratorio di San Ludovico, Venice

For PACA, earlier engagement with Venice through the University of Warwick led to another venture in the city, on the fringes of the 1996 Architectural Biennale, co-curated with the Gallery Nuova Icona in Venice. The aim was for a collaborative, creative response which would bring together artist and architect unfettered by any brief. Following consideration of several potential collaborative teams within the context of the international forum of the Biennale, an invitation was made to the architect Pierre d'Avoine and artists Dan Harvey and Heather Ackroyd. The project successfully blurred the boundaries between art and architecture, and resulted in an artistic response that was truly influenced by the place.

"Under the broad and ambiguous *Host* banner, the project has three essential elements: an exhibition of objects, a street-sited exercise in public interaction, and a site-specific installation.

"The exhibition at Nuova Icona is to be based on the module of the aedicule which the group has designed as a simple house or temple form and presented as a cast solid in various substances, testing and demonstrating the properties of materials and processes. In the streets beyond the gallery, the team intends to install especially commissioned slot-machine 'host dispensers'. Mechanically based on contraceptive machines, these objects serve up packs of three communion wafers to passers-by curious enough to engage with them. Chromium-plated, they are unmarked save for the aedicule motif stamped in the metal; the papery altar bread they contain, unblessed, will be embossed not with a delicate crucifix but with the same aedicule motif. Engagement with the machines will metaphorically enshrine an idea of a secular life guided by religion, and a religion not untouched by the venal.

"At the Oratorio di San Ludovico a further transubstantiation is to take place, the heart of the project. Inside the deconsecrated building, in the centre of the floor, a large timber version of the aedicule is to stand on stilts, above head height. Smeared with mud on its outer surfaces, it is to be planted with pre-germinated grass seed, which in the brief course of the project will grow and cover the object in a thick layer of green. The frameless, bottomless interior of the aedicule will be blackened.

"At its simplest, this object in an abandoned church could be a model of Venice. A fragile, transient structure tottering on stilts, a repository for devotional artefacts, teeming with life, straining ever upwards to escape its certain fate, and itself held in a position of overarching veneration, long since bereft of spiritual intent. Grass often grows vertically, but seldom from vertical surfaces. Yet wherever it grows, it pushes itself towards the light of heaven, for nourishment, for strength, in pursuit of its destiny. As it continues its pursuit of the light we stand beneath it, looking upward in our own unending quest for enlightenment, and we look into a dark abyss."
John Gillett, Host, PACA, 1996

Elements from the installation at Nuova Icona. left and opposite page: Sheets of embossed altar bread were clipped together into a diaphanous structure suspended from the ceiling over a steel tray filled with communion wine. above: Ten aedicules were cast in plaster, and 49 in earth. The plaster forms were eroded by placing them in channels of running water.

this page and bottom right:
Installation in the Oratorio
San Ludovico
far right: *Host* dispenser

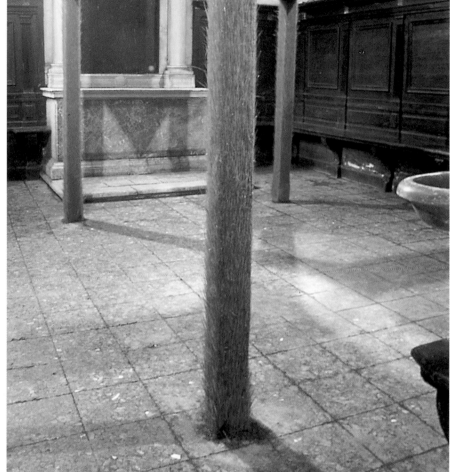

"We imagine the city as an organism constantly changing and transforming itself. Venice itself is a reminder, an instrument of meditation on the beauty of decay and the relentless passage of time. We are told that it is literally being submerged by the sea. Disappearing from view it becomes a symbol of introversion. It is no longer the materially powerful hub of an expanding empire yet it has colonized the western imagination and draws from us a complexity of responses to its perceived plight. We propose a series of sculptures which vigorously express the often contradictory and destabilizing forces at work on and within the seemingly static and solid." *Pierre d'Avoine, Heather Ackroyd and Daniel Harvey, 1996*

BANKSIDE BRIDGE, LONDON
Dan Graham and Mark Pimlott, with Jane Wernick, Ove Arup and Partners

A speculative proposal

DAN GRAHAM
b. Urbana, Illinois, 1942.
Lives and works in New York
MARK PIMLOTT
b. Montreal, Canada 1958.
Lives and works in London
JANE WERNICK
b. London 1954. Lives and
works in London

"Public Art Commissions Agency is about to launch a new project which seeks to question the current client-led status of much public art by inviting a number of speculative proposals by artists for specified or artist-selected sites. The locations that we are focussing on concern points of intersection – road, rail, air, river, canal, footpath, cyclepath, meridian – in three or four cities including London and Birmingham.

"I am writing to enquire whether you would accept an invitation from PACA to submit a proposal for the planned new pedestrian bridge across the Thames, linking Blackfriars and Bankside (the site of the new Tate Gallery of Modern Art).

"The idea of a new footbridge on this site has been mooted for at least the past two or three years. It is likely that an architectural competition will be launched at some point soon, backed by *The Financial Times*. There are a number of key stakeholders in the project, as you can imagine, the principal protagonists being the City and the Corporation of London (North Bank) and Southwark Council (South Bank) as well as the Tate Gallery. St Paul's Cathedral dominates the axis looking north, with Bankside – redundant cathedral to power? – to the south. The 'spring' points for such a bridge have been researched and various options put forward that would not obscure desirable sight-lines (to St Paul's).

"Our aim in inviting you is fourfold: first, to invite an artist of the highest calibre to propose a viable scheme that would receive maximum publicity; secondly, to raise awareness of the scope of artist-designed infrastructure schemes; thirdly, to showcase the potential for collaborations between design professionals, where an artist might lead rather than just being a member of a design team; and fourthly, to lobby for the scheme to be implemented."
Letter from PACA to Dan Graham

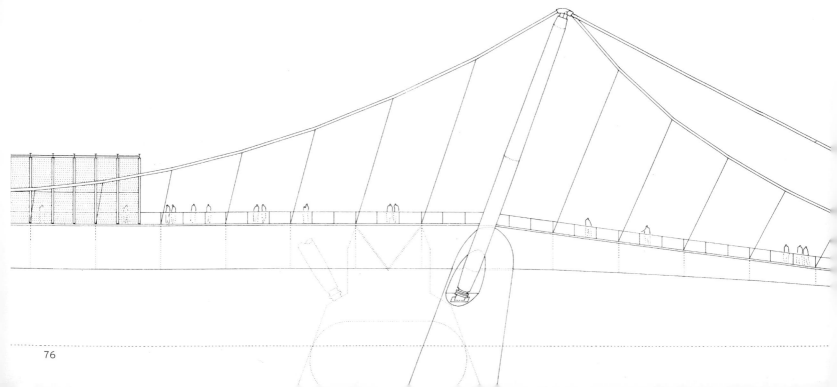

Dan Graham elected to collaborate with artist–architect Mark Pimlott and Ove Arup engineer Jane Wernick. Their subsequent collaborative proposal was entered anonymously under the rules of *The Financial Times* competition for a bridge for the site and appeared in the list of commended entries, but was not finally shortlisted. The competition was won by Sir Norman Foster with Chris Wise of Ove Arup and Sir Anthony Caro.

"We have designed a footbridge on the axis of St Paul's Cathedral and the Tate Gallery of Modern Art at Bankside that is a place of social interaction and pleasure. It is grand and evocative of many things, among them the seaside boardwalk, the broad footbridges of continental Europe, the Baroque interior, the office building and the fun palace. The bridge is intended for the use of everyone. Its breadth makes it a place rather than a simple conduit from one side of the river to the other.

"There is a pavilion in the centre of the span of the bridge. It is a precise volume, an enclosure of two-way mirror glass where people can view the sky, the river and the city; and themselves (looking out and looking at themselves). The bridge is devised to hold the pavilion over the river. Consequently, the structure is simple and minimal: a suspension structure carrying a formed torsion beam on which the pavilion rests. The bridge's pylons are splayed, exaggerating the appearance of the pavilion cradled in a web of fine cables.

"From the bridge, people would be able to see a clear relationship between two important monumental public buildings, St Paul's and the Tate Gallery of Modern Art. By relating them on an axis which can only be appreciated from an elevated position, it might be possible to consider the bridge to be a piece in a fantasy of civic monumentality in London which has rarely been fulfilled. This expectation certainly follows the Thames. So many people would prefer it to be like the Seine or the Tevere or the Vlatva; with bridges like the Pont des Arts or the Karluv Most.

"The Thames is different. It changes constantly over the course of the day because of the tide, and so its character changes. The temperamental English sky is the perfect partner to the big river. The river is one of the few places in London where the sky can be truly seen. It is dramatic, constantly in flux. The bridge and the pavilion are designed to take advantage of this, providing situations where people are fully exposed to the river and the sky, and where people are more conscious of the relationships between themselves, nature and the city. The effects of light in the pavilion are related to the effects of skyscape and natural light in the paintings of Constable and Turner."
Dan Graham, Mark Pimlott, Jane Wernick

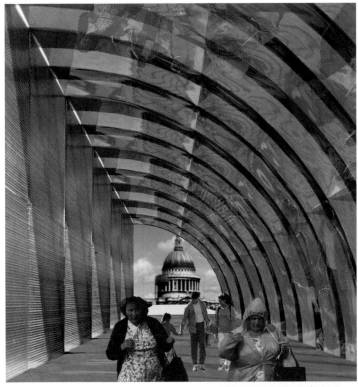

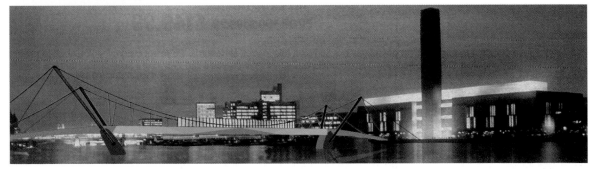

BIRMINGHAM TOWN HALL
Lise Autogena (lead artist)

CLIENT
Birmingham City Council

LISE AUTOGENA
b. Aarhus, Denmark 1964. Lives
and works in London

Birmingham City Council's plan for the development of Birmingham Town Hall into a leading arts venue emphasized from the outset the role of artists in ensuring an effective and distinctive result. The steering group for the project, comprising representatives of council departments and PACA, determined that a lead artist should be appointed, to work closely with the client, the architectural design team and PACA, to establish an innovative and coherent artistic vision for the building in keeping with the client's aspirations. This encompassed the presence of the building in its urban context and the visitor's experience of the Hall. The appointed artist was to propose an intervention that would contribute to the spectacle of the building, in day- and night-time use, inside and out, as well as formulating, with PACA, proposals for commissions by other artists and craftspeople to be implemented within the building process and as part of an ongoing programme. From a shortlist which also included Edward Allington, David Cheeseman, Anna Heinrich and Leon Palmer, Lise Autogena was selected as the lead artist. Implementation of the project, subject to Arts Council Lottery Funding.

Designed by Welch and Hansom, completed in 1834, and inspired by the Roman Temple of Castor and Pollux, the Town Hall is located on the edge of Victoria Square, near Gormley's *Iron:Man*.

"Birmingham Town Hall is an exceptional building, a monument and a celebration of the life and the history of the City of Birmingham. Like a sleeping giant its presence is felt upon the City squares, but sadly now in danger of entering a state of isolation. It is therefore necessary to create a renewed dialogue between the Town Hall and the City of Birmingham, between the old and new, the inside and outside. The artistic programme focusses on the interaction of interior and exterior spaces, on the experience of physical and historical 'layers' of the building. It uses the idea of archeological excavation – the opening up of spaces and cutting through layers to reveal the presence of the building, embracing areas of historical significance, and giving them new life. Characteristic elements from the exterior of the building will be recreated within the interior, and the listed ornamental interior will be embraced by simple and minimal spaces that will open up visually towards the life of the square.

"Lighting will be a main feature, linking spaces and passageways and heightening the experience of moving through the building. It will reveal the life inside the building. Light will create possibilities for transforming and interacting spaces, thereby extending the use and flexibility of the entire building as a performance space.

"The artistic programme aims to reawaken the past of Birmingham Town Hall; it seeks to research and unveil the lives of the Hall's processes, memories and the more subconscious presence and meaning of this remarkable building within the urban context."
Lise Autogena

Lise Autogena's own proposals comprise design interventions developed in collaboration with the client and design team and a major glass commission to be integrated into the fabric of the building.

"Light will be designed to enhance and to bring attention to the sculptural shapes, structures and characteristics present within the building.

"Lighting will be able to change and transform spaces – creating the possibility of interacting and linking spaces like side galleries and foyer areas together with the main performance spaces. It will therefore be possible to extend the use of the Town Hall, to extend performance areas, to invent alternative uses and to involve and to play with all areas of the building. Inside, outside, upstairs and downstairs will have the possibility of fusing activities – perhaps extending out into the town square."
Lise Autogena

FOUR OAKS STATION, BIRMINGHAM
Eilís O'Connell with Tom de Paor

A speculative proposal

CLIENT
Centro

EILÍS O'CONNELL
b. Derry, Northern Ireland 1953.
Lives and works in London
TOM DE PAOR
b. 1967 London.
De Paor Architects established
Dublin 1993

At the end of a series of commissions organized by PACA for Centro, the West Midlands Passenger Transport Executive, PACA commissioned a speculative proposal, this time for the railway station at Four Oaks. Earlier commissions had included a visionary 'Design Guide' for Midland Metro by Jack Mackie, Alice Adams and Andrew Darke, and infrastructural works by a number of artists including Darke and Anurhada Patel. Eilís O'Connell selected her own collaborator for the proposal.

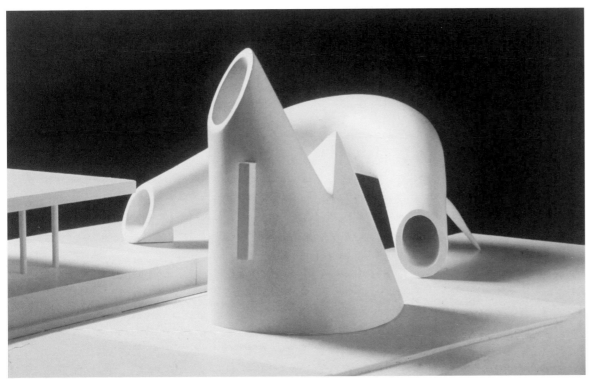

above: Maquette for Four Oaks right: Still from proposal video

The artist and architect team proposed to extend the existing timber-clad booking-hall canopy by four replica bays with new seating to provide shelter for passengers; replace the existing open bridge with an enclosed steel construction; and to erect a steel pavilion to act as a gateway to provide additional seating. They planned to install additional planting and refer to the existing features of the site: the existing road bridge, elevated mature trees on both sides of the tracks and the tower of the Methodist church.

"In accordance with ancient Roman tradition, the gateway pavilion is orientated on the cardinal points. It has two faces. Clad in steel plate on an exposed steel frame on concrete foundations, a 'light box' acknowledges the church tower while a 'wing' opens to the platform, catching the south light and providing sheltered seating. A disk of blue glass at the apex illuminates the interior by day and becomes a light marker by night.

"The form of the bridge responds to the dynamic of the pavilion. The shortest crossing of the tracks is provided, maintaining the position and clearances of the existing structure. Becoming broader at the apex to form a viewing platform, a strip window

opens along the northern face, while to the south an aperture provides oblique views. The inverse of the pavilion – the ribbed steel structure is exposed, with the steel-plate cladding to the interior. The platform, landings and folded metal steps are supported on one main beam, in turn supported by two angled steel members, all on concrete foundations. All steelwork to be paint finished."
Eilís O'Connell and Tom de Paor

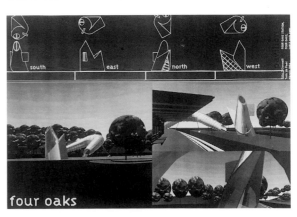

CLIENT
Land Securities plc
ARCHITECTS
Feary and Heron

PATRICK HERON, CBE
b. London 1920. Lives and
works in Cornwall
JULIAN FEARY
b. Christchurch, New Zealand
1948. Lives and works in London

STAG PLACE, VICTORIA, LONDON
Patrick Heron with Julian Feary
Wind Screen

Stag Place: a desolate, windswept, privately owned square, under-used because of the hostile environmental conditions. As part of a pedestrianizing, landscaping scheme by RHWL to bring the square to life and make it conducive to public use, particularly by residents and office workers from the surrounding buildings, artists were invited to propose structures for the pedestrian entrance to the square with the principal function of controlling and reducing the prevailing wind. The shortlist included proposals by Tim Head, Miles Davies and Julian Opie.

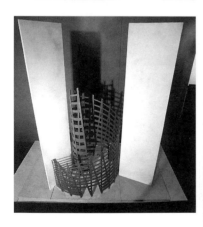

"It has been found by previous experience that a solid barrier only serves to redirect and accelerate the wind problems elsewhere; but a porous barrier will successfully filter the wind, reducing its energy and velocity. The distance over which any barrier is effective is greatly increased by making it about 50% porous. The distance before the strong winds from above the barrier again reach ground level is increased by the leakage of air through the barrier.

"The sculpture will be a highly visible feature in the streetscape and the competition is intended to identify artistic designs which will best satisfy both the wind factor and aesthetic considerations. An Oxford University report indicates that the sculpture need be no taller than twenty metres at its central point and can be reduced in density above ten metres. The average aerodynamic porosity should be between 45 and 55%" *Brief to artists*

"The detailed technical requirements set out in the brief generate the form of our proposal. These requirements must be understood and met if the artistic integrity of the whole is not to be compromised. We propose a great screen, designed to visually fill the gap between the buildings, supported by

structural elements calculated to take substantial wind loads. The design seeks to avoid an inherent contradiction – the need for a screen to baffle the wind while providing a clear opening to encourage entrance into the square.

"The brilliant colours of the gate will be a spectacular landmark attraction visible from a distance. Close to the entrance, paving indicates the route into the square. The screen is made up of two parts – an elegant mast structure as a support, supporting layers of perforated metal laid across each other as if drawn by 6B pencil, pen or brush, woven with warp and weft, pile or grain dividing the screen in the composition of a painting. Attached and supported on the screen are the elements of the painting itself, described by colour-coated metal elements, the large flat areas pierced as needed to reduce wind forces. The colour and composition read from both sides, and from all angles. The sense of space created within and around the work is intended to be both real and illusory. The colour is bright and varied, as recognizably by Patrick Heron as the graphic arrangement the forms take." *Patrick Heron with Julian Feary, 1996*

Proposals by:
top left: Julian Opie
centre left: Tim Head
bottom left: Miles Davies
opposite page: Manipulated image of Stag Place with *Wind Screen*

SEVEN DIALS PIAZZETTA
John Newling; Shelagh Wakely
Covent Garden, London

CLIENT
Covent Garden Estates Ltd
ARCHITECTS
Eric Parry Associates

SHELAGH WAKELY
b. London. Lives and works
in London
JOHN NEWLING
b. Handsworth, Birmingham 1952.
Lives and works in Nottingham

Seven Dials Warehouse lies at the confluence of three major streets (including Neal Street and Shelton Street) where a public space has evolved. This space is part of the new heart of Covent Garden which in recent years has been extending, if not shifting, from the Piazza at its heart. 110,000 people walk down Neal Street each week and disperse at the pedestrian crossing of Shelton Street, where they are confronted by an area lacking in clarity. With the proposal for a new underground station entrance on Neal Street in the future, the passage of people is likely to increase.

Covent Garden Estates, owners of the old Smith's Gallery building, recognizing the opportunity presented by the site, invited PACA to manage a new commission that might address some of the difficulties of this key pedestrian area. PACA, with the architect, Eric Parry, Covent Garden Community Association and the client, developed a brief that aimed "to develop the square's present accidental character to one that is more worthy of its location by contributing to the immediate space and enhancing the relationship between Covent Garden Piazza and Seven Dials Column". Shortlisted artists included Tim Head, Anish Kapoor, John Newling and Shelagh Wakely. Eventually the panel favoured Shelagh Wakely's proposal.

opposite: *Rainsquare* at
South London Gallery, 1994

JOHN NEWLING
MEMORIALIZING A MOMENT, 1997 (unrealised)

John Newling's proposal captured the commercial vitality of this busy shopping hub in its plans to commemorate either the family grocery list or an inventory of items bought in an afternoon in the area.

"I plan to generate a shopping receipt at a supermarket in Seven Dials. The receipt will be a reproduction of the staple needs of my family over one specific month, probably January 1997. The receipt is important because it does not simply list the products and their price but it also contains something of the history of the event in that it gives the time and date of the transaction, the method of payment and the name of the person on the till and the manager on duty. It freezes the very moment of transaction. The receipt will be made permanent through the familiar language of the memorial: the list will be engraved on polished granite thirty-two feet high and six feet wide and mounted on the wall of the warehouse; the characters on the receipt will be two inches high and picked out in gold. The work is very much about the loss of that one moment amongst the flux of similar moments.

" The second piece is located on the floor of the square: a Blank of the same dimensions as the wall-mounted receipt and made of machine-cut granite will be laid flush into a blue surface. The blue concrete slabs will extend to the edge of the kerb and a few yards along the streets that flank the warehouse. The Blank will have the appearance of floating on the deepest blue sea in front of the prow of the warehouse. The Blank holds within itself all the possibilities for future transactions; it points to the essentials of exchange and interrogates the parameters of needs in the future."
John Newling

SHELAGH WAKELY
RAINSQUARE, 1997-98

"Inset in the paved pedestrian area is a large square made up of sixteen squares of glass set out in a checkerboard pattern. Each of these glasses has a silvery organic patterning under its surface. The silvery patterning changes over the area of each glass and varies over the whole area. It glitters in the night lamplight or the daytime sun, reflecting the blue or grey of the sky and the overhanging trees.

"*Rainsquare* is made on site. Squares of glass are laid out having been previously leafed with aluminium leaf (very thin, like gold leaf). Rain falls on these silvery squares, the force of the drops breaking up the leaf into an organic pattern. When all the leaf is broken up, the original structure of the leafing disappearing, a second glass is placed over the patterning to preserve it. In Covent Garden the glass sandwiches are paved into the area flush with the stone paving, cut to fit alternating squares. This forms a large checkerboard, which is fitted with the normal paving. The first *Rainsquare*, a short-life work, was made in September 1994 at South London Gallery, it was a very successful and beautiful work *Rainsquare* has a sort of magic feeling about it but at the same time its cause is an everyday event, the rain." *Shelagh Wakely*

PIERHEAD, LIVERPOOL
Vito Acconci; Douglas Hollis and Anna Valentina Murch

CLIENT
Merseyside Development
Corporation

VITO ACCONCI
b. Bronx, New York 1940. Lives and
works in New York
DOUGLAS HOLLIS
b. Ann Arbor, Michigan 1948. Lives
and works in San Francisco
ANNA VALENTINA MURCH
b. Dunbarton, Scotland 1948. Lives
and works in San Francisco

"Public Art Commissions Agency has been commissioned by Merseyside Development Corporation to organize a commission adjacent to the Pierhead in Liverpool. The final site can be negotiated with the selected artist but there is a very exciting opportunity to use the natural phenomena around the banks of the Mersey, *i.e.* water, the great tidal range, the strong Atlantic winds.

"The prestigious project offers scope for a kinetic piece and there is a keen interest from the client in using water and possibly light. There is also scope for collaboration with engineers, environmentalists, architects and landscape architects. Liverpool has an interesting trading and cultural history and the city's most recognizable symbols, the Royal Liver building, the Cunard building and the Mersey Docks and Harbour Board building overlook the river at this point." *Brief to artists*

Vito Acconci was selected from a shortlist including Richard Wilson, Jaume Plensa and Janet Hodgson. Cost analysis at design development stage showed Acconci's proposal would exceed the budget; Hollis and Murch's proposal was subsequently agreed in principle. In autumn 1997 the Isle of Man Ferry made a successful bid to relocate its passenger terminal to Pierhead, thus negating the possibility of Hollis and Murch's scheme being implemented. A public art trail along Liverpool's waterfront is under discussion.

VITO ACCONCI
HIGH TIDE (unrealised)

"A machine for walking and sitting: floating bridges that rise and fall with the tide. Between each pair of lightposts, a section of wall – the width of the existent bridge – is detached and collapsed on to the ground. The fallen wall, embedded partly in the ground, functions now as a ramp: it leads up on to the stone curb, and on to each floating bridge.

"The floating bridge goes from the end of the cut to one side of the cut; or from one side of the cut to the other, in a straight line or at a diagonal; or from one side off to nowhere (the last bridge goes out over the river and doesn't come back).

"Each bridge is made of grating, a transparent pathway through the air. Down its length, each bridge is made half of steps and half of benches. In the middle of the bridge is a tree: the tree rises and falls, the steps and benches step up and down with the tide.

"Beneath the tree, and supporting the bridge, a round hollow column slides up and down over a cylinder that functions as its track. The cylindrical track is fixed to the ground at the bottom of the water. At the end of the sliding column is a flotation device.

"The tide raises and lowers the float which pushes the column up and pulls the column down, raising and lowering the bridge one step (and one bench) at a time. As the tide rises, the steps and benches step up from each end; as the tide falls, the steps and benches step down from the middle. The risers slide up and down tracks that function also as posts for a cable railing, its length adjusted by pulleys and counterweights.

"At low tide, you step down into the cut, and up again on the other side. You sit on a bench, facing the tree below you, away from the city. You're in a park, separated from the city.

"At mid tide, the steps and benches become a level passage. You walk across the cut, from one side to the other.

"At high tide, you step up above the cut, and down again to the other side. When you sit on a bench, you face the city. You're on a look-out now, watching over the city.

"On the last bridge, the bridge to nowhere, you step out, or up, or down, over the river. The bridge ends in the platform that holds the tree: you gaze out into the river, on to the distance." *Vito Acconci*

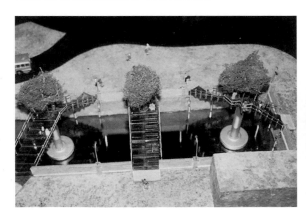

DOUGLAS HOLLIS AND ANNA VALENTINA MURCH
BEACONS AND BORDERS OF LIGHT AND SOUND
(unrealised)

"The approach we have taken in our proposal was guided in part by a strong message from the brief of looking towards the future, and the concept is one that seeks to illuminate this place in a new and engaging way. It deals primarily with the physical and experiential phenomena of the site; the wind, water, and weather through an array of beacons and borders of sound and light. It is, in a poetic sense, a recognition of the elements that had so much to do with why the city is where it is, and why it came to be the great city that it is; but also it has to do with these elements of nature, once harnessed to the service of commerce, that can now play an active role in what this place is becoming: an attraction, a point of entry, and a contemplative oasis along the riverside for visitors, commuters and residents alike.

"We think that the history of the cut and floating road that was once supported by it could be subtly remembered at the site, but is otherwise described well at the Museum. Our intention is to celebrate this place as an observatory of the ebbing and flowing river and, by outlining it with light, to lead the eye to the landmark steeple of St Nicholas's Church. Likewise, the matrix of illuminated wind-organ masts is shaped like a pointer towards the church and the city beyond. This field of elements also takes on an ongoing conversation, a choreography, with the river of wind flowing through the site, moving to aim into the stream, allowing the organs to form a harmonic choir of tones, constantly changing as the wind rises and falls. In the evenings, or on foggy days, the lights pointing up and down inside the perforated metal tailpieces will form moving columns of light. There are also four uplights in the paving through which the organ pipes will pass,

making them seem to appear and fade.

"The border surrounding the cut is also made of two layers of perforated stainless-steel sheet metal, lit internally at the base by a continuous row of fluorescent fixtures. Because of the two screens, a moiré pattern is created which gives the effect of a hedge of energy, lighting the active surface of the water below. Both the existing bridge and a second similar bridge would also have this light fence element incorporated into them. Because these fixtures have the capacity to be dimmed, we thought we could incorporate a tidal sensor that would raise the light level at low tide, and lower it somewhat at high tide.

"The work we are proposing is both simple and complex; not an object or artefact, but a field of experience, an armature or stage on which the theatre of natural forces and human interplay can occur. A place to which people will be drawn; a place where, on their way to or from work, people can have a moment of reflection and celebration about the changing nature of the place where they live."
Douglas Hollis and Anna Valentina Murch

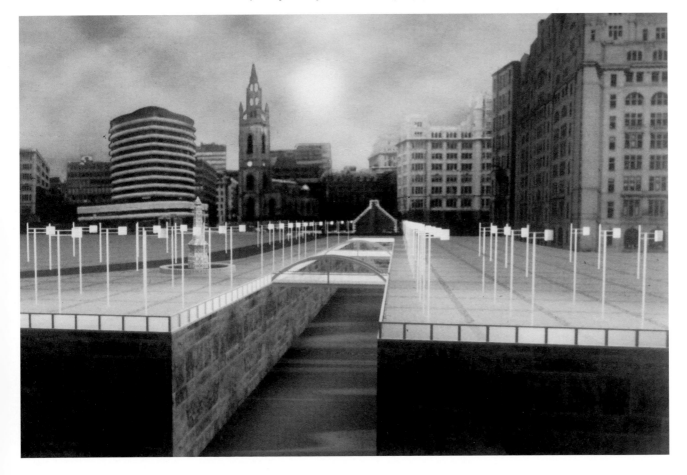

CLIENT
St John's College, Oxford
ARCHITECTS
MacCormac Jamieson Prichard

ALEXANDER BELESCHENKO
b. Corby, Northamptonshire 1951.
Lives and works in Swansea
BRIAN CATLING
b. London 1948. Lives and works
in Oxford
SIMON LEWTY
b. Sutton Coldfield, Warwickshire
1941. Lives and works in
Leamington Spa
WENDY RAMSHAW, OBE
b. Sunderland 1939. Lives and
works in London

THE GARDEN QUADRANGLE, ST JOHN'S COLLEGE, OXFORD

Alexander Beleschenko; Brian Catling; Simon Lewty; Wendy Ramshaw

"The new building will face the Fellows' Garden and form the final northern edge of the College. It will consist of two publicly accessible levels, which might be called an overworld and an underworld. The overworld will be a formal garden, level with the top of the medieval wall, a raised extension of the Fellows' Garden itself surrounded on three sides by students' rooms. The 'underworld' will consist of three major spaces, an 'atrium' at the centre, open to the sky, giving access to an auditorium and meeting-room on each side. The floor level of these spaces is below the level of the Fellows' Garden, giving them a cave-like or crypt-like quality, and it is these spaces and those around them that will be the setting for artists' work.

"It is difficult to be precise about the atmosphere of the building before its realisation. Our intention is that there should be a sense of discovery about these spaces. They will be off the beaten track, glimpsed from the cloister which connects the College to Parks Road, or revealed on entry through the gate from the Fellows' Garden. Seen through the glazed screen from the central space, the two large rooms will appear dark and mysterious, top-lit through cupolas and hollow keystones. Walls will be finished in darkly coloured waxed plaster – deep-green and deep-red in the meeting-room and auditorium respectively. The structure of the building will be white concrete, treated in various contrasted ways – 'grit-blasted' column bases, like slightly weathered stone, polished clusters of columns, polished arches, and pendentives hammered to crystalline flinty whiteness, the piers in the corners of the rooms deeply point-tooled to realise a craggy, rocky quality."

Richard MacCormac, MacCormac Jamieson Prichard

The architect's brief to artists for the commission of gates, railings, sculpture, acoustic panels, glass screens and chandeliers offers an extraordinary vision of the development at St John's College, Oxford, and sets the tone for the works that were to emerge from the project.

Designs were commissioned from the artists listed, as well as from James Horrobin (gates), Peter Randall-Page and Antony Gormley (sculpture), Elizabeth Ogilvie and Jane MacDonald (glass). The proposals of Wendy Ramshaw and Alexander Beleschenko were realised, and the printmaker John Howard was invited to record the process of the building's construction.

Alexander Beleschenko
top: Detail of chandelier
above: Glass screen
right: Fabrication of glass screen

ALEXANDER BELESCHENKO
GLASS SCREENS, 1992–93

"My response to designing for the glass has been to keep with the analogy of an underground world by basing the work on the theme of subterranean elements of rocks and water. It has not been my intention to depict these elements in a literal way but to suggest them whilst making patterns. This patterning owes some of its inspiration to Frank Lloyd Wright's work, although I have strictly avoided making any type of imitation.

"The suggestion of water running down over a surface is to be seen predominating in the screens that face into the atrium, whereas the hewn pieces of glass regimented into grid-like patterns predominate in the fully interior screens. There is a mix of both these qualities in the outer screen that faces the onlooker who enters the building via the garden entrance.

"The work of making the glass screens amounted to approximately seventeen thousand hours, undertaken by twelve people, over a period of a little under a year.

"The artwork of the five screens occupies thirty panels with a total area of 663 square feet. Encased within each panel several hundred pieces of loose laid glass are held in place by the two outer layers of safety glass. Each panel is one inch thick and weighs either 88 kilos or 186 kilos, bringing the total weight of all to a little over three and a half tons.

"A glass 10 mm thick and without any trace of colour was chosen for the desired qualities of transparency and sparkle in the screens. This glass was cut into the required shapes and to precise sizes. Although approximately twenty thousand pieces were needed to make up the screens, double the amount was cut in order that a selection could be made to secure the most accurate sizes with the cleanest break out of the edges. To each of these pieces of 10-mm-thick crystal-clear glass, two slithers of thinner clear or coloured glass were bonded. Thus the work is actually made up of some sixty thousand pieces of glass.

"All the pieces of glass were worked in some way. Most pieces were grooved either on their edges or front face, or both, with diamond-saw cuts, thus enabling the controlled chipping of the glass.

"Because of the techniques employed in the working of the glass, nearly all the machines and tools had to be specially made. The work required a lot of planning, with comprehensive information at hand on a database to sort through the batches of glass at the various stages: cutting, gluing, sawing, chipping through; laying out and cleaning.

"What is achieved by this working is a play of transparent and opaque qualities that modulate the light for the interiors. In some areas a web of light is trapped in the sparkle of the edge details, whereas other areas hold the glow of a white light in the sawn details. This play of light trapped in the matrix of the glass is seen as the underlying principle in the approach used in the glass working. This tapping of light is very important as the work will always be legible in either natural or artificial illumination, seen against either a light or dark background. The screens do carry a lot of colour which is mostly half hidden, depending on the position of the viewer. This colour is mostly cool and of the grey and green group. Ultimately I wish the work to inspire positive feeling in the onlooker, as well as the idea of shelter."

Alexander Beleschenko

WENDY RAMSHAW
GARDEN GATE, 1992–93

"For thirty years I have worked on small objects, using a multitude of techniques and materials. I had never considered working 'large', because all of my work has been site specific, the site being the human body.

"Vivien Lovell, from PACA, approached me to see if I would work on a large scale and design a gate for the new St John's building in Oxford – a site-specific piece. I was delighted to undertake the making of a maquette. Naturally, I approached the work in exactly the same way as I had my jewellery, concerning myself with the ebb and flow of space, the rhythm of patterns, and a central point from which the eye might move and to which the eye might return and rest.

"I experienced my maquette reproduced in exact detail at large scale through the skill of the master craftsman at the studios of Richard Quinnell. It was exciting. As I saw the work under construction, ideas on how to re-combine the shapes and spaces and possible ways of detailing other works entered my imagination, although the finished St John's gate remained true to the original maquette.

"I have subsequently worked on a number of large-scale projects, each one presenting a different kind of space and fulfilling a different need, all much in the same way that each client for a piece of jewellery brings a different stature, personality and requirement, so presenting a different inspiration to the maker.

"Working on the large scale, I continue to be interested in the combination of different materials, as in my jewellery, mainly using metal as the main frame.

"I think of the St John's gate as having opened a door into Alice's garden, where I find myself ready to undertake the journey into new territory."
Wendy Ramshaw

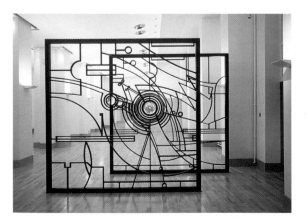

left: A subsequent commission: screens for the Victoria and Albert Museum, London, 1996–97

SIMON LEWTY
LOST WAYS, 1992 (unrealised)
PROPOSAL FOR A NARRATIVE TRAIL

Simon Lewty made two proposals. One was for a trail of up to ten niches to be set in the walls of the new building at scattered locations designated in the architect's plans. Each niche would be sealed by plate glass and contain material identified and arranged by the artist: drawings, maps, palimpsests and other objects which would create the sense of a reliquary, as well as linking into a wider narrative related by the series as a whole. The second, called *Lost Ways*, proposed to inscribe selected sites in the building with signs from past practices of way-marking, creating a sequence of arrivals and departures for the eye with symbols charged with hidden meaning.

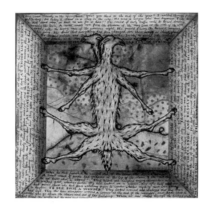

BRIAN CATLING
PROPOSAL FOR A NARRATIVE TRAIL, 1992 (unrealised)

Brian Catling proposed a poetic text for a narrative trail, its mood influenced by items in the College's collection.

"Each chapter will consist of a layered image of a book form, or rather the evolution of a book form, something obscured by folds of transparent material. They will be executed in glass and acrylic. Etched, mirrored and sandblasted surfaces will articulate levels of transparency, luminosity and opacity. Detail and tone will also be added by this process.

"Each chapter will contain a fragment of Portal stone (the stones removed from the ancient wall of the Fellows' Garden to make the entrance to the new building). These shards will appear mostly as shadows inside the light-filtering glass pages, they will be echo batteries or memory to the chapter. They will also structure a symbolic crossing of the old into the new."
Brian Catling

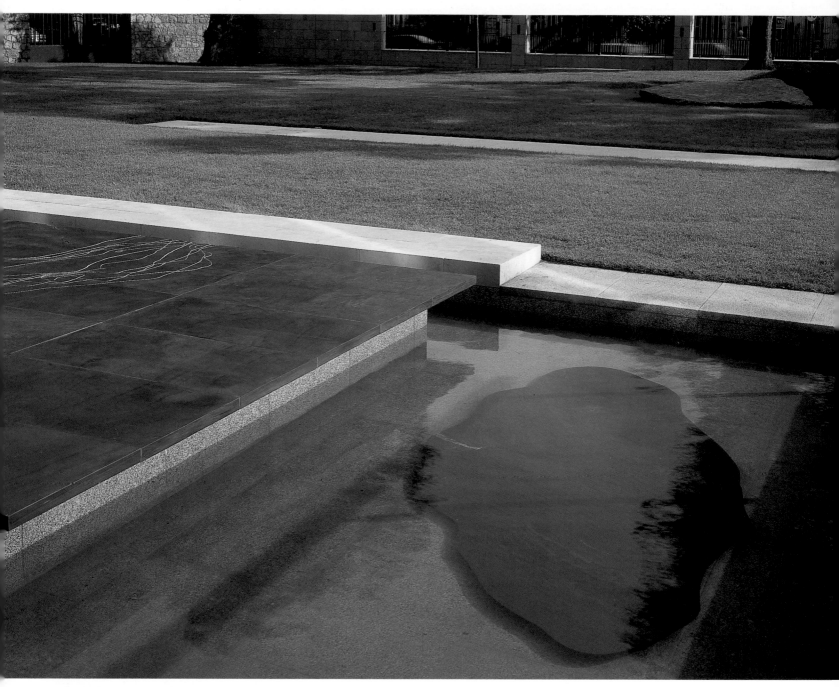

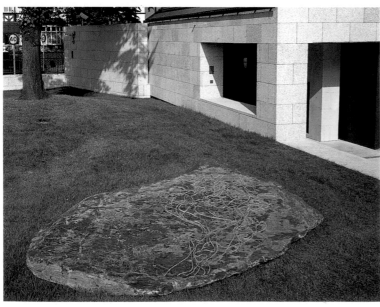

BRITISH EMBASSY, DUBLIN
Brian Catling; Susanna Heron; Susan Kinley; Peter Randall-Page

CLIENT
Overseas Estate Department,
Foreign and Commonwealth Office
ARCHITECTS
Allies & Morrison, London

BRIAN CATLING
b. London 1948. Lives and
works in Oxford
SUSANNA HERON
b. Welwyn Garden City 1949. Grew
up in Cornwall. Lives and works in
London
SUSAN KINLEY
b. Barnet, Hertfordshire 1956.
Lives and works in Penryn,
Cornwall
PETER RANDALL-PAGE
b. Rochford, Essex 1954. Lives
and works in Crockernwell,
Exeter, Devon

In 1994 the Overseas Estate Department invited PACA to organize commissions for the new British Embassy in Dublin. Working closely with the Government Art Collection, the client and the architect, Allies & Morrison, shortlists of artists were researched prior to decisions being reached by the client group chaired by HM Ambassador.

Window, by Brian Catling, was commissioned for the Government Art Collection, which also owns Catling's and Heron's maquettes. The sculpture *Secret Life II* by Peter Randall-Page was specially selected for the site by PACA from a body of work made in 1994, and was purchased for the Government Art Collection.

overleaf: *Island*
after the rain

SUSANNA HERON
ISLAND
"In the grassy area to the right of the path on leaving the lodge, a large rock surfaces in the ground. The main bulk of the boulder is buried, enabling a relatively flat surface to emerge obliquely from the ground and slope towards the south. It is a rough, unhewn stone, appropriate to this quiet natural area away from the building. Its uneven surface is crudely carved with a linear tracery.

"Next you start to see the reflecting levels of the moat and its island in front of the building. When it rains the rectangular island, made of slate, becomes a highly reflective plane appearing to hover over the water, the sharp channels engraved into its surface direct the passage of rainwater and change in visibility as they dry. As you approach, a carving in the slate shifts and appears to lengthen, while closer still you see an underwater, elongated ellipse, deeply black and smooth on the pale granite floor of the moat. Here it enables you to perceive reflections and acts as a black mirror when viewed from the bridge above. In this way there are light-reflecting surfaces both above and below the level of water.

"The ellipse is an echo of the unhewn rock. The tracery in the boulder appears like a spring of water flowing invisibly underground to re-emerge in the surface of the island. This is a cumulative work to be viewed in passing to and from the building at different times of day and from the adjacent office windows. It is a work suggestive of a quiet presence in Ireland appropriate to the fragile hope of peace at this time in history and for the future." *Susanna Heron, 1994*

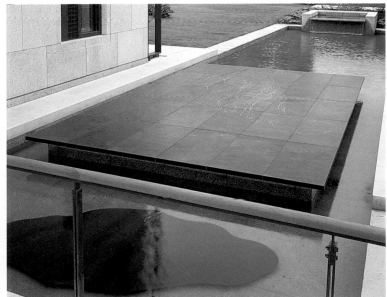

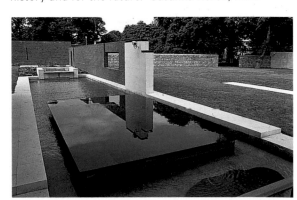

BRIAN CATLING
WINDOW

"The proposed sculpture works in direct contrast to the solid and security-conscious nature of the Embassy and past recent history. In a time of shifting political perspectives, the optimistic view of greater cultural exchange with our nearest neighbours looms large.

"The apparent fragility of the materials used and their enigmatic relationship emphasizes a fluid and layered complexity of form and light.

"The most fundamental and solid part of the work is a small stone that sits at the core of the work. It will be collected from the Burren, one of the major heartlands of the Irish Republic. It is geographically unique and mythically prime. At the beginning of this century, Dubliners travelled to visit it to substantiate their roots; a touchstone to place.

"The sculpture is a compacted, conceptualized window, delicate, formally firm but transmutable by reflection. Its emotional temperature is calm and stable; materials leaning towards invisibility.

"The theme of window and shutter are articulated in this visual poetic. The single solid stone from the Burren sits embedded in a slender glass and perspex shelf that bisects the rectangle in traditional landscape language. The stone's form is echoed elsewhere in the sculpture: either as iridescent profile sunken into the plaster of the recess, or etched into the screens; or cast in glass and embedded in the shelf; a transparent twin."
Brian Catling, January 1995

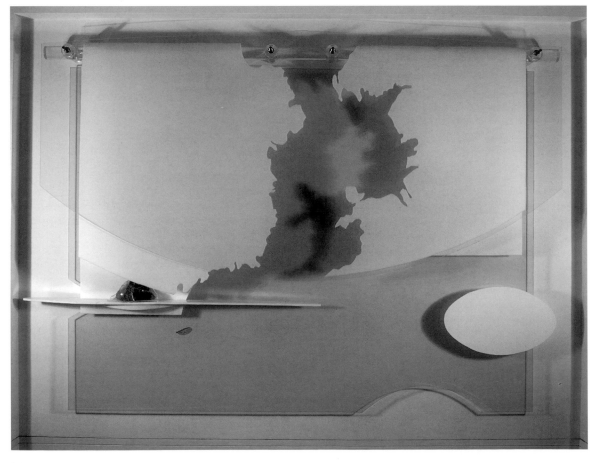

PETER RANDALL-PAGE
SECRET LIFE II

The sculpture is sited on the grass in the north-east corner of the interior courtyard: a pink granite boulder, split into two equal halves, its interior surfaces have been carved with organic forms and polished.

SUSAN KINLEY
CADENCE

Within the interior circulation area of the Embassy, in a double-height space, Susan Kinley's silk-textile artwork comprises six individual overlapping hangings, each comprising two or three layers of hand-painted organza. Movement and light create variations within the colours, predominantly greens, blues and russet reds, further enhanced by the moiré patterns achieved where the hangings overlap. The colours echo and intensify those in the courtyard, of grass, brick and sky.

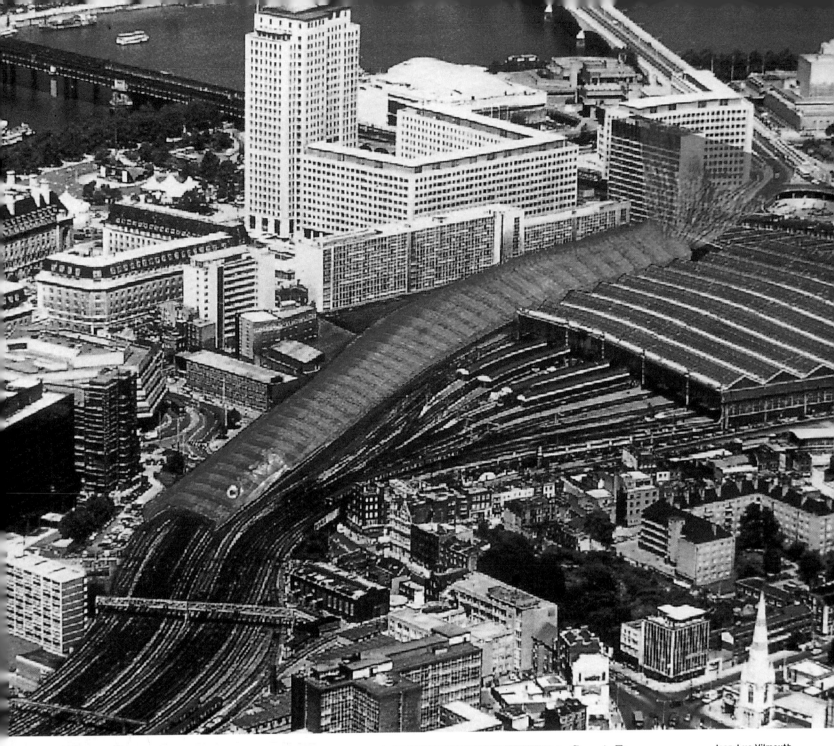

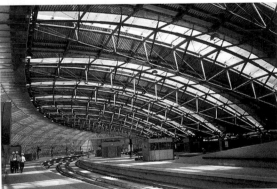

Jean-Luc Vilmouth
Channel Fish
left and above: stills
from proposal video
far left: Waterloo
International Terminal

WATERLOO INTERNATIONAL TERMINAL
Jean-Luc Vilmouth; Ron Haselden; Simon Patterson

CLIENT
European Passenger Services
ARCHITECTS
Nicholas Grimshaw and Partners

JEAN-LUC VILMOUTH
b. Creutzwald, France 1952. Lives
and works in Paris
RON HASELDEN
b. Gravesend, Kent 1944. Lives
and works in London and Plouer-
sur-Rance, France
SIMON PATTERSON
b. England 1967. Lives and works in
London

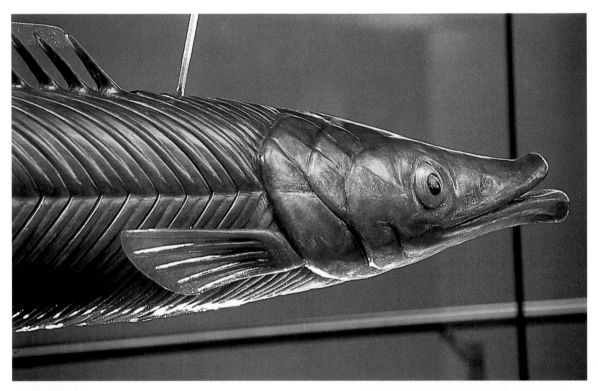

left: Fabrication
bottom left: Still
from proposal video

In October 1992, as Waterloo International Terminal neared completion, European Passenger Services invited PACA to organize an art commission for the building. As the first direct rail link between the capital of Britain and mainland Europe, the terminal provided a highly significant site; and the international calibre of Grimshaw's building, one of London's first grand projects, would offer superb opportunities for artists.

A selection panel considered the work of over eighty European artists, seven of whom where invited to visit the site: Angela Bulloch, Peter Greenaway, Ron Haselden, Maurizio Nannucci, Martine Neddam, Simon Patterson and Jean-Luc Vilmouth. In April 1993, Bulloch, Haselden, Patterson and Vilmouth were commissioned to submit designs and the following September the artists made their presentations to the panel. There were no traditional 'maquettes' but videos, audiotapes, photomontages and a fibre-optic model. Jean-Luc Vilmouth's *Channel Fish* was the unanimous choice.

JEAN-LUC VILMOUTH
CHANNEL FISH

"Passengers passing through Waterloo International terminal *en route* to the departure platform for the Eurostar train quickly become aware of something moving at their side. Silently, behind a high glass screen, a shoal of fish – long, silvery-turquoise streaks with large black eyes – seems to have become their fellow-traveller, apparently moving with them towards the channel. As another train pulls out with a barely audible rumble, they will notice the fish speed up, and although actually remaining static, appearing desperately eager to follow.

"These are the *Channel Fish*, the work of French artist Jean-Luc Vilmouth. These ten gently gyrating creatures were the winning entry in the competition to design a public art work which would complement Nicholas Grimshaw's architectural masterpiece. The brief was complex. Apart from having to harmonize with the architecture, the chosen work could be up to fifty metres long; it would have to work equally well when viewed from three different positions, including below; it would have to be thin enough to fit into the limited space offered and it would have to be invisibly suspended from the roof. Not only do Vilmouth's fish satisfy all these requirements, they transform the comfortable, functional modernism of the terminal's award-winning architectural space into a magical environment, appropriate to the start of an extraordinary voyage straight from the pages of Jules Verne. It is perhaps no coincidence that Vilmouth's chosen subject here should be Surrealism's favourite creature – the fish. What we see beside us as we embark, and suspended above our heads on our return journey, is the view we might have from the carriage were the train to travel through the water rather than thirty to forty metres below the sea bed. The artist has realised this grand illusion by fashioning his creatures from articulated sections of moulded resin. These he urges into motion by means of a simple mechanism of two wires, moving alternately on the fulcrum of a basic motor. The end result is captivating. Vilmouth's gigantic sand eels, modelled as they are on those indigenous to the Channel, wriggle and glow in their silver-blue livery, assuming a life of their own.

"But, aside from their seductive, decorative appropriateness, Vilmouth's fish succeed in a deeper purpose. In an artist's statement Vilmouth has said: 'The traveller should be able to feel a kind of similarity between the fish, the train, the tunnel and the station.' Part of his purpose is therapeutic. The appearance of the fish, both elegant and humorous, quietly robs the traveller of any potential apprehension at the coming journey beneath the waves. Rocking in their gentle rhythm, the fish seem to presage a journey which will be taken at a natural pace in a natural environment, quite belying the high-speed, man-made vehicle which is the triumph of the new cross-channel travel. In their increase in speed as the train departs, the fish even appear to enthuse, attempting almost to participate in the journey.

"Vilmouth's driving concern here, in a continuation of his past themes, is clearly to re-introduce nature into the modern urban context. In the past he has created wallpaper printed with a photograph of a forest and has evolved a scheme whereby vignettes of the world's birdlife might be presented to the public in an urban community centre housed within a disused airliner.

"With similar intent, here at Waterloo, Vilmouth's aim is to demonstrate that all human ideas ultimately derive their inspiration from natural sources. For Vilmouth the fish has become a metaphor for the train moving beneath the waves. His *Channel Fish* are in effect a reminder that despite the clean, sanitized, efficient appearance of both train and terminal, the real achievement of the tunnel link has been to traverse a wild body of water which has for centuries been both the nation's safeguard and its impediment. Like their real counterparts swimming in the channel, Vilmouth's fish are neither French nor English. In this simple ambiguity they seem to symbolize the notion of mankind's natural inclination to cross frontiers – the dream of global harmony.

"As the train link with the Continent is used with increasing frequency and its novelty becomes obscured by the everyday, perhaps Jean-Luc Vilmouth's *Channel Fish* will serve to remind the busy traveller of the epoch-making importance of the achievement they celebrate."
Iain Gale, Channel Fish, *PACA 1995*

RON HASELDEN
FRENCH CURVE (unrealised)

A sinuous curving coalescence of neon and LED lights sequenced by a combination of the vibration of trains coming in and out of the station and the number of passengers passing through the terminal. The lights would move up and down in the manner of the display panel for recording levels on a music amplifier.

SIMON PATTERSON
TIME MACHINE (not installed)

Simon Patterson's original proposal for the terminal competition was shortlisted but not realised. *Time Machine* was made in response to an invitation by PACA to make a temporary work for the terminal. It takes the form of a 3-metre slide rule.

"These tools for manual calculation were rendered redundant some years ago by the rise of the pocket calculator. Where calculators can provide quick results, they are not so good at demonstrating relationships, the aspect which Patterson finds most attractive about the slide-rule's function. Patterson substitutes chronological for mathematical relations, however, based on lineages of Old Testament patriarchs ('Salmon begat Booz begat Obed begat Jesse begat David' *etc*), of philosophers ('Machiavelli begat Erasmus'), and finally of Darwinian species, from primordial soup to homo sapiens. Seen together, they become much more interesting as illustrations of parallel development and non-linear influence."
Michael Archer and Greg Hilty, Material Culture, *Hayward Gallery, 1997*

WILFRED OWEN MEMORIAL, SHREWSBURY
Paul de Monchaux, *Symmetry*

CLIENT
The Wilfred Owen Association

PAUL DE MONCHAUX
b. Montreal, Canada 1934. Lives
and works in London

Born in Oswestry in 1893, Wilfred Owen lived with his family in Shrewsbury from 1904. Owen fought in the First World War and was killed in action, a week before the Armistice, at the age of twenty-five, whilst making a pontoon bridge across the Sambre canal. Wilfred Owen is now recognized to be one of the outstanding poets of the first half of the twentieth century.

The Wilfred Owen Association selected Paul de Monchaux from an invited competition organized by PACA to create a memorial to celebrate the centenary of the poet's birth. The brief specifically discouraged a figurative approach to the subject, with the clear intention of celebrating the poet and his literary achievements. The memorial was installed in the churchyard grounds of Shrewsbury Abbey, and inaugurated on Saturday, June 12 1994.

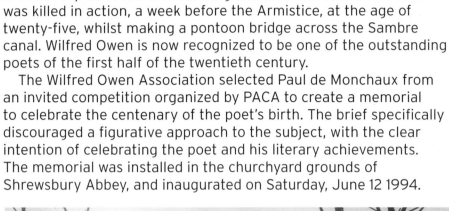

above: Soldier on parapet,
Somme 1916
right: Men walking on
duckboards, Ypres 1917
below: *Symmetry* under
construction
overleaf: *Symmetry*

"The commission brief asked that the work should celebrate Owen's poetry as much as his life and should incorporate a reference to one of his poems. I chose to use *Strange Meeting* because it is already a kind of monument: although it came out of Owen's personal experience of the First World War, it does not refer to that war directly. I have tried to find sculptural parallels for its structure and sentiments. The poem seems to me to be built around the idea of mirror symmetry, where the ground plane is imagined as a boundary between the living world above and its 'bloodless', 'soundless' and 'hopeless' reflection below. This symmetry is underscored by the way the poem's images of paired opposites are carried forward by the half-rhyme, only broken in the last line. From being a witness in his other work to the feelings of the living towards the dead, in *Strange Meeting* he adopts the point of view of the dead. The broken last line suggests that even life's pale reflection in the underworld is illusory and that the loss is total.

"The First World War landscape was criss-crossed with devices to prevent men, animals and equipment from sinking into the mud. Duckboards were even carried into battle; a kind of land-based life-raft. The duckboard or pontoon structure of the sculpture could be read as providing an additional layer or two on the right side of a metaphorical ground plane. The sculpture's dual function as a bench is quite deliberate in this context. The sculpture will be made of light-grey granite and it will rest on a circular York-stone base. The base and the sculpture will incorporate incised lettering including the line 'I am the enemy you killed, my friend' from *Strange Meeting*."
Paul de Monchaux

STRANGE MEETING

It seemed that out of battle I escaped 1
Down some profound dull tunnel, long since scooped 2
Through granites which titanic wars had groined. 1

Yet also there encumbered sleepers groaned, 2
Too fast in thought or death to be bestirred. 1
Then, as I probed them, one sprang up, and stared 2
With piteous recognition in fixed eyes, 1
Lifting distressful hands, as if to bless. 2
And by his smile, I knew that sullen hall, – 1
By his dead smile I knew we stood in Hell. 2

(18)

With a thousand pains that vision's face was grained; 1
Yet no blood reached there from the upper ground, 2
And no guns thumped, or down the flues made moan. 1
'Strange friend,' I said, 'here is no cause to mourn,' 2
'None,' said the other, 'save the undone years, 1
The hopelessness. Whatever hope is yours, 2
Was my life also; I went hunting wild 1
After the wildest beauty in the world, 2

Which lies not in calm eyes, or braided hair, 1
But mocks the steady running of the hour, 2
And if it grieves, grieves richlier than here. 3
For by my glee might many men have laughed, 1
And of my weeping something had been left, 2
Which must die now. I mean the truth untold, 1
The pity of war, the pity war distilled. 1
Now men will go content with what we spoiled. 2
Or, discontent, boil bloody, and be spilled. 2

(9)

They will be swift with swiftness of the tigress. 1
None will break ranks, though nations trek from progress. 2
Courage was mine, and I had mystery, 1
Wisdom was mine, and I had mastery: 2
To miss the march of this retreating world 1
Into vain citadels that are not walled. 2
Then, when much blood had clogged their chariot-wheels, 1
I would go up and wash them from sweet wells, 2
Even with truths that lie too deep for taint. 1

I would have poured my spirit without stint 2
But not through wounds; not on the cess of war. 1
Foreheads of men have bled where no wounds were. 2

(18)

'I am the enemy you killed, my friend. 1
I knew you in this dark: for so you frowned 2
Yesterday through me as you jabbed and killed. 1
I parried; but my hands were loath and cold. 2
Let us sleep now' +
 +
 1
 2 } ?

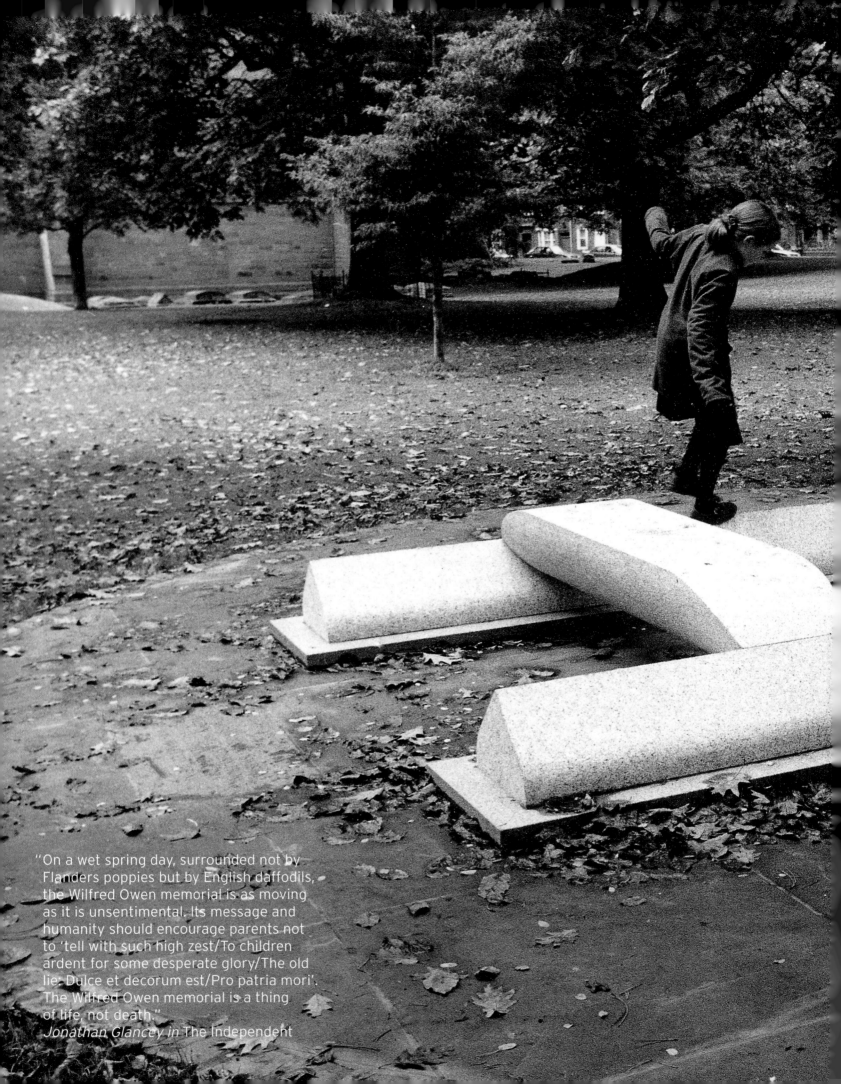

"On a wet spring day, surrounded not by Flanders poppies but by English daffodils, the Wilfred Owen memorial is as moving as it is unsentimental. Its message and humanity should encourage parents not to 'tell with such high zest/To children ardent for some desperate glory/The old lie: Dulce et decorum est/Pro patria mori'. The Wilfred Owen memorial is a thing of life, not death."
Jonathan Glancey in The Independent

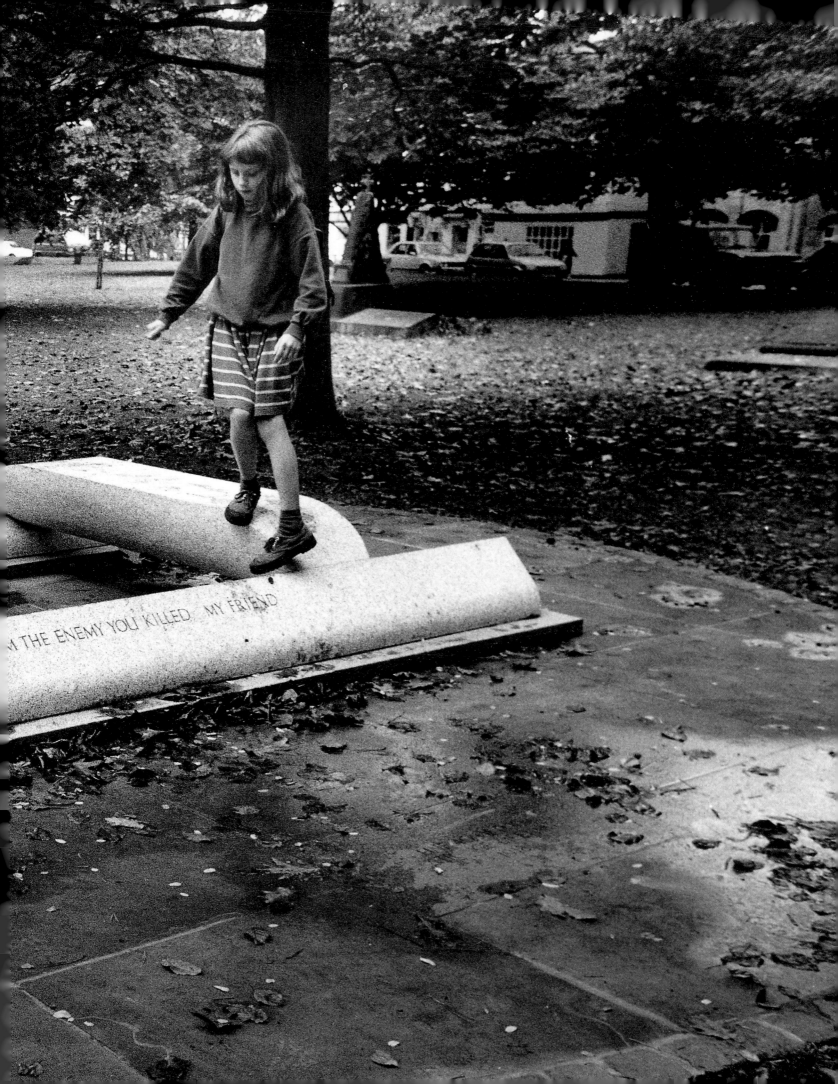

PACA PROJECTS 1987-1997

STRATEGIES, POLICIES, FEASIBILITY STUDIES

London Borough of Haringey
Wood Green and Haringey Heartlands Arts Initiative with Gillespies/Jon Rowland, 1997-98
Plymouth City Council
Public Art Strategy, 1997-98
Bristol Harbourside Centre
Public Art Strategy, 1997
Coventry Millennium 'Phoenix'
Public Art Strategy, 1997-98
Coventry City Centre
Public Art Strategy, 1997-98
Leominster District Council
Public Art Lighting Strategy, 1997-98
Lichfield District Council
Public Art Strategy, 1997-98
Queen Elizabeth Hospital, Birmingham
Art Commissioning Plan, 1997
Stonebridge Housing Action Trust
Public Art Plan, 1997
Birmingham City Council, Farm Park, Sparkhill
Public Art Commissioning Plan, 1997
National Trust Foundation for Art
Policy for Art Commissions, 1997-98
London Borough of Barking and Dagenham
Feasibility Study and Arts Council Lottery application, 1996-97
Labour Party
Seminar Series and Draft Public Art Policy Framework, 1996
Plymouth Millennium
Public Art Strategy, 1996
London Borough of Hackney
Public Art Strategy with Katharine Heron, 1995-96
University of Warwick
Percent for Art Guidelines, 1994
West Midlands Arts
Rural Arts Strategy, 1993
Midland Metro
Design Guide: Line 1 with Alice Adams, Jack Mackie, Andrew Darke, 1992
Ecotec/Scottish Arts Council/Scottish Tourist Board
Strategy for Arts Tourism: research paper on Cultural Tourism in France, 1991
Derby City Council/British Rail
Brighter Tracks/Environmental Works, 1991
Wolverhampton Borough Council
Public Art Strategy and Town Plan with Jane Kelly, 1990
Coventry City Council
Percent for Art Strategy, 1990
Cardiff Bay Development Corporation
A Strategy for Public Art in Cardiff Bay, Public Art Consultancy Team, Foreword by Vivien Lovell, 1989-91
Birmingham City Council
The 'Forward' Strategy: Public Art in the City Centre, 1989

London and Edinburgh Trust
A Feasibility Study for Public Art at the New Bullring, Birmingham, 1989
Centro: Passenger Transport Executive for the West Midlands
Public Art Strategy for Midland Metro, 1988
Black Country Route
Special Features Feasibility Study with Steve Field, 1988
Black Country Route
Oldbury Ringway Feasibility Study with David Patten, 1988
Black Country Development Corporation
Percent for Art Report, 1988

PACA INITIATIVES

Special commission for PUBLIC:ART:SPACE
Collaborative work by Mark Goulthorpe of dECOi Architects and artist Max Mosscrop
Well, One Thousand Lights
Temporary installation by David Ward The Royal Pump Rooms and Baths, Leamington Spa, 1997
Speculative Proposals
National project showcasing process and inviting artists to respond to points of intersection and sites of contention
– Dan Graham and Mark Pimlott with Jane Wernick, Ove Arup and Partners, speculative design for Bankside pedestrian bridge, London, 1997
– Jochen Gerz, proposal for the empty plinth in Trafalgar Square, London, 1996-98
Host
Collaboration by Pierre d'Avoine, architect, with artists Heather Ackroyd and Daniel Harvey at the Nuova Icona Gallery and other sites in Venice within the context of the Architectural Biennale, 1996
Livelli in Input
Alessandra Rossi and Craig Wood University of Warwick/Palazzo Querini Stampalia, Venice, 1994
Interpretation of Public Art in Birmingham for the Visually Impaired
with William Kirby and Erica Loane, 1994
The Honeymoon Project: The Eternity Ring
Miralda, with Ikon Gallery, 1992 Commission and participatory event

PUBLIC ART COMMISSIONS (selected)

PUBLIC SECTOR

Wolverhampton Metropolitan Borough Council
Out of Darkness, programme of light works by Anne Bean, Tony Cooper, Siobhan Davies, Richard Ellis, Peter Fink, Janet Hodgson, John David Mooney, Martin Richman, Leni Schwendinger and others, 1993-99
Wolverhampton Metropolitan Borough Council
Black Country Route
Commissions by Eilís O'Connell, Sarah Tombs, Miles Davies, Ashley Cartwright, Jamie McCulloch and others, 1994-98
National Trust, Fell Foot Park
Commissioned designs by Susanna Heron and Paul de Monchaux, 1996-98
Romsley Church Council
Commission by Michael Fairfax for St Kenelm's Well, 1994
Derby City Council
Water sculpture, William Pye, 1993
Hackney Community College, London
Commissions by Alexander Beleschenko, Matthew Fedden, Bettina Furnée/Ben Zephaniah, Dimitra Grivellis, Susanna Heron, Pat Kaufman and Martin Richman, 1993
St John's College, Oxford
Commissions by Alexander Beleschenko, John Howard and Wendy Ramshaw, 1992
Coventry Crown Courts
Basilica, Paul de Monchaux, 1991
University of Warwick, Mead Gallery
Moonlight (by permission), Pierre Vivant, 1989
Birmingham's Queen Elizabeth II Law Courts
Wattilisk, Vincent Woropay, 1988

Stoke City Council
Commissioned designs by John Aiken, Anna Heinrich/Leon Palmer, MUF Architects, Pierre Vivant and Simon Watkinson, 1997-98
City of Birmingham Symphony Orchestra, Birmingham
Commissions by Alexander Beleschenko, Ashley Cartwright, Bettina Furnée, Gary Kirkham, Wendy Ramshaw, Shelagh Wakely and Claire Whitcomb, 1996-98
South Thames College, Wandsworth
Commissioned designs by Susan Collins and Andrew Kearney in collaboration with Glenn Howells Architects, 1996-99

Birmingham City Council, Town Hall
Commission by Lise Autogena, 1996-98
British Embassy, Dublin
Foreign Office, Overseas Estate Department, commissions by Brian Catling, Susanna Heron, Susan Kinley; purchase of sculpture by Peter Randall-Page, 1995
Royal Philharmonic Hall, Liverpool
Sculpture by Marianne Forrest, 1995
Birmingham City Council, Central Library, Birmingham
Commission by Saleem Arif, 1993
Government Art Collection
Open competition for commissions, EU Administration Centre, Brussels Commission by Susanna Heron, 1993
Turning Point, Birmingham
Tony Hancock Memorial by Bruce Williams, 1993
Wilfred Owen Society, Shrewsbury
Symmetry, memorial to Wilfred Owen by Paul de Monchaux, 1992
Birmingham City Council Inner City Public Art Officer Post held by Jane Sillis
Initiated by PACA and co-funded with the Gulbenkian Foundation and Birmingham City Council
– Mobile Libraries by Liz Lepa, Lynne Gant, Vivien Blackett, Colin Howkins, 1991-93
– Bloomsbury Library Ironwork by Anurhada Patel, 1992
– St Thomas Peace Garden Ironwork by Anurhada Patel, 1992
– Yardley Wood, relief by Juginder Lamba, 1992
– Highfield School, Saltley, Indra Khana, 1991
– St Vincent Street West, Ladywood, Paula Wolf, 1991
– Urban Wildlife Trust Icarus, sculpture by Juginder Lamba and Tony Phillips, 1990
Birmingham City Council, International Convention Centre and Centenary Square
Commissions by Alexander Beleschenko, Ron Haselden, Tess Jaray, Tom Lomax, Raymond Mason, David Patten, Richard Perry, Deanna Petherbridge and Vincent Woropay, 1987-92
Sandwell Metropolitan Borough Council, West Bromwich
– Queens Square, commission by Laura Ford, 1990
– Memorial to John Wesley by Chris Dunseath, 1989
Birmingham City Council underpasses
Commissions by Sarah Galloway, Geoff Machin, Sue Ridge, 1989

PRIVATE SECTOR

Covent Garden Estates
Commission by Shelagh Wakely,
1997-98
**Birwelco/Tyseley Waste Disposal
(TWD) Ltd**
Commission by Martin Richman,
1994-98
Grosvenor Properties
Commissions for Cambridge shopping
centre by Bruce Williams and Peter
Logan, 1994-95
Temple Court, Birmingham
Commissions by Sarah Galloway and
Marianne Forrest, 1993
TSB, Victoria Square, Birmingham
Iron:Man, Antony Gormley, 1993
**Cordwell Property, Derby
City Centre**
Sculpture by Michael Pegler, 1993
Glenlivet Properties, Sheffield
Exhibition and sculpture commission
by Ronald Rae, 1993
**Heart of England Building Society,
Warwick**
Sculpture by Sarah Tombs, 1992
**Hortons' Estate Ltd, Birmingham,
Piccadilly Arcade**
Ceiling painting by Paul Maxfield, 1991
Cable and Wireless
Photographic documentation of new
Training College in Coventry by Colin
Shaw and Alex Ramsay, 1991

URBAN DEVELOPMENT
CORPORATIONS AND AGENCIES
**Merseyside Development
Corporation, Pierhead, Liverpool**
Commissioned designs by Vito
Acconci; Douglas Hollis and Anna
Valentina Murch, 1994-98
**London Docklands Development
Corporation**
Commissions by Sir Anthony Caro,
Eilís O'Connell, Pierre Vivant and
Richard Wentworth, 1993-98
Birmingham Heartlands
– *Sleeping Iron Giant*, by Ondre
Nowakowski, 1992
– Sculpture by Suzy Gregory, 1991
– Community bulb-planting scheme by
Myfanwy Johns, 1991

TRANSPORT AUTHORITIES
**Centro, West Midlands Passenger
Transport Executive**
Commissions by Alexander
Beleschenko, Matthew Fedden, Steve
Field, James Horrobin, Liz Lepa and
Rosemary Terry, 1993-94
Midland Metro, Advance programme
Commissions by Andrew Darke and
Anurhada Patel, 1993-94
**European Passenger Services,
Waterloo International Passenger
Terminal**
Channel Fish, Jean-Luc Vilmouth, 1993

HEALTH SECTOR

**Queen Elizabeth Hospital,
Birmingham**
Commissions by Rupert Williamson,
Nicholas Pryke and Jane McDonald,
1997-98
**Ross-on-Wye Community Hospital,
Herefordshire**
Commissions by Rupert Williamson
and Liz Ogilvie, 1997-98
**Hereford Hospital Commissions
Programme**
Organized by Erica Loane, 1997-99

AWARDS

Arts Council of England
– Speculative Proposals, research and
development, 1994
– Interpretation of Public Art in
Birmingham for the Visually Impaired,
pilot study, 1994
– *Channel Fish*, by Jean-Luc Vilmouth
at Waterloo International Terminal,
1994
– Alliance for Art, Architecture & Design,
1993
– Enhancement Funding Award, 1991-94
– Incentive Funding Award, 1990
– International Public Art Symposium,
'Context and Collaboration',
Birmingham, 1990
Arts Council Lottery

– Ross-on-Wye Community Hospital,
1997
– Feasibility Study, Wolverhampton Art
Gallery extension, 1997
– Public art programme associated with
the Cultural Quarter, Stoke-on-Trent,
1997
– Artworks along the A13 approach road
into London, London Borough of
Barking and Dagenham, 1997
– Artworks to be included in new
Oncology Unit, Queen Elizabeth
Hospital, Birmingham, 1997
– Feasibility study for new courtyard
project, South Thames College,
London, 1997
– *Out of Darkness*, a programme of
lightworks for Wolverhampton, with
Wolverhampton Art Gallery, 1995
**Association for Business
Sponsorship of the Arts Business
Sponsorship Incentive Scheme
(The Pairing Scheme) Award**

– Covent Garden Estates for
sponsorship of the Shelagh Wakely
commission with Eric Parry Architects
at Seven Dials Piazzetta, 1997

– Birwelco for sponsorship of the
Martin Richman lighting commission
at Tyseley Energy from Waste Facility,
Birmingham, 1996
– Nicholas Grimshaw Architects for
sponsorship of *Channel Fish* by
Jean-Luc Vilmouth at Waterloo
International Terminal, 1995
– European Passenger Services for
sponsorship of *Channel Fish* by
Jean-Luc Vilmouth at Waterloo
International Terminal, 1993
– Glenlivet Properties for sponsorship
of the commission and exhibition of
work by Ronald Rae, Nunnery Square,
Sheffield, 1993
– Trustee Savings Bank for sponsorship
of *Iron:Man* by Antony Gormley,
Victoria Square, Birmingham, 1991
– Pinsent & Co for sponsorship of
commission by Richard Perry at the
International Convention Centre,
Birmingham, 1991
– Ingersoll Publications for sponsorship
of open competition and commission
by Roderick Tye at the International
Convention Centre, Birmingham, 1990
**Association Française d'Action
Artistique**
– *Channel Fish*, Jean-Luc Vilmouth,
Waterloo International Terminal, 1993
British Council Visual Arts Award
– *Host*, Pierre d'Avoine, Heather
Ackroyd and Daniel Harvey in Venice,
1996
– *Channel Fish*, Jean-Luc Vilmouth,
Waterloo International Terminal, 1994
**British Gas 'Working for Cities'
Award**
– Winner of Public Art category for
Channel Fish, Jean-Luc Vilmouth,
Waterloo International Terminal, 1995
Calouste Gulbenkian Foundation
– Birmingham Inner City Officer post,
core funding, 1989-91
– PACA establishment costs and core
funding, 1987-88
Elephant Trust
– *Stills from Sculpture, three works
in public places*, Susanna Heron,
1995-98
**European Regional Development
Fund**
– *Out of Darkness*, a programme of
lightworks for Wolverhampton, 1993
**Foundation for Sport and the
Arts Award**
– Office equipment and furniture, PACA,
Birmingham and London, 1997
Henry Moore Foundation
– *Island*, Susanna Heron, at the
new British Embassy, Dublin, 1995
– *Channel Fish*, by Jean-Luc Vilmouth
at Waterloo International Terminal,
1994
**Prudential Awards for the Arts,
Visual Arts Award**
– Commendation and prizewinner, 1994
– Commendation and prizewinner, 1993
– Commendation, 1991

**Royal Society for the
Encouragement of Arts,
Manufactures & Commerce (RSA)
Art for Architecture Awards**
– Artist-architect collaboration (Claire
Whitcomb with Associated Architects)
for the City of Birmingham Symphony
Orchestra's new headquarters, 1996
– Artist-architect collaboration (Daniel
Harvey and Heather Ackroyd with
Levitt Bernstein) for the Victoria
Theatre, Stoke-on-Trent, 1996
– *Stills from Sculpture, three works in
public places*, Susanna Heron, 1996
– Publication of 'Gateways for the
Millennium', *Alliance for Art,
Architecture and Design*, 1996-98
– Artist-architect collaboration (Martin
Richman with Ray Perry of Faulks
Perry Culley & Rech) for Tyseley
Energy from Waste Facility,
Birmingham, 1995
– Artist-architect collaboration (Rose
Garrard with Levitt Bernstein) at Holly
Street Estate, Hackney, 1994
– Artist-architect collaboration (Wendy
Ramshaw with Richard MacCormac,
MacCormac Jamieson Prichard) for
the Garden Quadrangle, St John's
College, Oxford, 1993
Visiting Arts Unit
– *Channel Fish*, by Jean-Luc Vilmouth
at Waterloo International Terminal,
1994
West Midlands Arts
– St Kenelm's Well, commission by
Michael Fairfax, 1994
– Birmingham Library, commission by
Saleem Arif, 1992

PUBLICATIONS

– Alliance for Art, Architecture and
Design, *Gateways for the Millennium*,
published with Public Art Forum,
1996-98
– Susanna Heron, *Stills from Sculpture,
three works in public places*, 1998
– Martin Richman, *Made Light, Tyseley
Energy from Waste Facility*, 1997
ISBN 1 902257 00 6
– Pierre d'Avoine, Heather Ackroyd
and Daniel Harvey, *Host*, PACA/Nuova
Icona, Venice, 1996
ISBN 88 900111 1 4
– Jean-Luc Vilmouth, *Channel Fish*,
published with European Passenger
Services, 1995
– *A Strategy for Public Art in Cardiff
Bay*, published by Public Art
Consultancy Team for Cardiff Bay
Development Corporation, 1990
– *Context & Collaboration*,
International Public Art Symposium,
1990

ADVOCACY, EDUCATION, EXHIBITIONS (selected)

WEST MIDLANDS ALLIANCE FOR ART, ARCHITECTURE AND DESIGN
A PACA intiative supported by West Midlands Arts

ARTISTS' TALKS
A series for artists, architects and local authorities. Participants include Martin Richman, Emma Rushton and Derek Tyman ('The Mule') and Shillam + Smith Architects, Custard Factory, Birmingham, 1998

'PUBLIC ART: PROCESS AND REALISATION'
A seminar series aimed at local authority officers, 1995

'CONTEXT & COLLABORATION', INTERNATIONAL PUBLIC ART SYMPOSIUM
Organized with Jane Kelly
Participants included Alice Adams, Conrad Atkinson, Tom Beucker, Richard Burton, Peter Cook, Edward Cullinan, Kathryn Gustafson, Judy Hillman, David Jackson, Tess Jaray, Pippo Lionni, Jack Mackie, Miralda, Hal Moggridge, Marta Pan, David Reason, Ian Ritchie, Alan Robb, Colin Stansfield Smith and Francis Tibbalds, Birmingham, 1990

INTERNATIONAL CONFERENCES/ LECTURES (selected)
– MIT, Cambridge MASS, Centre for Advanced Visual Studies, 1995
– International Arts Management Group, Standing Conference, HEC, Paris, 1993
– International Public Art Conference, Musée d'Art Moderne, Paris, 1990
– International Sculpture Society of Ireland, Dublin, 1988
– Public Art in America, Philadelphia, 1987

ALLIANCE FOR ART, ARCHITECTURE & DESIGN
– 'Gateways for the Millennium', International Workshop, 1994
– Launch seminars at RIBA, 1992 and RSA, 1993

EXHIBITIONS (selected)
– 'Cities '95', Canary Wharf, London, 1995
– 'Gate', Wendy Ramshaw, RIBA, St John's College, Oxford, 1993
– 'Cities '93', International Convention Centre, Birmingham, 1993
– Royal Town Planning Institute, 1992
– 'New Meanings for City Sites', Birmingham Museum and Art Gallery, 1991

RESEARCH (selected)

– Arts Council of England: travel bursary to research new architecture in France, Germany and Spain, 1997
– Arts Council of England: travel bursary to research art and architecture collaborations in the UK and Holland, 1996
– Arts Council of England: travel bursary to research art and architecture collaborative project in Venice, 1996
– United States: sabbatical research on artist-architect collaborations and environmental projects, 1995
– Portugal: travel grant from Portugal 600 to research visual arts in Lisbon and Porto, 1994
– Arts Council of England: travel bursary to participate in Art in Transport conference in Brussels, 1994
– Arts Council of England: travel bursary to speak at International Arts Management Conference, HEC, Paris, 1993
– United States: research trip to Philadelphia, Washington DC and Chicago, 1987

STAFF

Founder-Director
Vivien Lovell
Commissions Manager (London)
Stephen Beddoe
Commissions Managers
Rachel Bradley
Angela Kingston
Trainee Commissions Manager
Alison Deely
Administrators
Maureen Gaynor
Jayne Higgins

Accountant
Richard Perkins & Co

Freelance Consultants
Maria Brewster
Hazel Colquhoun
Sharon Essor
Lesley Greene
Erica Loane
Sara Roberts
Judith Strong
Samantha Wilkinson

Contract Staff
Bridget Kovacs
Sarah Trigg

Trustees
Denys Hodson CBE (Chair)
Wendy Baron OBE
Julienne Dolphin-Wilding
Kenneth Dytor
*John Hawksley (Chair 1988–93)
Charles King-Farlow
Amanda Levete
Jill Ritblat

Previous Staff
Danny Callaghan
Olga Gribben
Emma Larkinson
Jane Sillis
Jennie Toussaint
Geoffrey Wood
Caron Wright

Retired Trustees
Andrew Benjamin
*Michael Diamond
*Avtarjeet Dhanjal
Hazel Duffy
*Rose Garrard
*James Hurford CBE (d. 1997)
*Hamish Miles
Tim Morris
*Andrew Sebire

Founder Trustee

BIBLIOGRAPHY

The list is intended to be a guide for further reading, and is necessarily selective.

E. Adams, *Public Art: People, Projects, Process*, London Arts Board, Public Art South West, Southern Arts, South East Arts, 1997
Architectural Competitions: A Handbook for Promoters, Department of the Environment, Department of National Heritage, London (HMSO) 1996
Architectural Design Profile
– 'Frontiers: Architects and Artists', 127, 1997
– 'Light in Architecture', J. Brogan (guest editor), 126, 1997
Art and Design Profile
– J. Stathatos (guest ed.), 'Art and the City, A Dream of Urbanity', 50, 1996
– A. Crabtree (guest ed.), 'Public Art', 46, 1996
– 'Marking the City Boundaries', 24, 1992
Arts Council, *A Creative Future*, London (HMSO) 1993
G. Bachelard, *The Poetics of Space*, trans. by M. Jolas, Boston (Beacon Press) 1958
P. Balkin Bach, *Public Art in Philadelphia*, Philadelphia (Temple University Press) 1992
J. Beardsley, *Art in Public Places*, Washington (Partners for Liveable Places) 1981
– *Earthworks and Beyond*, New York (Abbeville Press) 1989
H. Béchy (ed.), 'Rencontres Internationales autour de la Création dans la Ville et L'Environnement', *Les Dossiers de l'Art Public*, 6, Paris (Association Art Public Promotion) 1991
H.S. Becker, *Artworlds*, Berkeley (University of California Press) 1984
A. Beleschenko, T. Macfarlane, *Glass, Light and Space. New Proposals for the Use of Glass in Architecture*, London (Crafts Council) 1997
J. Berr, *The Arts in Health Care*, Dewsbury (Yorkshire and Humberside Arts Board) 1991
J. Bird, B. Curtis, T. Putnam, G. Robertson, L. Tickner (edd.), *Mapping the Futures*, London (Routledge) 1993
A. Blowers, B. Evans, *Town Planning into the 21st Century*, London (Routledge) 1997
O. Bouman, R. van Toorn (edd.), *The Invisible in Architecture*, London (Academy Editions) 1994
S. Brand, *How Buildings Learn*, London (Phoenix) 1994
A. Brighton, N. Pearson, *The Economic Situation of the Visual Artist*, London (Gulbenkian Foundation) 1985

British Rail Community Unit, *Railway Time*, London (British Rail Community Unit) 1990
L. Buck, *Moving Targets: A User's Guide to British Art Now*, London (Tate Gallery Publishing) 1997
R. Burton (Chair), *Percent for Art: Report of a Steering Group established by the ACGB with CORAA, Welsh and Scottish Arts Councils and the Crafts Council*, London (Arts Council) 1990
K. Bußman, K. König, F. Matzner (edd.), *Contemporary Sculpture. Projects in Münster 1997*, Münster (Verlag Gerd Hatje) 1997
D. Butler (ed.), *Making Ways*, Sunderland (AN Publications) 1987
Cardiff Bay Development Corporation, *The Strategy for Public Art in Cardiff Bay*, Cardiff (Public Art Consultancy Team) 1990
E. Carter, J. Donald, J. Squires (edd.), *Space & Place*, London (Lawrence & Wishart) 1993
S. Clifford, *Places: The City & The Invisible*, London (Common Ground) 1990
'Context and Collaboration' – The International Public Art Symposium, Birmingham (PACA) 1992
H. Conway, R. Roenisch, *Understanding Architecture*, London (Routledge) 1997
R. Cork, *Art Beyond the Gallery*, New Haven and London (Yale University Press) 1985
– *A Place for Art*, London (Public Art Development Trust) 1993
Commissioning Art Works, preface by R. Cork, London (Arts Council of Great Britain) 1996
T. Crosby, J. Garlick (edd.), *Art & Architecture – Second Register Of Artists & Craftsmen In Architecture*, London (Art & Architecture Ltd.) 1989
J.B. Cullingworth, V. Nadin, *Town and Country Planning in the UK*, London (Routledge) 1997
P. Curtis (ed.), *Patronage and Practice – Sculpture on Merseyside*, Liverpool (Tate Gallery) 1989
S. Cutts, *The Unpainted Landscape*, London (Coracle Press) 1987
J. Darke, *The Monument Guide*, London (Macdonald) 1991
N. de Oliveira, N. Oxley, M. Petry, *Installation Art*, London (Thames and Hudson) 1994
N. de Ville, S. Foster, *Space Invaders – Issues of Presentation, Context and Meaning in Contemporary Art*, Southampton (John Hansard Gallery) (1993)
M. Dixon (ed.), *Art With People*, Sunderland (AN Publications) 1995

G. Duby, J.L. Daval, M. Faux, P. Restany, G. Smadja, *L'Art et la Ville: Urbanisme et Art Contemporain*, Secrétariat Général des Villes Nouvelles, Geneva (Skira) 1990
S. Fainstein, S. Campbell (edd.), *Readings in Urban Theory*, Oxford (Blackwell) 1996
N. Faith, *Sold: The Revolution in the Art Market*, London (Hamish Hamilton) 1985
N. Felshin (ed.), *But is it Art? The Spirit of Art as Activism*, Seattle (Bay Press) 1995
M. Fisher, U. Owen, *Whose Cities?*, London (Penguin) 1991
H. Foster, *Recodings: Art, Spectacle, Cultural Politics*, Seattle (Bay Press) 1985
P. Fuller, *Images of God: The Consolations of Lost Illusions*, London (Chatto & Windus) 1985
S. Gablik, *Has Modernism Failed?*, London (Thames and Hudson) 1985
– *The Reenchantment of Art*, London (Thames and Hudson) 1991
Introducing Art for Public Places, Gateshead (Gateshead Borough Council Libraries and Arts) 1993
D. Ghirardo (ed.), *Out of Site: A Social Criticism of Architecture*, Seattle (Bay Press) 1991
M. Gilson, *Alchemy, The Public Art Programme at Garden Festival Wales*, Ebbw Vale (Garden Festival Wales Visual Arts Unit) 1992
Lord Gowrie, S. Robinson, *Creative Partnership – Working Together In The Arts*, London (Arts Council Of Great Britain) 1996
S. Grant Thorold, *Art and Craft in Green Places*, Winchester (Southern Arts/Hampshire Gardens Trust) 1992
L. Greene, *Art in Hospitals: A Guide*, London (The Kings Fund) 1989
– 'Principles on the Commissioning of New Work', *Arts Council of England Guidelines*, London (Arts Council of England) 1996
A. Guest, J. Smith (edd.), *The City Is a Work of Art: Glasgow – Artists & Architects In Dialogue & Collaboration*, Edinburgh (Scottish SculptureTrust) 1994
S. Hardingham, *England: a Guide to Recent Architecture*, London (Ellipsis/Konemann) 1996
– *London: a Guide to Recent Architecture*, London (Ellipsis/Konemann) 1996
S.P. Harris, *Insights on Sites: Perspectives on Art in Public Places*, Washington DC (Partners for Livable Places) 1984
D. Harvey, *The Urban Experience*, Baltimore (John Hopkins University Press) 1989

D. Hayden, *The Power of Place. Urban Landscapes as Public History*, London (MIT Press) 1996
Health Care Arts, 'Crafts In Scottish Hospitals', Dundee (Duncan of Jordanstone College of Art) 1995
J. Heath, *The Furnished Landscape: Applied Art in Public Places*, London (Bellew) 1992
R. Hewison, *Future Tense*, London (Methuen) 1990
B. Hoffman, *Public Art, Public Controversy: Tilted Arc on Trial*, New York (ACA Books) 1986
M.J. Jacob, M. Brenson, E.M. Olson, *Culture Chicago, Culture in Action*, Seattle (Bay Press) 1995
J. Jacobs, *The Death and Life of Great American Cities*, London (Pelican) 1961
M. Jacobson, *Art for Work*, Boston (Harvard Business School Press) 1993
S. Jones, *Art in Public: What, Why and How*, Sunderland (AN Publications) 1992
P. Jukes, *A Shout in the Street: The Modern City*, London (Faber and Faber) 1990
N. Khan, K. Worpole, *Travelling Hopefully – A Study of the Arts in the Transport System*, London (Illuminations) 1992
A. King (ed.), *Re-Presenting the City*, London (Macmillan) 1996
P. Korza, R. Andrews (edd.), *Going Public*, Amherst MASS (National Endowment of the Arts) 1998
W. Kochs, P. Owens, D. Salvadon, *The Artist and the Changing City – An Agenda For Urban Regeneration*, London (British American Arts Association) 1989
J. Kramer, *Whose Art is it?*, Durham NC (Duke University Press) 1994
S. Lacy (ed.), *Mapping the Terrain: New Genre Public Art*, Seattle (Bay Press) 1995
C. Landry, L. Greene, F. Biancini, F. Matarasse, *The Art of Regeneration – Urban Renewal through Cultural Activity*, Leicester (Comedia) 1996
N. Leach (ed.), *Rethinking Architecture. A Reader in Cultural Theory*, London (Routledge) 1997
J. Lee, S. O'Reilly, I. Robertson, *Careers in the Crafts; Professional Profiles – A Sample of Makers from Hackney and Islington*, London (Crafts Council) 1995
H. Lefebvre, *The Production of Space*, trans. by D. Nicholson-Smith, Malden MASS (Blackwell) 1991
R.T. LeGates, F. Stout, *The City Reader*, London (Routledge) 1996
J. Lewis, *Art, Culture and Enterprise: The Politics of Art and the Cultural Industries*, London (Routledge) 1990

J. Lingwood, *TSWA 3D*, Exeter (TSWA) 1987
– *New Works for Different Places – TSWA 4 Cities*, Exeter (TSWA) 1990
– (ed.), *House*, London (Phaidon) 1996
R. Lippard, *Overlay – Contemporary Art & the Art of Prehistory*, New York (Pantheon Books) 1983
E. Lucie-Smith, *Visual Arts in the Twentieth Century*, London (Laurence King) 1996
LUL Architectural Services, *Changing Stations*, London (LUL Architectural Services) 1993
Lux Europae, *Light Installations by 35 European Artists across the City of Edinburgh*, Edinburgh (Lux Europae Trust) 1993
K. Lynch, *The Image of a City*, London (MIT Press) 1960
– *What Time is This Place?*, London (MIT Press) 1972
– *Good City Form*, London (MIT Press) 1984
R. Martin (ed.), *The New Urban Landscape*, New York (Olympia & York and Drenttel Doyle Partners) 1990
D. Massey, *Space, Place and Gender*, Cambridge (Polity Press) 1994
B.C. Matilsky, *Fragile Ecologies: Contemporary Artists' Interpretations and Solutions*, New York (Queen's Museum of Art, Rizzoli) 1992
R. Maxwell, *Contemporary British Architects*, London (Royal Academy) 1994
M. Miles (ed.), *Art for Public Places – critical essays*, Winchester (Winchester School of Art Press) 1989
– *Art, Space and the City*, London (Routledge) 1997
Milton Keynes Development Corporation, *Art at work in Milton Keynes*, Milton Keynes (Milton Keynes Development Corporation) 1990
W.J.T. Mitchell (ed.), *Art and the Public Sphere*, Chicago (University of Chicago Press) 1992
J. Morland, *New Milestones*, London (Common Ground) 1988
W. Morrish, C. Brown, *Planning to Stay*, Minneapolis (Milkweed Editions) 1994
G. Moure, *Urban Configurations*, Barcelona (Ediciones Poligrafa SA & Olympiada Cultural) 1994
J. Myerscough, *The Economic Importance of the Arts in Britain*, London (Policy Studies Institute) 1988
National Endowment for the Arts, Art In Public Places, Washington DC (Partners for Livable Places) 1981
M. Nuridsany, *La Commande Publique*, Paris (Ministère de la Culture: Réunion des Musées Nationaux) 1991

H.U. Obrist, G. Tortosa, *Unbuilt Roads, 107 Unrealised Projects*, trans. by J.S. Southard, Stuttgart (Verlag Gerd Hatje) 1997
M. Pacione (ed.), *Britain's Cities: Geographies of Division in Urban Britain*, London (Routledge) 1997
M. Parfect, G. Power, *Planning for Urban Quality Urban Design in Towns and Cities*, London (Routledge) 1997
N. Pearson, *The State and the Visual Arts*, Milton Keynes (Open University Press) 1982
D. Perry, 'In the Right Company', *The Arts Business: The Arts, Architecture and the Environment*, Winchester (Southern Arts) 1990
D. Petherbridge, 'Art and Architecture: a special supplement', *Art Monthly*, 56, 1982
– 'Public Commissions and the New Concerns in Sculpture', *The Sculpture Show*, London (ACGB) 1983
– *Art for Architecture – A Handbook on Commissioning*, London (HMSO) 1987
A. Raftery, *Opening Lines: New Contexts for Artists' Projects*, London (London Arts Board) 1997
A. Raven, *Art in the Public Interest*, New York (Da Capo Press) 1993
M. Roberts, C. Marsh, M. Salter, *Public Art in Private Places*, London (University of Westminster Press) 1993
E. Rosenberg, *Architect's Choice – Art In Architecture In Great Britain Since 1945*, London (Thames and Hudson) 1992
R. Rogers, *Cities for a Small Planet*, London (Faber and Faber) 1997
In Search of Public Space: four Architects from London: Fretton, Parry, Ronalds, d'Avoine, Antwerp (de Singel) 1997
S. Selwood, *The Benefits of Public Art: The Polemics of Permanent Art in Public Places*, London (Policy Studies Institute) 1995
H.F. Senie, S. Webster, *Critical Issues in Public Art: Content, Context and Controversy*, New York (HarperCollins) 1993
H.F. Senie, *Contemporary Public Sculpture: Tradition, Transformation and Controversy*, Oxford (Oxford University Press) 1992
R. Sennett, *The Conscience of the Eye: The Design and Social Life of Cities*, New York (Norton Press) 1990
– *The Fall of Public Man*, New York (Norton Press) 1992
– *Flesh and Stone: The Body and the City in Western Civilization*, New York (Norton Press) 1996
– *The Uses of Disorder*, London (Faber and Faber) 1996

D. Shamash (ed.), *A Field Guide to Seattle's Public Art*, Seattle (Seattle Arts Commission) 1991
– *In Public: Seattle 1991*, Seattle (Seattle Arts Commission) 1992
P. Shaw, *The Public Art Report: Local Authority Commissions of Art for Public Places*, London (Public Art Forum) 1990
– *Percent for Art – A Review*, London (Arts Council of Great Britain) 1991
P. Shepheard, *What is Architecture?*, London (MIT Press) 1994
A. Sky, M. Stone, intro by G.R. Collins, *Unbuilt America*, New York (McGraw-Hill) 1976, repr. New York (Abbeville) 1983
Southern Arts, *Art and Craft Works – a step by step guide*, Winchester (Southern Arts) 1990
J. Steele, *Architecture Today*, London (Phaidon) 1997
M. Ström, J. Damase (ed.), *Metro – Art dans les Métropoles*, Paris (Jacques Damase) 1990
H. Tebbutt, S. Beddoe, *The Public Art File: A guide to public art resources in and around London*, London (London Arts Board) 1997
P. Townsend (ed.), *Art Within Reach*, London (Thames and Hudson/Art Monthly) 1984
R. Turner, P. Dormer, *Light Values: Modern Architectural Glass – A Photographic Survey*, London (Crafts Council) 1986
I. Vasseur, G. Prince, *Festival Landmarks '90*, Gateshead (NGF '90) 1990
C. Weyergraf-Serra, M. Buskirk, *The Destruction of Tilted Arc: documents* Cambridge MASS (MIT Press) 1991
W.H. Whyte, *The Social Life of Small Urban Spaces*, Washington DC (Conservation Foundation) 1980
– *City – Discovering the Centre*, New York (Doubleday) 1980
V. Wilton (ed.), *Siteworks*, London (London Siteworks) 1997
J. Wolff, *The Social Production of Art*, London (Macmillan) 1981
J. Williams, H. Bollen, M. Gidney, P. Owens, *The Artist in the Changing City*, London (British American Arts Association) 1993

PROJECT CREDITS

MARK GOULTHORPE OF dECOi ARCHITECTS WITH MAX MOSSCROP, 1998
A special collaboration for *Public:Art:Space* commissioned by PACA
PACA team: Vivien Lovell, Maureen Gaynor, Jayne Higgins
Freelance consultant: Sara Roberts
Computer imaging: Arnaud Descombes, Antoine Regnault
Funded by: PACA

THE EMPTY PLINTH, 1996
Jochen Gerz
Trafalgar Square, London
A speculative proposal commissioned by PACA
PACA team: Vivien Lovell, Maureen Gaynor
Freelance consultant: Sara Roberts
Funded by: PACA

CENTENARY SQUARE, BIRMINGHAM, 1988-91
Tess Jaray; David Patten
Client: City of Birmingham
Architects: Birmingham City Architects (Nigel Davies, Rod Hatton, Granville Lewis, Bill Reed)
PACA team: Vivien Lovell, Geoffrey Wood, Emma Larkinson, Jennie Toussaint, Maureen Gaynor
Client team: Michael Diamond, Cllr. J. Eames, Cllr. B. Byrd, Geoff Wright
- **Tess Jaray with Birmingham City Architects**
 Centenary Square, 1988-91
 Contractor: Impresa Castelli Construction UK Ltd, London
- **David Patten**
 Monument to John Baskerville – Industry and Genius, 1990
 Assistant: Mitch House

INTERNATIONAL CONVENTION CENTRE, BIRMINGHAM, 1988-91
Ron Haselden; Deanna Petherbridge; Vincent Woropay
Client: City of Birmingham
Architects: Percy Thomas Parnership and Renton Howard Wood Levine
PACA team: Vivien Lovell, Geoffrey Wood, Emma Larkinson, Jennie Toussaint, Maureen Gaynor
Client team: Michael Diamond, Cllr. J. Eames, Cllr. B. Byrd, Geoff Wright
- **Ron Haselden**
 Aviary, 1988-91
 Contractor: Sign Specialists, Birmingham
- **Deanna Petherbridge CBE**
 Architectural Fantasy, 1990-91
 Mural painting team led by Ward Vesey
 Sponsored by National Westminster Bank PLC

- **Vincent Woropay**
 Construction: An Allegory, 1991
 Plinth lettering carved by Bettina Furnée
 Sponsored by: John Douglas OBE, Robert M Douglas Holdings PLC

THE HONEYMOON PROJECT: THE ETERNITY RING, 1990-1991
Miralda
Birmingham
PACA team: Vivien Lovell, Geoffrey Wood, Emma Larkinson, Maureen Gaynor
Project management: Ikon Gallery team led by Elizabeth A MacGregor
- **Hattie Coppard and Jane Kelly**
 The Golden Barge
 Assisted by students from Walsall Art College
 Signwriter: John Horton
 Supported by: Birmingham City Council, Arts Council International Initiatives Fund, Ikon Gallery, PACA

IRON:MAN, 1991-93
Antony Gormley OBE
Victoria Square, Birmingham
Client: Trustee Savings Bank
PACA team: Geoffrey Wood, Vivien Lovell, Emma Larkinson, Caron Wright
Client team: Sir Nicholas Goodison, Mervyn Pedelty, Fiona Fleming-Brown
Contractors: Firth Rixon Castings Ltd, Wednesbury
Funded by: Trustee Savings Bank
Supported by: Association for Business Sponsorship of the Arts

VICTORIA SQUARE, BIRMINGHAM
Marta Pan
Water Feature, 1991
(unrealised)
Client: Birmingham City Council
Maquette made in collaboration with Andre Wogensky, Architect, Paris
PACA Team: Geoffrey Wood, Vivien Lovell, Jennie Toussaint

HACKNEY COMMUNITY COLLEGE 1995-97
Bettina Furnée; Dimitra Grivellis; Susanna Heron; Pat Kaufman
Artworks for a new campus in Shoreditch
Architects: Hampshire County Architects/Perkins Ogden Architects
Landscape architects: Pearson Landscape Design, Milton Keynes
PACA team: Vivien Lovell, Emma Larkinson, Maureen Gaynor
Client team: Chris Mortimer (Project manager); Chrissie Farley (Principal)
Supported by: Royal Society of Arts Art for Architecture Scheme

- **Bettina Furnée**
 State of Rock
 Architects: Perkins Ogden Architects: Alison Hebbert
 Pattern making: Andrew Tanser
 Casting: Rattee and Kett Ltd, Cambridge
 Installation: The Carving Workshop, Cambridge
- **Susanna Heron**
 The Sunken Courtyard
 Architects: Perkins Ogden Architects: Mervyn Perkins with Alison Hebbert
 Landscape architects: Pearson Landscape Design: Stuart Pearson, Pirkko Higson
- **Pat Kaufman**
 Quarry, 1997
 Contractors: Easton Masonry Co (Portland) Ltd
 Landscape architects: Pearson Landscape Design (Stuart Pearson, Pirkko Higson)

A PLEASURE GARDEN OF UTILITIES, 1997 (and ongoing)
Muf
Hanley City Centre, Stoke-on-Trent
Client: Stoke-on-Trent City Council
PACA team: Geoffrey Wood, Emma Larkinson, Caron Wright (1996-97); Vivien Lovell, Alison Deely, Maureen Gaynor (1997-); with Rachel Bradley (1998-)
Client team: Graeme Ives

A STRATEGY FOR PUBLIC ART IN CARDIFF BAY, 1989-91
Eilís O'Connell; Pierre Vivant
PLACE
Client: Cardiff Bay Development Corporation
Public Art Consultancy Team: Vivien Lovell (Project Director), Robert Breen, Lesley Greene, Andrew Knight, Tamara Krikorian, Alison Scott
PACA Administration: Maureen Gaynor, Jennie Toussaint, Danny Callaghan (trainee)
Cardiff Bay Development Corporation team: Hugh Hudson-Davies, Geoffrey Inkin, Barry Lane, John Pickup, Duncan Syme, Griff Taylor
Projects managed by Cardiff Bay Art Trust: Sally Medlyn, Barbara Rhys
- **Eilís O'Connell**
 Secret Station, 1990-92
 Patinated bronze, galvanized steel, fibre optics and steam generators
 Contractors: Sculpture Factory, London
- **Pierre Vivant**
 Untitled, known locally as **'The Magic Roundabout'**, 1992
 Fabrication and installation: Fonderie de Coubertin, Chevreuse, France
 Road signs fabrication: Standard Signs, Newport

LONDON DOCKLANDS 1992-98
Bosch Haslett; Sir Anthony Caro; Bill Culbert; Siobhan Davies; Antoni Malinowski with Future Systems; Eilís O'Connell; Jorge Orta with Lucy Orta; Mark Pimlott; Pierre Vivant; Richard Wentworth
Client: London Docklands Development Corporation
PACA team: Vivien Lovell, Emma Larkinson (-1985), Olga Gribben (1995-1997), Stephen Beddoe (1998-), Maureen Gaynor
Client team: Cynthia Grant, Simon Borthwick, Jeff Hennessey
- **Bosch Haslett**
 Light Objects for London, 1996
 (unrealised)
 Bosch Haslett design team: John Bosch, Gordon Haslett, Jacobien Hofstede, Yvon Visser
 Structural engineer and costing: ABT-West Adviesbureau, Delft
 Lighting consultant: Lighting Design Partnership, London
- **Antoni Malinowski with Future Systems**
 Proposal for Royal Docks Business Park, 1997
 (unrealised)
 Future Systems: Jan Kaplicky, Amanda Levete, Angus Pond
 Quantity Surveyor: Bucknall Austin
 Structural Engineer: Anthony Hunt Associates
- **Eilís O'Connell**
 Vowel of Earth Dreaming its Root, 1994-98
 Circular Plaza
 Landscape architect: Branch Associates: Andrew Rendell
 Contractors: Kilkenny Limestone, Ireland
- **Jorge Orta with Lucy Orta**
 Signs – Light, 1996
 (unrealised)
 Lights/Drawbridge/Luminographic boat/Boat cranes 1996
 Computer graphics: W. Poutsma
- **Pierre Vivant**
 Traffic Light Tree, 1995-98
 Heron Quays roundabout
 Fabrication and Installation: Boundary Metal, Newbury
 Consultant structural engineers: Glanville & Associates, Milton, Oxon
 Signalhead supply, wiring, programme control: Peek Traffic Ltd, London
- **Richard Wentworth**
 Globe, 1995-98
 Cannon Workshops Wall
 Contractor: H.S. Walsh and Sons, Beckenham, Kent: Pat Sheehan

GATEWAYS FOR THE MILLENNIUM, 1994
International Collaborative Workshop, Alliance for Art, Architecture and Design: a Public Art Forum/RIBA initiative
PACA team: Vivien Lovell, Maureen Gaynor, Caron Wright
Alliance Steering Group: Vivien Lovell, Andrew Knight, Andrew Wheatley, Vanessa Swann, Richard MacCormac, Richard Burton, David Wright, Graham Roberts, Lisa Harty
Supported by: British Rail Inner City Unit, Sainsbury Trust, Public Art Forum
Sponsored in kind: RIBA

WELL, ONE THOUSAND LIGHTS, 1997
David Ward
The Royal Pump Rooms and Baths, Leamington Spa
A PACA initiative
PACA team: Vivien Lovell, Alison Deely, Jayne Higgins
Freelance consultant: Sam Wilkinson
Artist's assistant: Sarah Trigg
Other assistants: John Herbert and Foundation Studies students from Warwickshire College, Leamington Spa
Funded by: PACA, West Midlands Arts, Warwick District Council

OUT OF DARKNESS
1989 (and ongoing)
Tony Cooper; Siobhan Davies; Richard Ellis; Ron Haselden; Janet Hodgson; Martin Richman
Wolverhampton Town Centre
Client: Wolverhampton Borough Council
Public Art Strategy prepared in collaboration with Jane Kelly
PACA team: Geoffrey Wood, Caron Wright (-1997); Emma Larkinson (-1995); Vivien Lovell; Maureen Gaynor (1997-); Rachel Bradley (1998-)
Freelance consultant: Sam Wilkinson (1996-)
Client team: Sarah Campbell, Nick Dodd
Technical support: Mark Sutton-Vane Associates, London; Jeremy Lord Colour Lighting Company, London; Paul Heath, WBC; Richard Astle, WBC; Sue Whitehouse, WBC; John Davies, Wolverhampton Art Gallery
The Arts Council Lottery bid was submitted by Wolverhampton Metropolitan Borough Council and PACA

Supported by: Arts Council Lottery; European Regional Development Fund; Wolverhampton Borough Council; City Challenge; West Midlands Arts; MEB; Philips Lighting, Croydon
– **Tony Cooper**
School Street Car Park
Specialist contractors: Drakeset Ltd, Wolverhampton
– **Martin Richman and Tony Cooper**
St Peter's Church
Specialist contractors: Cosgriff Electrical Ltd, Wolverhampton
– **Martin Richman**
Wolverhampton Art Gallery
Specialist contractors: Chambers Electrical (Wolverhampton) Ltd
– **Siobhan Davies**
Lines of Desire **(unrealised)**
Technical consultants: Architectural Enlightenment
– **Richard Ellis**
Central Library
Specialist contractors: Cosgriff Electrical Ltd, Wolverhampton
– **Ron Haselden**
Children's Voices, **1997**
Sound recordist: Mark Tomlinson
Sound stores: Golding Audio
Lighting: Mark Sutton-Vane Associates, London
Electronics design and construction: Iain Goodhew
Recordings made at: Heath Park School, East Park Primary School, Hill Avenue Primary School, Westcroft School, Christ Church C of E Primary School, Highfield School

MADE LIGHT, 1994-97
Martin Richman
Tyseley Energy from Waste Facility, Birmingham
Client: Tyseley Waste Disposal (TWD) Ltd with Birwelco Ltd
Architects: Faulks Perry Culley & Rech: Ray Perry
Engineering contractor: Birwelco Ltd
PACA team: Vivien Lovell, Emma Larkinson, Olga Gribben, Alison Deely, Maureen Gaynor
Freelance consultants: Angela Kingston, Sara Roberts
Client team: Stuart Sim, Anthony Warder (TWD); Peter Slater, Geoff Allchurch (Birwelco)
Supported by: Association for Business Sponsorship of the Arts, Business Sponsorship Incentive Scheme, Royal Society of Arts Art for Architecture Award, West Midlands Arts
Publication: *Made Light*, PACA, 1998

MOONLIGHT (BY PERMISSION); MADE IN ENGLAND, 1990
Pierre Vivant
Artist's residency at the University of Warwick
Client: Mead Gallery, University of Warwick
PACA team: Vivien Lovell, Jennie Toussaint
Client team: Kate Eustace, Victoria Pomeroy, Ashley Wright
– *Moonlight (by permission)*
Audiovisual equipment: Isis Communication
System installation: Richard Sharpe
Light hire: Samuelsons, London
Publication: *Moonlight (by permission)*, University of Warwick 1990
– *Made in England*
Several sites provided by the Royal Agricultural Society of England
Exhibition tour: The Southern Arts Touring Exhibitions Service, The Winchester Gallery
Publication: *Made in England*, South Hill Park, 1993

LIVELLI IN INPUT, 1995
Alessandra Rossi and Craig Wood
Palazzo Querini Stampalia, Venice/University of Warwick
PACA team: Vivien Lovell, Emma Larkinson
EU Traineeship holder: Lorenza Savini
Funded by: University of Warwick, PACA
Sponsorship in kind: Hotel Bisanzio

HOST, 1996
Pierre d'Avoine with Heather Ackroyd and Daniel Harvey
Nuova Icona Gallery and Oratorio di San Ludovico, Venice
A PACA initiative with Nuova Icona, Venice
PACA Team: Vivien Lovell, Emma Larkinson, Maureen Gaynor
Nuova Icona team: Vittorio Urbani, Vincenzo Casali, Francesco Zavagno
Pierre d'Avoine Architects team: Pierre d'Avoine, Joyce Chan, Thomas Emerson, Hiroki Ishikawa, Alessandra Maiolino, Clare Melhuish, Janek Schaefer
Consultant structural engineers: Dewhurst Macfarlane and Partners
Supported by: The British Council, The Arts Council of England, West Midlands Arts, IRE Venezia
Publication: *Host*, PACA, 1996

BANKSIDE BRIDGE, LONDON, 1996
Dan Graham and Mark Pimlott, with Jane Wernick, Ove Arup and Partners
A speculative proposal commissioned by PACA
PACA team: Vivien Lovell, Maureen Gaynor
Assistant to Mark Pimlott/model maker: Alex Ely
Assistant structural engineer: Sophie Le Bourva, Ove Arup and Partners
Funded by: PACA

BIRMINGHAM TOWN HALL, 1997 (and ongoing)
Lise Autogena (lead artist)
Client: Birmingham City Council
Architect: Birmingham City Architects: Martin Brown, Nigel Davies, Roger Oakes
PACA team: Emma Larkinson (-1995), Alison Deely (1997-), Vivien Lovell
Client team: Birmingham Leisure and Community Services: Graham Allen, Bruce Epps, Neil Johnston, Anthony Sargent
Computer assistance: Dan Blore, Joshua Portway
Business planning consultants: KPMG: Richard Samuda, Glyn Jones
Arts Council Lottery support applied for

STAG PLACE, VICTORIA, LONDON
Patrick Heron with Julian Feary
Wind Screen, **1996-98**
Client: Land Securities plc
Architects: Feary and Heron
PACA team: Vivien Lovell, Geoffrey Wood, Maureen Gaynor, Caron Wright
Client team: Ian Henderson, Peter Frackowicz
Structural engineers: Ove Arup and Partners, Dewhurst Macfarlane and partners
Construction specialist: Vector Special Projects
Lighting design: Peter Freeman

SEVEN DIALS PIAZZETTA, COVENT GARDEN, 1997-98
– **Shelagh Wakely**
Rainsquare
Client: Covent Garden Estates Ltd
Architects: Eric Parry Associates: Eric Parry, Amanda Bulman
PACA team: Vivien Lovell, Maureen Gaynor
Freelance consultant: Sara Roberts
Client team: Peter Williams, Douglas Rose
Supported by: Association for Business Sponsorship of the Arts Business Sponsorship Incentive Scheme

PIERHEAD, LIVERPOOL, 1995
(unrealised)
**Vito Acconci; Douglas Hollis and
Anna Valentina Murch**
Client: Merseyside Development
Corporation
PACA team: Geoffrey Wood, Caron
Wright (-1997)
Vivien Lovell, Maureen Gaynor (1997-)
Steering Group: Chris Farrow, Paula
Ridley, Lewis Biggs, Robert Hopper,
Tony Woof, Julian Treuherz, Robert
Fraser

**THE GARDEN QUADRANGLE,
ST JOHN'S COLLEGE, OXFORD,
1992-93**
**Alexander Beleschenko; Brian
Catling; Simon Lewty; Wendy
Ramshaw OBE**
Client: St John's College, Oxford
Architects: MacCormac Jamieson
Prichard (Richard MacCormac, Jeremy
Eastop)
PACA team: Vivien Lovell, Emma
Larkinson, Maureen Gaynor
Client team: Anthony Boyce, William
Hayes, Nicholas Purcell, Denis
Moriarty
– **Wendy Ramshaw OBE**
Garden Gate, 1992-93
Fabricators: Richard Quinnell
Supported by: Royal Society of Arts
Art for Architecture Award

**BRITISH EMBASSY, DUBLIN,
1994-95**
**Brian Catling; Susanna Heron;
Susan Kinley; Peter Randall-Page**
Client: Overseas Estate Department,
Foreign and Commonwealth Office
Architects: Allies and Morrison,
London: Bob Allies, Graham Morrison,
Joanna Green, David Amarasekera, Ian
Sutherland, Chris Bearman, Robert
Maxwell, Deborah Miller, Deborah
Bookman, Paul Summerlin, Stephen
Archer, Honor Thompson, Hattie
Arabaci, Pauline Stockmans, Kevin
Allsop
Consultant Architect: Arthur Gibney &
Partners, Dublin: Arthur Gibney, David
Harris
Landscape Architect: Livingston Eyre
Associates, London: Georgina
Livingston, Simon Monro
Consultant Landscape Architect:
Mitchell & Associates, Dublin: Gerard
Mitchell, Fergus McGarvey
PACA team: Vivien Lovell, Emma
Larkinson, Maureen Gaynor
Freelance consultant: Jenny
Haughton, Artworking
Client team: David Pennington
– **Susanna Heron**
Island
Supported by: Henry Moore
Foundation

**WATERLOO INTERNATIONAL
TERMINAL, 1993-95**
Jean-Luc Vilmouth
Channel Fish
Client: European Passenger Services
Architects: Nicholas Grimshaw and
Partners
PACA team: Vivien Lovell, Emma
Larkinson, Maureen Gaynor, Caron
Wright
Freelance consultants: Amanda
Crabtree, Joan Asquith
Client team: John Palmer, Peter
Kendall, Lesley Retallack
Client's advisory architect: David
Levitt, Levitt Bernstein Associates
Technical advisers: Cabinet HARO
Architects, Jean-Marie Mandon, Loïc
Julienne
Fabrication: Nawak and Ventilo
Supported by: Arts Council of England,
Henry Moore Foundation, Visiting Arts,
Association Française d'Action
Artistique, Association for Business
Sponsorship of the Arts Business
Sponsorship Incentive Scheme
Sponsored by: Nicholas Grimshaw and
Partners, YRM Anthony Hunt
Associates, Davis Langdon & Everest,
Sir Alexander Gibb & Partners, Avesta
Sheffield Ltd, Techspan Systems Ltd,
Vitra Ltd
Publication: *Channel Fish*, European
Passenger Services, 1995

**WILFRED OWEN MEMORIAL,
SHREWSBURY, 1993-94**
Paul de Monchaux
Symmetry
Client: The Wilfred Owen Association
PACA team: Vivien Lovell, Emma
Larkinson, Maureen Gaynor
Client team: Robert Hutchison; William
Mostyn Owen; John Davies, Bishop of
Shrewsbury; Helen McPhail
Lettering: Ruth de Monchaux
Contractors: Natural Stone Products
Ltd, CF Piper & Son, WS Crossley Ltd,
Parker & Morewood
Funded by private subscription
Supported by: Airlife Publishing Ltd,
The Barbinder Trust, The Britten-Pears
Foundation, William A Cadbury Trust,
Foundation for Sport and the Arts,
Furrows Ltd, The Earl of Harewood's
Trust, Kingsland Grange, The
Millichope Trust, The Plumbing Shop,
The Rank Foundation, The Rayne
Foundation, Shire Vending Services
Ltd, Shrewbury and Atcham Borough
Council, Shrewsbury Decorative Arts
Society, Shrewsbury Sixth Form
College, Shropshire County Council,
Tanners Wines, West Midlands Arts,
The Wilfred Owen School, The Garfield
Weston Association

Published by Merrell Holberton
Publishers on the occasion of the tenth
anniversary of Public Art Commissions
Agency (1987–1997)

PACA is an educational charity
(no. 519652) and a company limited by
guarantee (no. 2179330), registered at:

Studio 6, Victoria Works,
Vittoria Street,
Birmingham B1 3PE
Tel: 0121 212 4454
Fax: 0121 212 4426
E-mail: paca.org.uk
http://www.paca.org

PACA (London),
118 Commercial Street,
London E1 6NF
Tel: 0171 247 2484
Fax: 0171 375 0672

PACA evolved from a West Midlands
Arts public art initiative with the
Gulbenkian Foundation, developed by
Vivien Lovell, then West Midlands Public
Art Coordinator, from 1985–1987.
 Early champions of PACA were the
West Midlands Public Art Steering
Group, chaired by Christopher Bailey;
Andrew Sebire, architect, and principal,
Sebire/Allsopp; and Charles King-Farlow,
solicitor, Pinsent & Co.
 PACA's Founder-Trustees were Michael
Diamond (Chair 1987–88), James
Hurford, Andrew Sebire, John Hawksley,
Hamish Miles and Avtarjeet Dhanjal.
 From its inception, PACA has received
annual funding from West Midlands Arts
Board for its programme of education
and advocacy in the West Midlands.
The majority of its work and revenue
derives from public and private sector
clients. PACA's Speculative Proposals
programme and other intiatives are
made possible through fundraising.

Front cover: David Ward, *Well, One
Thousand Lights*, 1997, The Royal Pump
Rooms and Baths, Leamington Spa,
commissioned by PACA
Back cover: Susanna Heron, *The Sunken
Courtyard*, Hackney Community College,
artistic direction by PACA
pp. 2–3, 8–9: Mark Goulthorpe of dECOi
Architects with Max Mosscrop, a special
collaboration for *Public:Art:Space*
commissioned by PACA, 1998

Copyright © 1998 PACA
Introduction copyright © 1998 Mel
Gooding

All rights reserved

First published in 1998 by
Merrell Holberton Publishers Ltd,
Willcox House,
42 Southwark Street,
London SE1 1UN

British Library Cataloguing in
Publication Data
Public – art – space
Public Art Commissions Agency
2. Public art
3. Installations (Art)
I. Gooding, Mel
709'.049

ISBN 1 85894 048 6

Compiled and edited by Sara Roberts
Commentaries by John Gillett
Edited in house by Annabel Taylor
Designed by Stephen Coates
Design assistance by Jason Beard
Produced by Merrell Holberton
Printed and bound in Italy

ACKNOWLEDGEMENTS
Grateful acknowledgement is made to
the following for permission to
reproduce material:

Photography
p. 13 Courtesy Giraudon/Bridgeman Art
Library, London/New York
p. 16 centre: Courtesy Anthony d'Offay
Gallery, London
p. 16 bottom: © ARS, NY AND DACS,
London 1998
p. 22 bottom left: Courtesy Earth 2000
Ltd and the London Aerial Photo Library
p. 22 top and middle right: Courtesy
FISA
p. 22 bottom right: Courtesy Thomas
Benacci
pp. 42, 43 top right, bottom right,
44–45: Courtesy Cardiff Bay Art Trust
p. 49 bottom left: Courtesy London
Docklands Development Corporation
p. 64 aerial photograph: Courtesy
Tyseley Waste Disposal (TWD) Ltd
p. 100 top left, top right: Courtesy of
The Trustees of The Imperial War
Museum, London. (Q 3990, Soldier on
Parapet, Somme, 1916; E(AUS) 122, Men
walking on duckboards, Ypres 1917.)

Text
p. 38 *A State of Rock*, poem by
Benjamin Zephaniah from *Inna
Liverpool*, Edinburgh (AK Press) 1992
p. 47 *Kinship* by Seamus Heaney, from
North, London (Faber and Faber Ltd)
1980.
p. 101 *Strange Meeting* by Wilfred Owen
from *Collected Poems*, London (Chatto
and Windus) 1963; Courtesy the Estate
of Wilfred Owen and Chatto and Windus.

Maps/plans
p. 46 map by Karen Crane, LDDC.
Reproduced from the 1993 OS London
area 1:65,000 map with the permission
of the Controller of Her Majesty's
Stationery Office © Crown Copyright
p. 64 axonometric drawing Courtesy
Faulks Perry Culley and Rech

PHOTOGRAPHIC CREDITS
All photographs courtesy the artists,
architects and PACA except where
stated otherwise.

Mike Bruce: p. 16 (centre)
John Davies: pp. 42, 43 (top right,
bottom right), 44–45
Rod Dorling: front cover; pp. 25, 26, 32,
33, 34, 58, 59, 60, 61, 63, 82, 88 (top
left, centre left, right), 89
Christoph Grothgar: p. 56 (bottom)
Susanna Heron: back cover.
David Hoffman: pp. 22, 23, 46, 47, 48
(bottom left), 49 (top left, bottom right),
57, 80 (top left, centre left, bottom left),
97 (top, centre left, bottom right), 98
Jane Kelly: p. 31
Lizzie Kessler: pp. 102–03
Timothy Kovar: p. 94
A. Morin: p. 52 (top left)
Dennis Mortell: p. 94 (bottom), 95
(bottom)
News Team: p. 27 (bottom right)
Anthony Oliver: p. 64 (top), 65
Chris Thomond: p. 27 (bottom right)
Michael Walters: p. 24 (bottom left)
David Ward: p. 36, 37, 90, 91, 92–93
Alan Williams: p. 88 (bottom left)
Edward Woodman: p. 70 (top left), 83

PUBLIC:ART:SPACE